FOOLING HOUDINI

FOOLING HOUDINI

Magicians, Mentalists, Math Geeks
& the Hidden Powers of the Mind

ALEX STONE

HARPER
An Imprint of HarperCollins*Publishers*
www.harpercollins.com

HarperCollins books may be purchased for educational, business, or sales promotional use. For information, please write: Special Markets Department, HarperCollins Publishers, 10 East 53rd Street, New York, NY 10022.

Grateful acknowledgment is made to the Conjuring Arts Research Center for permission to reprint the image on page 263.

FIRST EDITION

Designed by William Ruoto

Library of Congress Cataloging-in-Publication Data
Stone, Alex.
 Fooling Houdini : magicians, mentalists, math geeks, and the hidden powers of the mind / Alex Stone.
 p. cm.
 ISBN 978-0-06-176621-3
 1. Stone, Alex. 2. Magicians—United States—Biography. 3. Magicians—United States. 4. Magic—Psychological aspects. 5. Magic—Social aspects. I. Title.
 GV1545.S78A3 2012
 793.8092—dc23
 [B]
 2011041927

12 13 14 15 16 ov/rrd 10 9 8 7 6 5 4 3 2 1

For my parents, Carmen and Bill Stone

The most beautiful thing
we can experience
is the mysterious.

—*Albert Einstein*

CONTENTS

FOOLING HOUDINI

THE MAGIC OLYMPICS

I n the foyer of a hotel in downtown Stockholm, a stunning twenty-two-year-old Belgian girl with dark brown eyes and long chestnut curls had attracted a small crowd. She held an ace in each hand, and as she twirled her arms through the air, the cards transformed into kings. The audience had seen this sort of thing before—they weren't the kind of people who would go wild for a single change. But then, in one fluid sequence, she coiled her wrists again and the kings became queens. The energy in the room quickened as her arms snaked through the air like a flamenco dancer's—once, twice—and the queens faded into jacks, then tens. The people around her began to cheer. Another whirl and the tens turned into jokers. She is one of the only magicians in the world who can pull off five transformations in a row, and the audience was now crazy for her.

Toward the back of the lobby, a florid man in a black pork-

pie hat demoed a shell game—that age-old gypsy swindle with three hollowed-out shells and a pea. In the corner by the entrance, a gaggle of teenagers in red lounge chairs were performing an acrobatic kung fu of card stunts known as Extreme Card Manipulation—a flurry of cuts, spins, and flourishes. In the hands of these kids, the cards became pyramids and snowflakes, whorled mollusk spirals, mandalas of cycling angels. The leader of the group, a chubby alpha nerd in a black skullcap, flaunted a move in which stacks of cards formed intersecting geometric patterns that resembled an M. C. Escher illusion. Then there were the mentalists—mind readers, spoon benders, second-sight acts. Dressed mostly in black, they'd staked out a pair of round tables in the middle of the lounge, and I would have given a kidney to be a fly on one of their beer glasses. Everywhere you looked—in the hallways, at the bar, in the restaurant, by the elevators, even in the bathrooms—men and women were sharing secrets, trading moves. I clutched a worn deck of blue Bicycle cards in my fist and drank in the scene.

It was almost ten o'clock on a balmy weekend night in early August, but the Stockholm sky was not yet dark, and a gauzy dusk seeped through the skylights, casting a maze of shadows on the carpet of the atrium lobby. In Sweden during the summer months, the sun hardly sets, and the insomnia of endless daylight can throw you into delirium. Not that I planned to sleep. Here I was sharing the same air with the world's greatest magicians, many of them my heroes.

We were all in Stockholm for the 2006 World Championships of Magic, otherwise known as the Magic Olympics. Every three years the greatest conjurors from around the globe descend on a chosen city, armed with their most jealously guarded secrets, and duke it out, trick for trick, to see who among them is most powerful. The Twenty-third Olympics in Stockholm

were the biggest in history, with nearly 3,000 attendees from 66 countries and 146 competitors vying for medals in 8 events. This year I was one of the challengers.

Given that the Olympics is by far the toughest magic competition in the world, getting into the games at all was something of a miracle. To be eligible, you must belong to one of the eighty-seven magic societies sanctioned by the Fédération Internationale des Sociétés Magiques, or FISM, the world's largest and most prestigious magic alliance. The United States has three FISM-approved magic societies: the Academy of Magical Arts, seated at the Magic Castle in Hollywood, the International Brotherhood of Magicians, and the Society of American Magicians, or the SAM ("Magic, Unity, Might!"), of which I am a card-carrying member.

The entrant must also obtain written authorization from the president of his or her society, and having never competed in an international tournament—or any tournament, for that matter—I had been all but certain that SAM president Richard M. Dooley would reject me outright. I was stunned when he wrote back a week after I sent in my request wishing me luck.

I would need it.

I WAS FIVE YEARS OLD when my father, a geneticist and dyed-in-the-wool skeptic who makes his own cologne and brushes his teeth in the car, presented me with an FAO Schwarz magic kit he had bought on a trip to New York for an academic conference. It was a beginner's set with a wand and a book and a dozen or so simple tricks. There was a small green plastic cup—a miniature goblet—with a ball that vanished, a family of small red foam bunnies that could be made to multiply in your hand, and a small wooden box that turned pennies into

nickels. I'll never forget the look of amazement on my father's face when I showed him my first trick.

My debut gig was my own sixth birthday party, and photographs exist somewhere of me gesturing tentatively, in a top hat and red-and-black cape sewn by a neighbor, before a small group of friends. I was woefully unpolished, and they heckled me to tears. But I didn't quit, thanks in no small measure to my father's encouragement. Dad was not a religious man. He wasn't into sports or the great outdoors. We never went to ball games or on camping trips. The Chopin *Études* I hammered out in our living room—the product of several years and several thousand dollars' worth of piano lessons—rarely elicited more than an absentminded nod from him. But even the simplest magic trick would light up his face. It was a language we both understood. Saturday trips to JCR Magic in our hometown of San Antonio—a phantasmagoria of trick coins and dove pans and fake vomit—became our ritual; magic shows, our sporting events.

One of the biggest treats my father ever gave me was a pair of tickets to see David Copperfield at the ritzy, chandeliered Majestic Theater downtown. Watching the show, I quickly recognized that Copperfield was no mortal. He walked through walls, levitated, vanished astride his roaring Harley, only to appear, seconds later, at the very rear of the theater, proud in his snug leather pants. But the most exciting part of all was that I got to meet the illusionist in person after the performance. I'd practiced for weeks what I was going to say to him. I stood in the receiving line in the carpeted lobby of the Majestic for half an hour, worrying over my note cards before coming face-to-face with the unearthly being, he of the feathered hair and flouncy pirate shirt, sitting atop what seemed like a giant throne. When my ten seconds finally came, my vocal cords seized up and the only words that came out were "Can I touch you?"

By the time I was in high school, I'd gotten good enough to start doing paid shows—birthdays, weddings, bar mitzvahs. Mostly I did these shows so I could afford to buy new tricks, the way a junkie deals to support his habit.

In my mind, magic was also a disarming social tool, a universal language that transcended age and gender and culture. Magic would be a way out of my nerdiness. That's right, I thought magic would actually make me *less* nerdy. Or at the very least it would allow me to become a different, more interesting nerd. Through magic, I would be able to navigate awkward social situations, escape the boundaries of culture and class, connect with people from all walks of life, and seduce beautiful women. In reality, I wound up spending most of my free time with pasty male virgins.

My interest in magic has only grown since childhood. As I entered the workforce—as a fact checker and later an editor at *Discover* magazine—magic became an escape from the fluorescent anomie of cubicle and commute. Later on, when I started taking upper-level physics classes at Columbia University, with an eye toward applying to graduate school, magic provided a welcome respite from a world bound by logic and empiricism, a relief from my father's metaphysics. There's something deeply liberating about letting go of the reins that couple cause and effect, the X and Y axes. Not even wrestling a grungy quantum mechanics problem to the ground could give me quite the same pleasure as mastering a new baffler, and I took an almost perverse joy in stupefying Columbia's illustrious faculty.

That said, I also began to notice a number of connections between magic and science—especially psychology, neuroscience, mathematics, and physics. Magic, at its core, is about toying with the limits of perception. And as any neuroscientist will tell you, one can learn a lot about the brain by studying

those bizarre moments wherein it succumbs to illusion. Magic lives in these moments. At its best, magic is a kind of psychological cage match. What distinguishes a good magician is his or her ability to divert an audience's attention and manipulate their expectations. Expert conjurors possess an instinct for how people see things, a marksman-like ability to get a good bead on a person's perception.

As a practitioner of magic, you become more attuned to the limits of other people's perceptions as well as your own. As a result, you become better at distinguishing reality from illusion, at reading the angles and decoding the fine print. You gain an intuition for how people behave. You even learn ways to influence their behavior. This makes you less susceptible to all manner of deception. It is this heightened state of awareness, this sixth sense, that has kept me interested in magic well into my supposedly adult life.

To truly understand the art of magic and its timeless appeal, you wind up asking questions not just about how the mind works—and why sometimes it doesn't—but also about some of the most fundamental aspects of human nature. Why do people take pleasure in deceiving others? How does the brain perceive the world and parse everyday experience? What are the psychological consequences of secrecy? What is reality, and how much of it do we consciously take in? How much faith can we have in our memories? Why are humans programmed to believe in the supernatural? These are the kinds of questions that philosophers and scientists have puzzled over for centuries. Which is to say that, strange as it may sound, studying magic ultimately leads you to ponder some of life's deepest mysteries. Perhaps this is why, as I came to learn, the world of magic is filled with scientists and the world of science is filled with magicians. Both fields appeal to the same breed of intellectual

thrill seekers that Victorian stage magician John Nevil Maskelyne referred to as "people who take an interest in mysteries."

Eventually my fascination with the mysteries of magic, and my quest for new material, led me to immerse myself in a world of meetings, lectures, and workshops—an underground community of like-minded obsessives for whom magic is more than just a hobby: it's a way of life. In any given week in New York City, where I now lived, there were a dozen private gatherings—in the backs of diners, at split-level veterans' lodges, in spare rooms at medical centers and universities, and in various other undisclosed locations. I quickly learned that the juiciest secrets were seldom printed in books or packaged in magic kits. The most valuable knowledge—the real work—was passed along in secret sessions and backroom conclaves. Deception, I came to realize, was one of the few remaining oral traditions.

In November 2005, I sought to improve my skills alongside the experts at the Society of American Magicians, the world's oldest magic fraternity. To join the SAM, you must enlist the sponsorship of three members, pass a test, and swear an oath of secrecy—all of which I managed to do. Founded a century ago in New York City—Harry Houdini was president from 1917 until his death in 1926—the SAM boasts 30,000 members (or "illustrious compeers") in 250 assemblies nationwide, a monthly magazine, a secret handshake (known as The Palm), a national contest and convention, millions in assets, its own liability insurance policy that it issues to members, its own credit card, and an Occult Investigation Committee that sniffs out paranormal claims à la Mulder and Scully. In 2009 the SAM held a meeting aboard the International Space Station. Levitations made easy.

Soon after I joined, bimonthly meetings of the Society be-

came a big part of my social life—if you can call it that—and on a typical Friday night I was less likely to be found at the latest hotspot than in the poorly ventilated upstairs room of the Soldiers', Sailors', Marines', Coast Guard and Airmen's Club on Lexington near Thirty-seventh Street, the SAM's guildhall, trading moves with geriatrics and ungainly teenagers. I never left home without a deck of cards in my back pocket and a trio of Kennedy half dollars. Saturdays found me at Tannen's, New York's oldest magic store, founded in 1925 by a scrappy red-haired Brooklyn magician named Louis Tannen, who toured with the USO and the Red Cross during World War II.

There's a heart-wrenching scene in *Rudolph, the Red-Nosed Reindeer*, the old stop-motion Christmas TV special, that has always resonated with me. After his run-in with the Abominable Snowman, Rudolph and his buddies seek asylum on the Island of Misfit Toys, a haven for crappy, deformed, and unwanted toys presumably built by an elf with substance abuse issues. There's the choo-choo train with square wheels, the water pistol that shoots jelly, the cowboy riding an ostrich, the white elephant with pink polka dots, the infelicitously named Charlie-in-the-Box. "Hey we're all misfits, too!" Rudolph squeals to his newfound friends, and everyone breaks into song. I cry every time I see it.

Throughout most of my life, I've felt a bit like that square-wheeled caboose. I was the only child of older parents, and when I went out with my dad people would say things like "How nice of you to take your grandpa for a walk." Up until junior high, I hung out mostly with adults. In elementary school, I was nerdy and unsocialized, a dweeb who wanted to talk about biology and play with his chemistry set while the other kids were playing foursquare. In middle school, I was a band geek. In high school, a debate dork.

For me, discovering the world of magic was like finding my own island of misfit friends, a place where everyone was special in the wrong way. Magic, let's face it, is a pastime for misfits, an outlet for outcasts with low self-esteem. It offers a structured medium through which you can be social without really dealing with people on a personal level, a way to get back at the alphas through trickery, a secret skill you can lord over your social betters. With magic tricks, you can seem extroverted and outgoing while still maintaining a safe social distance. Magicians hide in the spotlight, much in the way that photographers often mediate their social experiences from behind a lens and comedians hide behind jokes. Like physics, magic is all about nerds playing god with the universe.

Once you enter this world, you find that there are people everywhere who are just like you. They start to come out of the woodwork. You begin to make what are known as "friends in magic." A restaurant owner in Barcelona takes you into his wine cellar to show you the Shapeshifter change and a soft double lift. In return you teach him the faro. The meal, of course, is free. A neuroscientist at a major university e-mails you about a new mind-reading technique he's discovered. You become fast friends. His dream is to retire so he can focus on magic. You meet a salesman who credits magic with adding millions to his bottom line. You arrive in strange cities to find yourself in instant communion with a band of strangers. You travel the world never in want of a place to stay.

The deeper you immerse yourself in this world, the more it seems like the only one that matters. The real world of clock watchers and brown baggers with their 401(k)s and tidy job hair seems lethally boring by comparison. None of them can do what you can do. Increasingly, you see the world as split between two classes of people. Only two. There are magicians

and there are laypeople. If you're not on the inside, you're on the outside.

This is how magicians act.

This is how magicians think.

Everyone else is a layperson. The NASA rocket scientist, the CEO, the fashion model, the celebrity—they may be smarter or richer or better looking or more famous, but you've fooled them all.

So now who's the misfit?

But while most hobbyists are content to fool laypeople, competitive magicians live to fool *other* magicians. These are folks who move from tournament to tournament, for whom honor is more important than money or fame, and the ultimate prize is to fry your opponents with a brilliantly crafted trick or routine. The social order of this rapidly growing subculture is based largely on who fools whom. Atop the hierarchy sits a small number of eccentric geniuses all but unknown to the outside world, but revered as royalty within their sect.

The thrill of victory. A shot at the title. This was what had brought me to Stockholm. I, too, wanted to be a magician fooler, a misfit king.

Magic Olympic Village, where the official events would all take place, turned out to be a titanic fuselage-gray complex of low-slung metallic buildings on the edge of town, just off the highway. I checked in on Monday morning and received an ID badge, a program, that day's edition of the *FISM Daily*, and a swag-filled World Championships of Magic tote bag.

Events at the Magic Olympics fall into two main categories: stage magic and close-up magic, reflecting a long-standing division within the art. A Grand Prix medal is awarded at the

conclusion of the weeklong games to the top performer in each category, upon whom is bestowed the title "World Champion of Magic," along with membership in the elite World Champions Club and career-making contracts at such venues as the Greek Isles Hotel in Las Vegas, the Palladium in London, and the Crazy Horse in Paris.

My specialty is close-up magic, or what the Europeans call micro magic, a school of conjuring that dispenses with the bisected showgirls and materializing fowl of stage illusions in favor of intimate effects using small, unassuming props: cards, coins, cups, balls, rings, ropes, rubber bands, thimbles, and cutlery. Close-up magic is the kind of magic that happens, as they say, right under your nose.

The close-up prelims would be staged in a 280-seat auditorium that, for the duration of the events, would be known as the Vernon Room, named after the most influential sleight-of-hand expert of the twentieth century, The Man Who Fooled Houdini. The story is legend. At the height of his career, Houdini boasted that no man could fool him three times with the same trick. Magic, of course, relies heavily on the element of surprise, and even the greenest conjuror knows never to repeat an effect for the same audience. ("Once is a trick, twice is a lesson," goes an old saying.) Years passed, and the challenge went unmet. Then, one night in 1922, during a SAM dinner held in Houdini's honor at the Great Northern Hotel in Chicago, Dai Vernon, at the time a complete unknown, drew a pack of Aristocrats from his coat pocket and executed a deceptively simple version of the Ambitious Card routine, in which a signed card returns to the top of the deck after being placed in the middle. Ringed by his disciples in the mirrored banquet hall, the man who had proclaimed himself the greatest magician in the world blanched in disbelief. Houdini was stumped.

Vernon repeated the effect no fewer than seven times before Houdini and his wife walked out in defeat. Ever since that night, the Professor, as Vernon came to be known, has held an exalted place in the foolers' pantheon, and the Ambitious Card, often called the perfect trick, remains a staple of virtually every magician's repertoire, including my own.

The fortune of a Magic Olympics hopeful rises or falls on the strength of his routine, a five-to-ten-minute act performed before a panel of eight judges. It's a lot like figure skating. Marks are handed out for technical skill, originality, showmanship, entertainment value, artistic impression, and magic atmosphere, on a scale of zero to one hundred. If, in the opening minutes of his act, an entrant fails to meet FISM's minimum skill level requirement, a red lamp is illuminated, signaling instant disqualification. Curtains are drawn and the contestant is sent packing.

The foreman of my close-up jury was slated to be none other than Obie O'Brien, leader of the ultrasecretive FFFF, or Fechter's Finger Flicking Frolic, the Templars of magic. Each year the FFFF holds an invitation-only convention in upstate New York widely regarded as the most exclusive gathering of close-up magicians in the world. Being invited to the FFFF is like becoming a made man in the Mafia. It means you have arrived. Also on the judging panel was Roberto Giobbi, whose *Card College*, volumes 1–5, had replaced *The Royal Road to Card Magic* as the standard elementary text. When the time came, I'd have to perform for the guy who'd literally written the book on card magic—and from whose book I'd learned most of what I knew.

Not only that: I'd have to *fool* him.

AS I ENTERED THE VERNON dressing room to prepare for my act, I saw eight small cubicles, each outfitted with a table, a

chair, and a mirror. A TV monitor had been set up on the land-ing so that the competitors could watch the acts, and several magicians were gathered there when I walked in. One of them sat cross-legged on the floor, eyes closed and hands doing some sort of prayer-like maneuver. Next to him stood Canadian cruise ship wizard Shawn Farquhar, up first, and just about the last guy I wanted to follow. A fourth-generation magician, Farquhar had notched forty-seven international victories and was the only person in history to win the International Broth-erhood of Magicians competition in both stage and close-up. He took home a pair of silvers at the last Olympics, but was now after bigger quarry: "Grand Prix or gold," he told me, as we chatted for a moment, "then I'm done."

Before each act, the challenger is announced. His coun-try, magic society, and the president who consecrated him are named. More than just a formality, this custom is meant to establish accountability between the Fédération and its nu-meraries, for FISM statutes expressly forbid a president from approving anyone who is "under FISM level," and societies deemed in breach of this rule face suspension from future games.

Farquhar marched onstage brimming with confidence in his lavender suit and caution-yellow tie. He'd been doing his act since 1997, a gloss on two classics, both scorchers. First was his signature Ambitious Card routine, in which the signed card winds up inside a new cellophane-sealed deck in its cor-rect location. I had no clue how he did it. Judging by their schwas of wonder, the audience, mostly magicians, didn't ei-ther. His closer was a version of the cups and balls, the oldest recorded magic trick, which started off normally enough but ended with the cups revealed to be solid slabs of steel. The guy was a master.

I was waiting in the wings when I heard the announcer call out my name. Fighting a rising panic, I almost fled. But something stopped me. I thought of my parents, who had flown in from Spain to watch me perform. I thought of my SAM brethren, their honor in my charge. I thought of the guys rooting for me at a neighborhood bar back home, my favorite place to practice. I thought of Richard M. Dooley, who'd placed his trust in me, commended me to his peers, and asked nothing in return. I thought of my girlfriend Rachel's good-luck card with the coven of barefoot warlocks drawn beneath the heading "KNOCK THEIR SOCKS OFF!"

I stepped out into the light.

"LADIES AND GENTLEMEN," I BEGAN, "back in the Renaissance, magic and what we now call science were one and the same. Today we view the two disciplines as separate, but I know a little something about physics, and I can tell you that the laws of magic and the laws of physics are but two sides of the same coin." As I said this, I gestured at a small blackboard behind me, on which I'd scrawled some formulas, and produced an Eisenhower silver dollar from thin air.

I rolled the silver dollar in my fingers and tossed it into my left hand. Just then I heard a loud "clink," and I felt as if all the air had been sucked out of my lungs. A drop! Mortified, I knelt down to pick up the coin, and some sympathy applause followed as I vanished it with a retention pass—a false transfer that exploits an intrinsic lag in the brain's visual frame rate.

After the vanish, I ditched the coin in a secret pouch (a "topit") sewn into the lining of my coat—a kind of magical colostomy bag. Actually, the topit is an old pickpocketing tool (the "poacher's pouch") repurposed to great effect by mid-

twentieth-century magicians. It is sometimes said that the magician's best friend is a good tailor. Unable to find the right fit in New York, I had mailed my coat to a seamstress in Vegas who specialized in fabric manipulation for magicians. I thought for certain her topit would bring me luck. Wishful thinking.

Directly in front of me was a three-by-five-foot table covered with green felt cloth, where my two volunteers—a well-dressed man with an ambitious comb-over and a matronly woman of about fifty—were seated, regarding me with a mix of confusion and pity. Clearly they weren't impressed.

Behind them, in the front row, sat the judges, four to one side of the center aisle and four to the other, all of them looking very stern. Staring at them, I could feel my nerves going into overdrive. My face was flushed, my vision blurry. I could hear myself speaking at warp speed, but was powerless to slow down. My hands trembled and were slick with sweat, which made holding on to the coins all the more precarious. Nor did it help that there were nearly a thousand people in the crowd, including my parents, television crews, and reporters from all over the world, cameras bearing down on me from every angle.

I managed to eke out the next phase of my routine—another series of coin tricks—without too much grief, but things got scary when I pulled out a deck of cards for the finale. First, I was supposed to give the deck a blind shuffle—a false shuffle that leaves the order of the cards unchanged—but my hands dipped below the table, violating a rule as old as card cheats. (This is not unlike letting your guard down during a prizefight.) The audience snickered, and I could all but see the judges shaving points off their scorecards.

Much to the crowd's dismay, my hands stole beneath the table again a few beats later, this time to grab a secret duplicate card on my chair. More withering laughter. *What's going on?* I

thought, *This wasn't what I'd anticipated*. Their patience exhausted, the audience began to turn on me. Scattered heckles congealed into an uproar. I fought to remain calm as I asked my female volunteer to pick a card, my hair damp with sweat, my hands trembling. I felt as if I were performing magic for the first time in my life. I cut the deck, all tremors, struggling to remember my patter, and dropped the cards into my lap. This was supposed to be a sneaky deck switch, but it fooled no one. I was so panicked I didn't even see the devilish glare of the red lamp bearing down on me. Next thing I knew, the Spanish judge was waving for me to stop.

"That will be all," he said flatly.

What?

"It's over."

There are many ways to lose at the Magic Olympics. You can fail to qualify, run out of time, get eighty-six'd on any number of technicalities—but nothing compares to the disgrace of being red-lighted in the middle of your act. This indignity befell only one competitor at this year's close-up competition: me. I hadn't just lost; I'd been humiliated. Oozing shame, I scooped up my tackle and dashed offstage. Scrambling upstairs, I ditched the chalkboard behind a curtain in the dressing room and hurled the rest of my props into the nearest trash bin. I wanted to disappear, and in a moment of anguish, I vowed never to do magic again.

STILL LICKING MY WOUNDS, I eventually worked up the nerve to head downstairs and brave the crowds pouring out of the competition rooms. I couldn't tell what was worse, the mockery or the sympathy. Couples approached me arm in arm offering condolences sufficiently grave to have been occasioned

by the death of a relative or a diagnosis of inoperable cancer. A Swedish mentalist told me in all earnestness that in twenty (twenty!) years I would look back on this and laugh. "I hope you don't stop competing," he said, laying a hand on my shoulder. Then he leaned in closer. "If it had been an Asian guy, he would probably stop with magic forever, because it would have been such a humiliation," he said. "But you Americans . . ."

My father, always my biggest fan, greeted me with a pat on the shoulder and a bromide about having given it my best, which did little to lift my spirits. According to him, it was a "real honor" to have been invited to the Olympics, and I think he believed it. Almost two years later, he was still carrying his official Magic Olympics tote bag to work every day. In fact, I'm pretty sure he kept on carrying it until it finally wore out.

THAT NIGHT, I FOUND MYSELF sitting at the bar a few feet from Lennart Green, winner of the gold medal at the 1991 Lausanne games, and a hero of mine. A former doctor, Green had suffered humiliation and defeat at the 1988 Olympics in The Hague when the judges, baffled by his unusual repertoire, accused the underground card man of using a trick deck and planting stooges in the audience to shuffle the cards for him. (The use of audience confederates at the Magic Olympics is strictly forbidden.) His effects, the experts maintained, were impossible otherwise. But Green's act, a heroic display of skill masked by well-feigned clumsiness, relied on no such trickery. During his many late nights at the hospital, Green had devised a complex new machinery of card sleights that had since revolutionized the field, shattering many long-held assumptions about what was possible with a deck of cards. When Green returned to the Olympics three years later, he performed the

same act but allowed the judges to shuffle and examine the cards. This time, he routed all his opponents.

Green was tall and lumbering, with huge hands, Coke-bottle glasses, and a boyish mop of hair. Aware of his interest in science, I engaged him in a conversation about physics and math, subjects he seemed to know a lot about. I felt intimidated talking to one of my heroes, but Green was generous and obliging, and he invited me to have a drink with him in the foyer. We drank beers on the couches, at a glass coffee table, surrounded by his usual flock of young devotees. Also with us was white-haired head judge Obie O'Brien, who'd presided over my elimination. He said I got DQ'd because my hands had dropped below the table—a real rookie mistake.

Green, it turned out, was a big puzzle head, and I edited a monthly puzzle column, so the two of us traded brainteasers. After scribbling a few puzzles on paper, Green rooted around in his leather bag and produced a small wooden block with a cylindrical cutout on one face into which a smooth, cone-topped cylinder fit loosely. The goal was to extract the loose piece without lifting the block off the table. Pinching the cone between the fingers wouldn't work because it slipped out due to the smoothness and slope of the wood. "There are many solutions," Green said, "but only one elegant solution." Meanwhile, O'Brien looked down at the block dismissively.

I stared at the block for a few minutes, and then it hit me. I inhaled deeply and blew a sharp puff of air straight down at the cube. The cylinder rocketed out of the block, and I caught it mid-flight. "Bernoulli's principle!" I cried, unable to hide my emotion. O'Brien furrowed his brow. "It's how lift works," I explained. Rising to his feet, Green shook my hand and smiled. "Very good," he said. "It was the elegant solution." And for a brief moment, I felt redeemed.

. . .

CURLED UP IN A WINDOW SEAT on the long flight home, high above the ocean, I rehashed all that had happened over the course of the week and was filled with regret. Before coming to the Magic Olympics, I'd thought I was a fairly competent magician. As it turned out, I had only been fooling myself. My tricks were derivative and, I'd learned, ridiculously impractical pipe dreams. (They were, as one online commentator succinctly put it, "crap.") Unlike Green at The Hague, I'd been eliminated because I was genuinely bad. I had no business trying to pass myself off as a world-class magician. A world-class hack was more like it. A champion loser.

Wounded and humiliated, I'd sacrificed not only my dignity, but also my will to perform. Though it pained me to think it, I knew my love affair with magic was over, and like any long-term relationship that abruptly comes to an end, this breakup was fraught with heartache. Sure, I had lots of fond memories. And, who knew, maybe someday, with enough distance, we'd manage to become friends again. But at that moment all this seemed achingly far away. For now, it was Splitsville. Magic and I were parting company. And the breakup had *not* been mutual. I'd been cruelly, callously, and unceremoniously dumped.

MYSTERY SCHOOL

After the flogging I received at the Magic Olympics, I went off the grid for a while. I stuffed my impressive collection of magic gear into my World Championships of Magic tote bag and stowed it in the back of my closet. I stayed home most of the time and sulked, wallowing in self-pity and watching bad TV. When I did go out, I no longer carried cards and coins in every pocket. If friends or family members requested a trick, I would wince and change the subject. Although my doctor told me I was nuts, I was convinced I was experiencing signs of PTSD. I had nightmares of walking into a SAM meeting only to be greeted with deafening silence, followed by a roar of laughter and an outburst of hooting and unkind epithets. Head judge Obie O'Brien's ghost-white face haunted me in my sleep. I was afraid to show my face in the magic community and abandoned my weekly ritual of shopping at Tannen's magic store on Satur-

days. I felt like Clark Kent after he loses his powers in *Superman II*. My goal of becoming a magic hero had never seemed more distant. I was washed up—*finished*, as they say in showbiz.

Things only went from bad to worse. Two months after Stockholm, Rachel told me we needed to talk. She was sitting on the edge of the bed, her eyes swiveling nervously around the room, as if watching a fly.

"I'm going to Venezuela," she said.

"Like, on vacation?"

She threw her arms around me.

"So . . . Not a vacation?"

No, not a vacation. She had been awarded a Pulitzer fellowship, a swanky travel grant for Columbia University journalism students looking to work overseas. Her plan was to spend a few years in Caracas, apply for wire jobs, then maybe go to Africa. Of course I was happy for her. Wasn't this why she'd gone to journalism school in the first place? Of course I'd miss her. Of course we'd Skype. But she was leaving forever, and no amount of magic could make her stay. By October she was gone, and I was alone with my misery and my Sinead O'Connor albums.

I did finally get some good news the following spring, when I found out that I had been accepted to a PhD program in physics at Columbia. I'd been interested in physics for a long time, but for several reasons (pot, pot, and more pot) I hadn't pursued it. Instead, I'd majored in English as an undergrad, a decision I later came to regret, if only because—as my Spanish relatives were quick to point out—didn't I already speak English? As part of my work at *Discover* magazine, I often interviewed physicists about their research, and the conversations intensified my curiosity. In time I realized that I wanted to be on the other end of the phone. So, while working at *Discover*, I started taking physics classes at Columbia and moonlighting

in an experimental astrophysics lab, with the goal of eventually quitting my job and going back to school full time. Now, after several years of hard work, I'd finally reached this goal.

The lab I worked in was run by a young experimental physicist who specializes in cosmology, the study of the origins and structure of the universe. Our group built balloon-borne instruments to measure the cosmic microwave background, or CMB. The CMB is the earliest radiation to have emerged after the Big Bang, some 13.7 billion years ago. Loosely speaking, the CMB is the echo, or heat signature, of the early universe. If the Big Bang were a camera flash, the CMB would be the afterimage that lingers on your retina after you close your eyes.

Physics had always struck me as a kind of spiritual pursuit, a window into the deepest mysteries of nature. How did the universe begin and how will it end? What are the smallest irreducible building blocks of matter? What is the geometry of space and time? These are lofty questions, and it's remarkable how close physicists have come to answering them.

"The most incomprehensible thing about the world," Einstein mused, "is that it is comprehensible." But even Einstein probably never envisioned the likes of string theory, an ambitious attempt to describe everything from black holes to the atomic nucleus with one godlike equation. According to string theory, all matter is composed of tiny* vibrating strands of energy known as strings. These wispy filaments can sound different notes (not unlike guitar strings), and these notes correspond to the fundamental particles observed in nature (electrons, quarks, neutrinos, etc.). As if this weren't enough, string theory allows for the possibility of parallel universes (another you, an-

*How tiny? Strings are on the order of the so-called Planck length, roughly 1/100000000000000000000000000000000000 of a meter.

other me), miniature black holes, and an endless chain of Big Bangs stretching back through time in a Nietzschean cycle of eternal rebirth. Got magic?

String theory also requires the existence of extra dimensions—the original three (length, width, and height), plus time, plus a bunch more we don't see—and physicists are busy hunting for evidence of these other realms inside particle accelerators like the Large Hadron Collider, an Olympian machine 8 kilometers west of Geneva that accelerates protons to 99.9999991 percent the speed of light (roughly 186,281.998 miles per second) and smashes them together in a cosmic fireball 625,000 times hotter than the core of the sun.

After the 1999 publication of the bestselling book *The Elegant Universe*, by Columbia's own Brian Greene, it seemed like everyone knew enough about string theory to have a conversation about it in a bar. Not that anyone—save for a few eggheads—actually knew what they were talking about. Still, physics had caught the public eye. Physics professors (some of them people I'd studied with) were appearing on late night television, sitting down to talk with David Letterman, Jon Stewart, and Stephen Colbert. Greene, for his part, had become something of a celebrity, a nerd hero, one of the most recognizable names in the sciences. Physics, it seemed, had hit a pop culture tipping point. More so than at any time since World War II, physicists were deemed cool.

My friends in academia, who were busy clawing their way toward tenure, quickly dismissed my starry-eyed fascination with physics as so much restless woolgathering, a misguided search for meaning and a textbook case of post-college seven-year itch. Grad school was unlikely to quell my existential longings, they assured me. But at the very least, I thought, it might satisfy my curiosity, so I left the editor's desk at *Discover* and

enrolled for the fall term. After more than six years of holding down a job, I was a student again.

Before going to grad school in physics, I thought of myself as a fairly smart person. But that got hammered out of me faster than it takes muons to decay into electrons and neutrinos— roughly 2.2 microseconds (in the muon's frame of reference). I quickly found myself wondering how I had managed to survive into adulthood with so blunt an intellect. Was I, like, an idiot? For the first time in my life I felt stupid.

Being surrounded by geniuses was humbling, to say the least, but it was exhilarating, too, and the contact high I got from feeling the occasional spark of insight rub off on me was well worth the grueling hours I spent in an airless room slogging through heaps of differential equations alien as hieroglyphs and tearing my hair out over problems that took days, or even weeks, to solve.

Luaus and umbrella drinks were nowhere in sight, but the life of a grad student, even a physics grad student, afforded plenty of leisure time. Ostensibly, these hours were for boning up on tensor analysis and sifting through preprints, but I could only jam so much physics into my brain before it started to hurt. I needed an escape from all those integrals, a psychological release, a safety valve, a way to channel my anxiety and burn off steam. But with Rachel gone, my primary social outlet had vanished south of the border. Who would help me while away the hours? How would I waste time?

Once upon a time, magic had been my go-to act of escapism. But the magic virus that infected me when I was five had been in remission ever since the Magic Olympics. It was still there, only dormant. Lately, however, I could feel it tingling at the base of my spine.

I think it wanted to come out and play.

• • •

Eventually I worked up the nerve to attend a gathering of the SAM. I hadn't been to a SAM meeting in a long while. The last time had been for a funeral—or, more precisely, a Broken Wand Ceremony, a ritual for a deceased magician, in this case a longtime SAM affiliate and New York native who had died of a heart attack. I'd read about the ceremony in the *Spellbinder*, the SAM newsletter, and had decided to pay my respects.

SAM parent assembly president Ken Schwabe, a middle-aged substitute teacher with a nasally New York voice, had presided over the ceremony. Standing at the front of the room, he'd held a wooden stick over his head with both hands and intoned these words: "When you were initiated into the Society of American Magicians, you were presented with a wand, this ancient emblem of mystery. It symbolized the magic power that was yours as you used your knowledge of magic secrets and your skill in their exemplification. Now its power is gone. It is a mere stick. Devoid of all meaning and authority. Useless without your hand to wield it!"

He paused and looked out over the faces of his flock, then lowered the wand to chest level. His face clenched in a look of exertion as his short, pudgy frame struggled to break the scepter. The SAM bylaws include precise specifications for the Broken Wand Ceremony: "The wand should be made or obtained from inexpensive lightweight wood, painted black with white tips, and easily broken in the hands. If the dowel is too strong to break, it should be weakened (precut partway through the center). It is always better to test break a duplicate wand or two when rehearsing the ceremony than to have difficulty in breaking the wand at the actual ceremony. A good source for balsa

dowels or other easily broken lightweight wood is from a hobby shop that sells supplies to model makers."

"Harrumph!"

The wood finally yielded, snapping in a splinter of sound. Ken resumed the oration, his voice a knell: "Fellow compeers, may the broken wand symbolize our submission to the mandate of the Supreme Magician to whom all secrets are known, even of life and death. Into the surety of his love we commit the keeping of our brother!"

That was the last time I'd seen my fellow magic brethren at an official SAM function. In a sense, the Broken Wand Ceremony had been an omen, because shortly thereafter I met my own untimely end at the Magic Olympics. It seemed fitting, therefore, that an initiation ceremony would be what brought me back to life.

Walking in through the double doors of the large conference room where everyone had gathered, I found the ceremony already in progress. Ken Schwabe was again officiating, this time with two neophytes—a middle-aged man with a dark dye job and a cheerful-looking blonde woman of about the same age—standing next to him onstage.

"These are the two new applicants that we tested tonight," a man from the membership committee informed the assembly. "We passed both of them."

Ken nodded. "All those in favor of granting them membership, say aye!"

The audience replied as one. "Aye!"

"All those opposed, say nay!"

Silence.

"Members, rise!"

We all stood up as the neophytes took the pledge. (Ken hadn't brought his ritual book with him, so he had to wing it.)

He administered the vow one line at a time, pausing after each phrase so the neophytes could respond.

"I do solemnly swear."

"I do solemnly swear."

"To be a member of national SAM and Parent Assembly Number One."

"To be a member of national SAM and Parent Assembly Number One."

"To keep the secrets of magic of both organizations as secrets."

"To keep the secrets of magic of both organizations as secrets."

"And not to hurt any member willingly."

"And not to hurt any member willingly."

"And to use my magic to promote harmony and elevate the art."

"And to use my magic to promote harmony and elevate the art."

The audience chimed in unison: "We all bear witness to their oath!"

Ken shook the neophytes' hands, welcoming them into the fold, and everyone cheered. After a few announcements, a man in the third row moved to adjourn, and Ken closed the ceremony with the sacred catechism.

"What is our Cabala?" he asked in a booming voice, and the assembly chorused in reply: "M—U—M!"

Class dismissed.

After the ceremony, I circled the room, chin down, trying to stay under the radar. I waited for the laughter and booing, but none came. Nobody seemed to care. I saw a skinny high-school kid who had been at the Magic Olympics in Stockholm. He smiled and waved. A few feet away by the exit, Ken Schwabe was greeting people. He too had seen me get whacked in Stockholm. I dreaded speaking to him. I tried to sneak away, but he caught up to me and put his hand on my shoulder. "How are

you doing?" he asked, drawing me into his orbit. "Glad to have you back."

That's it? No scolding? No insults? No lectures about how I'd brought shame to the Society? After speaking to a few more of my peers that night, I was shocked that none of them took the opportunity to knock me down a peg. If anything, the chutzpah I'd shown in braving the Magic Olympics against all better judgment had gained me some respect among my fellow conjurors, some of whom, I suspect, had always dreamed of competing but, unlike me, knew better. Though hardly a hero's welcome, it was enough to make me think about doing magic again.

Gradually, I eased my way back into the saddle. The following Saturday, I went to Tannen's, which had lately relocated to the sixth floor of an old building on West Thirty-fourth Street, near Herald Square, down the hall from what had once been Martinka and Co., a shop Houdini had owned in his prime. Tannen's is as close to a permanent New York institution as one finds in this day and age. It has catered to all the greats, from Dai Vernon to Doug Henning to David Blaine. (Blaine is an alumnus of Tannen's Magic Camp, and he frequently asks the staff to consult on his television specials.) But its role as a store is secondary. Above all, Tannen's is a meeting place, a hub of the underground magic community, where magicians gather and share their secrets.

The store was unusually busy that day, its cramped space humming with eager dads and their wide-eyed kids, a number of pros stocking up on supplies—flash paper, mouth coils, close-up pads, gaff coins, thumb tips, cards, dove pans—and several amateurs hanging out and jamming. Leaning against a glass display case filled with shiny coins, an ancient man in a fobbed blue three-piece suit was palming cards off the top of a deck with a hustler's grace, swearing all the while like a

drunken sailor. I tried to show him a card trick, and he made a disparaging remark about my manhood.

In one corner of the shop, a trio of gawky teenagers were manipulating cards with remarkable speed. The cards fanned and blossomed like flowers, sprang out of the deck as though possessed, changed colors in the blink of an eye. Watching them, I couldn't help but wonder why everyone wasn't doing this. They were like superheroes walking around in broad daylight, amazingly skilled. "Holy cow," I thought to myself. "I wish I could do that."

I started going to SAM meetings again. I began to contemplate a comeback. In all likelihood I'd never again be allowed to compete at the Magic Olympics, but there were other competitions. The top U.S. tournament, hosted by the International Brotherhood of Magicians, attracted a yearly roster of world-class talent. With enough dedication and practice, could I compete at the IBM without fear of being hustled offstage? What would it take to reach that level? I tried to picture myself standing in front of the judges again, only this time, instead of being heckled red and doused with loser juice, I win the crowd and wow the experts with what *Magic* magazine (the publication of record in the magic world) calls an antic mash-up of jaw-dropping miracles and heart-stopping feats of magical derring-do. The judges, nodding in accord, hold up a row of tens. What's that? A standing ovation? *Pour moi?*

One thing was certain: it would take immense dedication. I'd have to knuckle down, sharpen my focus, and approach the study of magic with the same semimonastic discipline I was applying to my physics studies. I wondered how I would ever be able to pursue these two goals simultaneously without overextending myself. But whatever reservations I had at the time didn't stop me from plunging recklessly ahead.

Having spent several years futzing around on my own only to have my ass handed to me at the Magic Olympics, it occurred to me that if I was truly serious about magic, I might want to seek out formal training. What I needed was a place where I could learn the real secrets of wizardry, a place like Hogwarts, except not fictional and not British. I decided, in short, that it was time to go to a magic school, and I persuaded myself that this was a perfectly reasonable adult ambition.

What I knew from my research prior to the Magic Olympics, and the minimal reporting I did at the games, was that magic schools do exist. They are a bit like the art world. As with the Barbizon, Antwerp, or Hudson River schools, a magic school typically comprises not only studios with teachers and students but also a distinct set of values and belief systems; they are schools of thought. Because magic is primarily an oral tradition organized around great masters, new ways of thinking about the craft tend to radiate outward much in the way that languages and cultures do. Descendants of one tradition in turn migrate away from their schools, exporting the school's teachings in the process.

The premier academic brand in magic is the Madrid School, spearheaded by Juan Tamariz, gold medalist at the 1973 Magic Olympics in Paris and by most accounts the greatest living close-up magician.* Having groomed two generations of Olympic champions, the Madrid brand looms large at international competitions. Young magicians from all over the world flock to Spain to train under Tamariz, often returning to

*Tamariz's Olympic debut may have been as inauspicious as mine. "I was so tense my first FISM, I was supposed to do a deck switch, and I dropped the cards from my lap and they spilled all over the floor," I overheard him saying in Stockholm. "I remember seeing the judges cross out my name, and at that moment I just stopped caring and it really helped." He went on to win the gold three years later.

their native lands to found satellite schools of their own. The influential "Flicking Fingers" clan in Germany and the Argentine academy of one-handed master René Lavand are two such spin-offs.

I also knew that state-sponsored magic schools in Asia—particularly China and Korea—produce many powerhouse teams. Students at these schools train in formal apprenticeships designed to groom them for careers in show business and the circus. They are known for their technical virtuosity, especially in stage manipulation, and they frequently dominate the international circuit. (The winner of the gold in stage manipulation at the Olympics in Stockholm, whose name was Dai, trained at a school in Beijing funded by China's Ministry of Culture.) But I knew nothing about magic schools in the United States. Did they even exist? What were the American counterparts to these overseas institutions?

Googling "U.S. magic school" led me to the website of a place in Las Vegas called McBride's Magic and Mystery School. I recognized the name at once. Jeff McBride is one of the world's top professional magicians, a towering figure in the magic community. He is perhaps best known for his exotic outfits and his love of masks, which he deploys onstage in a heady mix of illusion, mime, dance, martial arts, and Japanese Kabuki theater—a sweaty son et lumière extravaganza I'd seen him perform on the main stage at the Magic Olympics. (If McBride were a rock band, he'd be Kiss.) His bestselling video series, *The Art of Card Manipulation*, is a favorite among beginners. I'd learned how to fan cards from volume 1.

The next class was in January, in two months, and it cost $675, which would take a big bite out of my graduate stipend. But Vegas would be nice at that time of year—nicer than New

York at least. Plus it was only a three-day class, and it was over a weekend, so it wouldn't compromise my physics studies all that much. I filled out an online application and two days later received an e-mail. Not bad, I thought. Columbia had taken three months with their decision. "You are invited to join us," it read. I had snagged the last available spot. A nice piece of luck, I thought. Perhaps even an omen.

THERE MUST BE A SERUM, some sort of neurotoxin in the local water table, that numbs the critical faculties of people who visit Sin City but to which long-term residents have become immune. Otherwise, how could the city survive? (Let alone thrive: for years Vegas was the fastest-growing metropolis in America.) Clearly I had the frail resistance of an uninoculated newcomer. Within hours of landing, I'd eaten at Burger King, scarfed down a Cinnabon with extra frosting, lost fifty bucks at craps, and purchased an Ed Hardy T-shirt. The flood of negative introspection unleashed by this mindless bender helped shed light on all those jump-proof windows you see in the hotels: in Vegas, the suicide capital of America, the odds of a random person taking his or her life are twice those of any other city; on average, someone commits suicide here each day. Still, this didn't change the fact that if I was serious about magic, I'd have to keep coming here, because aside from being the off-yourself capital of America, Vegas is also, as Jeff McBride is fond of pointing out, the World Capital of Magic. "There's more magic per square foot here than anywhere in the world," he told us on the first day of class, tossing back his long hennaed curls. "Where there's light, there's magic."

The Magic and Mystery School is based out of Jeff McBride's two-story home—dubbed the McBride House of Mys-

tery—in a rambling suburb east of the airport. Driving there on a clear, brisk morning in early January, past tract homes and parched lawns, I experienced the same queasy feeling I always do when I'm reminded that real people with jobs and families actually live in Las Vegas, a zone that feels about as nourishing to life as the hardpan alkali doomscapes of Death Valley two hundred klicks northwest, and where raising a child must be a violation of some UNICEF guideline.

Jeff McBride, aka Magnus, the cultish leader of the Mystery School, is one of the world's most acclaimed magicians. He began headlining in Vegas in his twenties and has since gone on to perform in sixty-seven countries and on every major television network. Holder of three Guinness World Records for his card-handling abilities—he can bullet them hundreds of feet in the air—McBride was recently crowned Magician of the Year by the Academy of Magical Arts, one of magic's top honors. McBride is also, as far as I know, the only magician in the world—or should I say, galaxy—to have a role created for him on *Star Trek: Deep Space Nine*. (McBride played Joran Belar, the humanoid host of a symbiotic life form that hailed from the Alpha Quadrant.)

Even now, years after the show was canceled, his typical outfit boldly goes where no wardrobe has gone before. Mc-Bride's tastes run to ornate pan-Asian vests, kimonos, billowy Afghan pants, frock coats, top hats, and tinted oval shades. On the road, he wears a marsupial-like fanny pack loaded for bear with magic paraphernalia (cards, thumb tips, pocket DVDs, wallets, confetti).

His house was crowded with scrolls and New Age artifacts. As I walked in, I noticed a collection of swords by the entryway, one of which looked like the blade Arnold Schwarzenegger wields in *Conan the Barbarian*. The next thing to catch my

eye was a photograph of McBride shaking hands with George H. W. Bush.

Then there were the masks. They were everywhere, scattered across the walls in a kind of surreal mosaic: Japanese samurai masks, blade-nosed Venetian masks, jesters, Southeast Asian masks, twin Greek tragicomic smiles and frowns, Native American shamans—a hundred hollow stares leering inward, bearing witness.

I was early, so I milled about aimlessly until everyone else had arrived. A few people were checking out McBride's sizeable book collection, while several others were lounging around on couches and chairs in the living room, some of them with cards and coins in their hands. A pudgy kid showed me a trick in which a card magically threaded itself onto a chain he had around his neck. Impressive.

Once everyone had checked in, McBride sounded a bell to let us know it was time to start, and we assembled in a large room at the front of the house.

McBride likes to call his school "Hogwarts for grownups," and what happened on the first day was straight out of *Harry Potter*. To begin with, we were asked to congregate around a flame burning at the center of the room atop an iron pedestal. The shutters had been drawn against the January light, and it was murky inside. As we rose to our feet the flame trembled, casting a ripple of shadows on the walls. Contorted by the shifting play of light, the masks seemed to flicker awake in a momentary flash of borrowed life.

Each of us was then handed a medieval-looking document and told to read it out loud, sentence by sentence. On it was printed a vow of secrecy. We were given to understand that this was a matter of some consequence. The oath, McBride had us all know, was not to be taken lightly, and as far as I could tell,

no one did. One by one, in solemn tones, we spoke the words, and then signed the document. With pens, sadly. No blood oaths today.

In a movie or a Dan Brown novel, we'd have drunk from a human skull or engaged in an act of ritual sacrifice. But this being suburbia and all, we retired instead to the linoleum-tiled kitchen, where on a small side table an offering of Little Debbie snacks awaited us. I ate more than my share.

The document I'd signed was called the Obligation of the Mage, a covenant designed to protect the secrets taught at the Mystery School, and required of all its students. The master class was but one of many courses in the school's extensive catalog. Also available were classes on mentalism, street magic, card manipulation, magic for martial arts, magic for the medical professional, and a ladies-only course called Sisters of Magic and Mystery. The Mystery School even offered a three-day residency program. "You stay here in a private room and work on your act," McBride explained. "It's popular among European students." I'd chosen the three-day master class because it promised "detailed, personal instruction in an intimate and safe setting," along with "two videotaped feedback sessions," but wouldn't require me to miss much school or bunk in a strange magician's home.

Before class got under way, we went around the room and introduced ourselves, AA style.

Hi, my name is Alex and I've been doing magic for twenty years.

Hi, Alex!

Except, in AA, as far as I know, you don't pass around a Native American talking stick shaped like the caduceus—two serpents linked in a helix. (In Greek mythology, wing-footed Hermes, postman to the gods and docent of the underworld,

carried the caduceus staff.) Each of us was asked to state our goals and write them down in the Magic and Mystery School three-ring binders we'd received.

I wasn't sure if I was supposed to talk into the staff or not, so I didn't, but when my turn came I did say that I needed . . . *ahem* . . . help. I said I wanted to understand magic on a deeper level and eventually create a routine that I could showcase both professionally and at a competition like the IBM. And to contribute to the art. "I mean, that's what I really want to do," I stammered. "To make my own sort of contribution."

Of the twelve students at the workshop, all were male and most wore black. The class was a mix of career hobbyists and full-time professionals. There was a marine from Camp Lejeune, three-time president of his local SAM assembly, who wanted to travel around and do magic full time. He had a strong southern accent and always addressed McBride as "sir." Besides doing magic, he was also a master herbalist and a martial arts expert.

There was a former construction worker who'd written a book about picking up women with magic tricks, and who performed onstage as Houdini. "One night I just woke up in a cold sweat sitting there and I went, 'Do a one-man show as Houdini,' and that was like twenty-five years ago," he said. When it came time to fill out his feedback form, I wrote, "You must *become* Houdini!"

There was a middle-aged former freelance writer from LA who'd recently finished a novel about street magic and dreamed of working on cruise ships. His act featured an "imaginary friend" named Fanny, which, as McBride pointed out, might offend some British cruisegoers.

There was a hefty man from Chattanooga who belonged to the Fellowship of Christian Magicians and was a member

of the Tennessee Methamphetamine Task Force. "I'm also a leathersmith," he said. "And I do a lot of bead work."

There was a heavy metal drummer from Loveland, Colorado, who wore black nail polish and had long black hair. His eyebrows, ears, and nose were pierced and a talisman ring had been tattooed on the fourth finger of his left hand. He dreamed of being the next Criss Angel and one day headlining his own casino show.

There was an older gentleman from Toronto named Ted Harding, who performed under the name the Great Hardini and ran a carpet-cleaning business—and would later fool everyone in class, including McBride, by vanishing a coin under his watch.

There was a young Irish magician who said he'd created a form of alcoholic candy and was looking for ways in which to incorporate magic into the marketing of this new product.

There was even a doctor—or, at least, a man who called himself doctor. In reality, he was a former ad exec and current Internet marketer who had given himself the title after reading Edward Bernays's *Propaganda*. "I now go by Dr. Ben Mack," he said. "And I have a PhD in bullshit." (Online he was known as Howard Campbell.) When McBride asked him what kind of magic he liked, Mack said, "Laughter and storytelling"; and when called upon to state his long-term goal, he answered plainly, "I stand for the possibility that every human on this planet can have immediate access to drinkable water in my lifetime."

The most accomplished member of our class was Chris Randall, a Vegas professional who'd had a number of original effects featured in *Magic* magazine, including an ingenious method for switching decks. (If only I had known about it at the Magic Olympics!) Randall was the only person in recent

history to publish a trick in *Magic* two months in a row. "I was ecstatic," he said of this accomplishment. He performed regularly at the illustrious Magic Castle in Hollywood and had just recorded his first television spot, on the prime-time show *Masters of Illusion*. Randall had competed fifteen times but couldn't catch a break. "I never won once," he told me. After entering the annual World Magic Seminar in Vegas and losing to a talented Korean teenager, he had repaired in haste to the Mystery School. "I'm sick of losing to seventeen-year-olds," he said.

The youngest member of the group was in fact a chubby seventeen-year-old with black skater hair, whose mother had dropped him off earlier. "When I'm not doing magic, I'm stuck in my school," he said. "Because I'm still a kid."

WITH ITS SMALL STAGE, SPOTLIGHTS, and backstage area for costume changes, McBride's living room gave new meaning to the term *home theater*. Long red curtains hung from the ceiling while a PA system piped out music on cue. It was in this makeshift theater that we showed off our skills, or lack thereof, while McBride and Eugene Burger, the dean of the Mystery School whom McBride introduced to us as his master, assessed our performance.

The master class, Burger explained, was based on the conservatory model, wherein students learn by receiving feedback on their performances and by observing the performances and critiques of the other students. "About ten years ago we decided to apply this system to the teaching of magic," Burger said, stroking his garden gnome beard. A former philosophy teacher, Burger had recently been listed in *Magic* magazine as one of the most influential magicians of the twentieth century. "At the Mystery School gatherings," he told us, "we wanted to

create a feeling of intimacy, trust, and connection among the participants. We wanted to create a safe space for our students to experiment and grow."

When it came time for me to take the stage, I performed one of the tricks I'd tried to do at the Magic Olympics. After I finished, McBride walked up to me and put his hand on my shoulder, wearing a good-natured grin. "It's a great effect," he said, "but a bad method." The sight lines were a mess, he explained. The handling was convoluted. In short, the trick was beyond repair, a total nonstarter.

Not only that, but McBride's delicately worded critique tipped me off to the sad fact that I was a dreadful performer. I yammered onstage, tripping over my words. I lacked stage presence and a coherent persona. Rather than working from a script, I ad-libbed my patter, hemming and hawing and filling the air with meaningless interjections McBride disdainfully called linguistic lint. I had no grasp of psychology or timing. My card-handling skills were remedial at best. I flashed moves, manhandled the deck, held my breaks visibly, stared at the cards while shuffling, straining through moves that were meant to be subtle. In short: I was a hack. By and large, the other students—even the high school kid—were far more dedicated to the practice of magic than I had ever been. They treated magic as a discipline, much like the competitors at the Magic Olympics, and they worked diligently to hone their skills. I was a layabout by comparison, shiftless and inept. If I wanted to be a contender, I realized, I would need to up my game.

THREE DAYS LATER, BACK IN New York, I hung the Obligation of the Mage on my wall, beneath a framed portrait

of Albert Einstein. Each morning, as I sipped from my souvenir Magic and Mystery School water bottle, I studied the document, petitioning it for inspiration. *Sing in me, oh Magic Muse.*

The oath was printed in large Celtic letters on parchment bond and emblazoned with the official device of the Mystery School—an eight-pointed star nested in a circle. A runic-looking map of the sort found in many fantasy novels served as a watermark, and in each corner of this mythical landscape was the image of a face. These, McBride had explained, were the four cardinal stations of magic: Trickster, Sorcerer, Oracle, and Sage. "These four archetypes represent the four stages in the age cycle of the magician," he said. "They are like the four ages of man: infancy, adolescence, maturity, and old age."

The first stop on this journey is the realm of the Trickster. The Trickster is the imp in the family, quick-witted, resourceful, a fast-talking troublemaker who uses magic to contend with the world, overcome shyness, and build self-esteem. "We all begin as Tricksters," according to McBride. "The Trickster is the earliest phase, the birth of our fascination with magic. Usually kids get into magic around seven or eight. The Trickster teaches us how to use magic to develop our communication skills."

The next stage, the Sorcerer, is dutiful and hardworking, a serious student of the art who views magic not as a tool but as an end in itself. "Where the Trickster feeds on mischief and chaos," McBride explained, "the Sorcerer focuses on transforming chaos into order. Sorcerers are skillful, disciplined, and put considerable time and energy into their work, acquiring the various technical skills that it takes to become a magician."

In the third phase, that of the Oracle, the focus shifts from

the body to the mind. The Oracle explores the hidden realms of perception and strives to master the psychology of magic. Finally, the enlightened Sage, master and elder of the art, passes on a lifetime of distilled wisdom to the next generation, completing the cycle. If magic were basketball, the Trickster would play for the Harlem Globetrotters, throwing up trick shots in exhibition games, while the Sage would coach his team through game seven of the NBA Championships.

Where did I fit into this picture? The answer was clear: I was a Trickster, and a middling one at that. I'd been stuck on level one ever since I started doing magic many years ago. My lack of growth was astounding. But where did magic fit into my life as an aspiring physicist? Did I really want to grow up? And if so, what did I need to do to advance to the next stage?

For McBride, the initiation to the second phase, the realm of the Sorcerer, came through his study of martial arts, which he later fused with his magic act. "I started martial arts when I was about eight years old," he explained, gesturing with his entire body. "Judo and then aikido, tae kwon do, and finally kung fu and weapons forms. This taught me martial discipline."

As an avid fan of kung fu films, I knew that martial arts training begins with finding a master. More often than not, this is a wise old man with a silvery beard who, despite looking like a shriveled walnut, can still hand deliver ass whippings thirty-six ways to Sunday. Part personal trainer, part philosopher, the master holds the key to his student's inner strength, doling out boot-camp slimnastics and fortune-cookie spiritualism to the whisper of a bamboo flute. When the master is murdered by an evil eunuch, the student must avenge his death, and through this archetypal act of retribution—slaying his master's killer—the student becomes a master in his own

right. More than just a marriage of convenience, the master-student bond is the cornerstone of the warrior's way—and the heart of the movie.

Mentorship is also a dominant theme in magic. The annals of conjuring are filled with famous legacies, and great magicians, past and present, are often identified patrilineally, in language that reeks of kung fu films—and of Homer: "Spanish champion Woody Aragón," they'll say, "disciple of the cunning Juan Tamariz, leader of the Madrid School, whose master was the great Arturo de Ascanio, father of Spanish close-up." World champion Lance Burton likes to remind audiences at his Vegas show of his status as the last surviving descendant of a century-old royal dynasty that began with Alexander Herrmann, the leading French magician of the late nineteenth century. Before his death in 1896, Herrmann passed the torch to Harry Kellar, who in turn anointed Howard Thurston. After Thurston came Dante, then Lee Grabel, and in 1994, thirty-five years after retiring, Grabel found his successor in Burton. And while this story is largely a marketing gimmick, there's no denying the importance of inheritance in magic.

Jeff McBride calls his master, Eugene Burger, "one of the most important Sages in the world," and both Burger and McBride stressed the importance of mentorship to the students at the Mystery School. "In order to go from Trickster to Sorcerer you need a master," McBride told us. "The question you need to ask yourself is 'Who's *my* Yoda?'"

Convinced that locating a sensei was my ticket out of Tricksterville, I set out to find a mentor in New York City. If I wanted to become a master, I reckoned, I first had to become an apprentice. Only then could I start figuring out how serious I was about progressing to the next stage. But where to find this magical Mr. Miyagi?

It is said that when the student is ready, the teacher will appear. But I figured it couldn't hurt to make a few phone calls. (What if he lived in Queens?) I canvassed a slew of magicians, and the answer, to my surprise, always came back the same.

"Just hang around Wes," they said.

"Really? Wes? Are you *sure*?"

This was going to be tougher than I thought.

Chapter Three

MIRACLES ON
THIRTY-FOURTH STREET

W es was Wesley James, a whiskery sleight-of-hand master
and fifty-year veteran of the New York scene who all but
lived at a grimy pizza parlor near Herald Square in the heart
of Houdini's old stomping grounds. Cafe Rustico II is one of
those places with a mop and a bar of soap in the bathroom,
where even the grease stains are prewar. Back in the 1960s, if
you wanted to learn the real work, you'd have gone to the caf-
eteria of the Wurlitzer Building on Forty-second Street to hang
with Dai Vernon and his disciples on Saturday afternoons. In
the 1970s, the magic Mafia migrated three blocks north, to
the Piccadilly Hotel Coffee Shop, then to Reuben's Deli in
Midtown, which shut down in 2001 after its owners failed to
make their numerous health code violations disappear. After

Reuben's closed, the Saturday posse reconvened at Rustico II, which had ample space and a scarcity of customers and was apparently up to code.

Now there were actually *two* Saturday afternoon sanctuaries, the second being the private downstairs room at Maui Tacos on Fifth Avenue, where local IBM president Doug Edwards held court. Wesley James was the reason for the schism. A few years back, in a rabid dispute over the provenance of an old magic trick called Cling Clang (wherein a flower petal or a piece of tissue paper is transformed into an egg), Wes slugged Doug Edwards—who is twenty years his junior and a black belt in karate—sending him flying across the room and splitting the community in two.

Wes had worked alongside some of history's greats. He was one of the few surviving members of an ultrasecretive underground community led by Dai Vernon and Chicago card genius Edward "The Cardician" Marlo. Wes was also one of the original members of the invitation-only FFFF Club led by Obie O'Brien, the head judge who voted me offstage at the Magic Olympics. Wes still went most years to the FFFF convention upstate, but claimed it was no longer elite enough for his taste. "Back then it was really small, and you had to perform," he later told me. "Today they'll let anybody in." Some say Wes is the greatest underground magician alive. Others say he's just an asshole.

I'd met Wes once or twice before, but never made much of a connection. His personality was somewhat akin to the sound a truck makes while backing up. For many years he refused to lecture, even to magicians. But I was told that, now retired and probably nearing his own Broken Wand Ceremony—he sucked down menthol cigarettes like candy—he had started unloading bits and pieces from his vast stockpile of secrets.

Maybe he'd be willing to break off some knowledge in my general direction?

I found Wes at Rustico II, sitting at the head of the table, a fisher king flanked by his disciples, some of whom I recognized. To his left was Bob Friedhoffer, a foul-mouthed Brooklyn magician who uses magic to teach science to kids. Friedhoffer looked like a bloated George Carlin, a short, stout, fireplug of a man with thin strands of silver hair slicked back in a tight ponytail. Woolly tufts of chest fuzz sprouted Chia-like from under his polo shirt, and his breathing sounded effortful. He was what you might call a Darth breather. Next to him was a former mathematician named Jack Diamond, a wan, mousy guy with curly white hair and powder blue eyes.

John Born, a twenty-six-year-old Wichita transplant who'd recently won the IBM close-up competition, was at the other end of the table, sporting short sleeves and a leather newsboy hat. (Apparently some of the IBM folks occasionally patronized Wes's salon despite the schism.) A silver half dollar danced and rolled in Born's right hand, seemingly on autopilot. He closed his fist over the coin, then opened both hands again, palms out, fingers splayed like a starfish—empty!

In the middle of the action sat Wes, leaning back in his chair like he was above it all. Grizzled and haggard, he was almost seventy but seemed older in a way, his face drawn and cratered, lengthened by a mangy doorknocker beard the color of sandstone and rust. What remained of his silver hair clung to his temples by sheer force of will, arcing across his rutted brow like broken telephone wires and down the hulking span of his back in a yard-long Manchu queue. But his hands were those of a much younger man, having been preserved, it seemed, at the expense of the rest of his body, and they moved with the elegance of a concert pianist's.

I edged my way to the table, gnawing on a slice of mushroom pizza that tasted as if it were from the Jurassic era. Wes was showing Jack Diamond an obscure "hand mucking" technique, a diabolical switch of a facedown pair during a round of poker. Say the game is Texas Hold 'Em, the most popular variety of serious poker, and you don't like your hole cards, the two facedown cards dealt to each player at the start of every hand. Mucking is a way to improve on fate and tilt the odds against your opponents by slyly subbing in a better pair secretly copped from the deck and palmed away earlier in the game. In this particular mock deal, Wes had found 2-7 off suit, the worst starting hand in Hold 'Em. He casually peeked at his cards, partially obscuring them for a split second beneath both his hands—nothing unusual. Except that when he turned the cards over again moments later, he now had a pair of aces in the hole.

Burning with curiosity, I pulled in closer. Wes acknowledged my presence dimly, if at all. I unsheathed my cards and warmed up with a few double lifts and riffle shuffles. Inching into his field of vision, I executed a spread pass, a move for transposing two halves of a deck, and one that I felt I'd pretty much mastered.

"You're flashing," he said.

What?

"When your thumb juts out like that it's a dead giveaway. The thumb should stay tucked in at all times, like this." He showed me his take on the move. He was right. The thumb was a tell. Oops.

Still trying to impress him, I whipped out my ribbon-bookmarked pocket edition of S. W. Erdnase's *The Expert at the Card Table*, the card cheater's bible. I'd bought it at Tannen's only an hour earlier. It was a virginal copy, its spine still

unbroken. I hadn't even read the table of contents. Hopefully he wouldn't notice.

If Wes was impressed, he didn't show it. Instead, he let me know right off the bat that his knowledge of Erdnase was vastly superior to mine. "There are fifteen mistakes in Erdnase," he said, gruffly. "Eight that are universally acknowledged, four more that only a few people know of, and three that only *I* know about."

Frustrated, I put down the Erdnase and took out my physics book, Jackson's fearsome *Classical Electrodynamics*. If I wasn't going to learn any magic, I thought, I might as well get the jump on this week's homework. The man responsible for my assignment was Professor Miklos Gyulassy, of Szolnok, Hungary, a notorious hard-ass who once threw away an entire class's midterm exams in disgust when he deemed them unworthy of being graded. You might say Gyulassy was Columbia's answer to Wes James.

To my surprise, the physics book piqued Wes's interest more than my magical overtures and lame attempts at talking shop. "What are you studying?" he asked, raising an eyebrow. I told him, and he gave a low groan. "If nothing else, a PhD gives you some credibility," he said, meeting my gaze for the first time. "Whether or not it should is another matter." Wes, I was surprised to learn, had a PhD in computer science (although during his multidecade professional magic career, he billed himself as a "Professor of Enchantments"). Soon we were talking about quantum mechanics, computers, card counting, the mathematics of shuffling, and deck memorization. Science turned out to be our common ground.

Pivoting off our discussion of physics, I mentioned that my presentation of the Ambitious Card routine—the famous trick that fooled Houdini—drew on my knowledge of quantum

physics. Creating your own Ambitious Card routine is a rite of passage among magicians, for whom the effect serves as both a calling card and a secret handshake. ("Show me your Ambitious Card" is a common greeting among conjurors.) The Ambitious Card is the 100-yard dash of magic, the SAT. It's to sleight of hand what the Beethoven sonatas are to concert piano. And while the basic template is more than a century old—a card bubbles to the top after being placed in the middle—magicians are constantly reinventing the effect. In 1982, for instance, a version surfaced, and won gold at the World Championships in Lausanne, that culminated with the signed card escaping from a deck that had been hog-tied Houdini-style in a three-foot coil of rope.

My spin on the trick was all about the patter—the story I told while performing it. "In the quantum realm," I would say, as I put the card in the middle of the deck, "particles can tunnel through impassable barriers, the microscopic equivalent of David Copperfield walking through the wall of China." (That's right, I was combining magic and physics. Watch your back, Tom Brady.) Wes seemed to like the idea but was less than flattering about my technique.

"No, no, no," he rumbled, grabbing my hands. "That's not right." He molded my fingers into a more forward grip, freeing them up to cover the bottom half of the deck, protecting it from exposure. This way, the lower two fingers of my right hand screened the move, making it undetectable. "I spent a whole day trying to teach Johnny Thompson this," Wes said, sipping his diet soda. "But he was so used to doing it the other way that he just couldn't get it." (Johnny Thompson, aka The Great Tomsoni, was a seasoned Vegas showman now in his late seventies.)

I gave it another shot. "No, straight back," Wes said. "Keep

these fingers relaxed." He gestured at the lower three fingers of my right hand. "Always point your index finger directly to the left of the left-most line of vision." This, I later learned, was a general principle for neutralizing angle issues.

I kept drilling, straining my hand muscles and stretching my fingers out as far as they would go. I felt as if I were doing splits, and it actually hurt. "You're too tense!" Wes bellowed at me. "The spectator will spot *any* tension!" This was another general principle, I came to realize. Moves should look and feel natural, Wes insisted, because even if the spectators don't detect the move itself, they can sense the exertion behind it, which lessens the believability.

Wes's pedagogical method didn't exactly help me relax, but I took a deep breath and gave the sleight another try, and another, practicing over and over again for more than an hour. It was a knacky move, but finally, after doing it a hundred times or so, I felt something click, like a dead bolt latching into place. Wes's face brightened. It was the first time I'd seen him show any hint of excitement. "Yes," he said. "That's it! You've got it!"

I worked with Wes for the rest of the afternoon, four arduous hours of intense magical training. By the end of that grueling first day, my hands were throbbing, my back was as stiff as a poker, and I was exhausted. "Keep practicing," Wes told me as I turned to leave. "It takes me twenty-one days to train a muscle." But I knew it would take a lot longer than that to master what he was teaching me.

Still, my meeting with Wes had been inspiring, and it motivated me to work harder. It felt good to have found a potential mentor. Maybe I was deluding myself, but even after one day, I felt I'd improved. Later that night, while hanging out at a bar with some fellow magicians, I heard through the grapevine that Wes thought I showed potential, but that I was "rough

around the edges." I recalled the scene in *The Empire Strikes Back* when Yoda tells Luke, "Control! Control! You must learn control!" I chose to take it as a compliment. Coming from a Jedi master, it was a ray of hope.

ONE WEEKEND TURNED INTO MANY. Saturdays at the pizzeria became my newest ritual—harking back to the one that began in my early childhood, when my father would take me to the magic store on the weekends. My friends and family soon learned not to call me on Saturdays; I observed the magic Sabbath more faithfully than the Hebrew one. (I may be half Jewish, but I'm *all* magician.) Little by little, Wes took me into his confidence.

A typical weekend started at Tannen's magic store, formerly in the heart of the Garment District and now on Thirty-fourth Street. After that, I'd usually head a block south to Fantasma, the hip new magic and toy emporium that opened its doors in May 2004, in direct competition with the bellwether Tannen's. There was a lot of bad blood over this. The owners of Tannen's talked about Fantasma as if it were a hostile army advancing on their turf, fearing that an around-the-corner rival might push them into Chapter 11. And they had a point. Tannen's was a lot like the record store in the film *High Fidelity*. It was small, nondescript, a lightly trafficked shop that never advertised. There wasn't even so much as a sign outside to alert the foot traffic on Thirty-fourth Street that miracles were for sale inside on the sixth floor. The kids who manned the counters were foul-mouthed slackers who made no attempt to please the customers and push their inventory. Instead, they insulted the clientele and made dick jokes while arm-punching each other.

Fantasma, on the other hand, was all about eye candy. Pic-

tures of celebrities adorned the walls, the floor was crowded with original Houdini artifacts—including his famous substitution trunk—and a rabbit named Rambo scurried around in a cage by the left counter for all to pet. (Most days, Rambo looked like he had combat shock from all the petting.) Every few minutes, an animatronic Houdini descended from the ceiling and unstraitjacketed himself. Roger Dreyer, the store's owner, was a smooth-talking salesman who was tireless in promoting his brand. He hosted magic parties for A-listers and hawked his wares at all the major conventions. The store even had a sign, a great big one smack in front of the subway entrance on Thirty-third Street, the better to lure in tourists who, once inside, rarely left empty-handed. There was always a novelty item or a children's magic set on sale.

After picking up experience points at both shops, and dropping cash into their tills, I'd head over to the pizzeria and rendezvous with Wes. He was always there. In the aftermath of a nuclear war, cockroaches would continue to flourish and Wes would still be at Rustico II every Saturday. His motto might easily have been that of the U.S. Postal Service: *Neither snow nor rain . . .*

The only time he wasn't at Rustico II was on the last weekend in April, when he attended Obie O'Brien's FFFF convention in upstate New York. He never went on vacation. On Memorial Day weekend, when the pizzeria was closed, I half expected to find him sitting outside with his back against the corrugated storefront security door. While others came and went, Wes was a constant, the first to show up and the last to leave. He came at around noon, as if it were his job, and left just after six without having to consult the time on his Casio calculator watch. After sixty years and more than three thousand Saturdays, the rhythm had been starched into his ganglia.

Brackish and brooding, Wes smiled rarely and laughed even less. He croaked more than he talked, his gravelly Brooklyn prizefighter's baritone an homage to Burgess Meredith. His eyes were like dog tags pierced with bullet holes. He professed hatred for David Blaine—who used to inhabit these Saturday haunts before he became famous—and cherished grudges like pets, including one against Roger Dreyer, owner of Fantasma. "I'll never set foot in there," he said to us one afternoon, his face darkening and his voice cracking like dry cigar paper. And yet, for all his cragginess, Wes presided over his ragtag team of weekend wizards with unassailable dignity. Solomonic in his bearing, he radiated wisdom. I couldn't help but admire the guy.

Originally from Florida, the eldest son of an airplane mechanic who was stationed in Jacksonville during World War II, Wes moved to Brooklyn in 1945, at the age of nine. "I grew up in a very tough neighborhood," he told me with an air of pride. "I may have a PhD, but I'm a street kid." He earned his doctorate from NYU in computer science, a field that, in 1956, was still in its infancy. Wes's dissertation was on something called modular programming, and until a few years ago, his thesis was still on display at the Boston Museum of Computing.

After graduate school, he took a job in IT before becoming a full-fledged professional magician, working trade shows and nightclubs and hospitality suites for the next two decades. During those years, he was often on the road seven days a week. When he eventually grew weary of traveling, he retired from professional magic and started a custom hardware and software development company, which he sold after the death of his partner in 1993. But magic has always been his one true passion, the torch he carries through life.

This passion first took hold, as it often does, on the weekends. "It was always Saturdays," he said. "Back then we met on

the Lower East Side. After that I'd usually go to Flosso's store." Al Flosso was the legendary "Coney Island Fakir" who owned Martinka and Co. magic store from 1939 until his death in 1976. "Every Saturday I would show up there and listen to the guys talk about things. Al would throw me out—'get out of here and don't come back, ya hear!'—and the understanding was I'd buy coffee for everyone and come back. Then he'd secretly pay me. He'd always ask, 'You got enough money to go home?' Because a lot of kids would spend every dime."

Wes met Dai Vernon in 1946, at the age of ten, when his mother began allowing him to take the Fourth Avenue local into the city after school. "I used to go up to Max Holden's Magic Shop. His wife took a liking to me and she introduced me to Vernon. I didn't know Vernon was anybody important. We would go downtown to the Forty-second Street Cafeteria during the week, when Holden's would close at five p.m. Vernon would ask me to do this or that and then he would give me pointers. He'd critique what I was doing. Or he'd show me stuff and ask me if I could figure it out. And that was kind of the basis for our relationship. Very few of the older guys would even talk to kids. So Vernon was an exception in that regard. It's sort of not by accident that he got the nickname the Professor, because he liked teaching."

It was the beginning of a relationship that would last until Vernon's death in 1992, at the age of ninety-eight. A year before he died, Vernon sat in on a performance of Wes's at the Magic Castle in Hollywood. "He'd never actually seen me do a whole formal close-up performance," said Wes. "He sat there with a big shitty grin on his face, just pleased as punch. And that's the last I saw of him." Wes's voice seemed to catch on the last few syllables, and his eyes took on a filmy aspect. "At least he got a chance to see what I turned into."

Like his master, Wes also seemed to enjoy teaching. Every time I'd show up, he'd hunch his shoulders and shuffle in his seat and ask me what I was working on. Saturdays at Rustico II reminded me a bit of my weekly piano lessons as a kid. If I'd been practicing, I'd march up to the Steinway and sweep the back of my shirt out from under me with a maestro's poise. But if I'd slacked off, I'd sit in shame and listen to Mrs. Goldsmith sight-read the nocturnes I was supposed to be learning, mentally checking off the minutes until my mom swung by to pick me up.

On one of those cheerful white-tie-and-tails-type days at Rustico II, I flaunted a fancy one-handed cut I'd recently taught myself in the hope that it would catch Wes's eye. When I was sure he was paying attention, I broke the cards into three even blocks with my left hand and hinged them into an equilateral triangle, grinning like an idiot. I'm sure I looked as happy as a schoolboy on a brand-new Huffy while showing off this new move, but Wes only scowled. "That'll get you killed," he said, turning away. Clearly he didn't share my enthusiasm. But murder seemed a little harsh, even for Wes.

Wes went on to explain that an open show of skill, however brief, is deadly during a magic act, because it gives the audience a reason not to believe. Even if they don't figure out the method, he explained, they'll attribute the effect to manual dexterity and not magic. "You're giving them the secret to everything you do," he said. I had to admit, I'd never thought about magic in this way before. "Magic is not about selling your prowess," he hollered at me, when I pressed him on the issue. "It's about the effect you create—a profound violation of the natural laws of the universe. I don't want them to think I'm skillful. I'm a magician, not a juggler. A juggler is selling skill. I want to get credit for the magic, not the skill."

World-class jugglers know to drop at least once during a performance, Wes told me, because it makes their act appear all the more difficult, drumming up suspense for the finale and driving home the message that they're operating at the extreme edge of human potential. This is known as juggler's logic. But a magician has a different mission. This is not to say that technique isn't important in magic—it's crucial—but must remain invisible at all times. There can be no man behind the curtain. There can't even be a curtain.

In a sense, this is true of many endeavors. The best actors and dancers and musicians toil endlessly so that, come opening night, people will say they make it look so easy. Audiences are swept away by the magic of the performance—the sublime mysteries of the muse—not the power of rote. No one applauds the ten thousand hours of practice, only the ninety-minute chef d'oeuvre that is the end product of those hours. This is especially true for magicians, because magic, by definition, must betray nothing of its cause. Only then will people give themselves over fully to the experience.

This philosophy, which Wes hammered into all his underlings, wasn't really Wes's to begin with, or any other magician's, for that matter. It had originated in the world of gamblers and card cheats, where flaunting your skills can literally endanger your life. "If you blow a card trick, they don't shoot you for that," Wes grumbled. *"Usually."* Wes, after all, was a student of Dai Vernon, who won his spurs in the underground gambling dens of Chicago's Levee district, alongside the cardsharps and blacklegs and four-flushers of the Windy City's thriving demimonde. The Vernon Touch, as it came to be known, arose from magic's fruitful intersection with gambling and grift. "Vernon would look at an effect and bring something to it that would make it special," Wes told me. "The Vernon Touch—that was

real." ("The Vernon Touch" was also the name of a column Vernon wrote for twenty-two years in *Genii* magazine.)

Historically, some of the best ideas in magic were concocted out of a desire to beat the house, and many great masters honed their skills in the underground gambling world. Magic, after all, is cheating for amusement, to borrow a phrase from the nineteenth-century French watchmaker and godfather of modern magic Jean-Eugène Robert-Houdin (whose last name Harry Houdini, né Erik Weisz, cribbed in tribute—and later disowned). Professional card cheats are among the most gifted sleight-of-hand artists around because of the unforgiving sword-of-Damocles conditions under which they work. When you're caught in a high-stakes underground poker game with your hands beneath the table—as I was at the Magic Olympics—you don't just get hustled offstage.

Magic and gambling share a common language and a common lineage, and magicians—particularly those who specialize in sleight of hand—are the spiritual descendants (and, in some cases, the *actual* descendants) of the great cheats who thrived on the culture of speculation and greed that took hold during the latter part of the nineteenth century, when wealth and power were consolidated in the hands of tycoons and traders, and enormous fortunes were made. As America emerged as an empire and money flowed across the land with record speed, gambling quickly became the nation's favorite pastime. Unsurprisingly, the rise of gambling in America also coincided with the widespread investment of private funds in financial markets. (The first stock ticker was introduced in 1867.) What is Wall Street, it is often asked, if not a high-stakes casino—and a rigged one at that—where every gain is yoked to another's loss?

This connection did not escape Erdnase. "[T]he vagaries of luck, or chance," he wrote, long before the financial she-

nanigans we've witnessed in the last few years, "have impressed the professional card player with a certain knowledge that his more respected brother of the stock exchange possesses, viz.— manipulation is more profitable than speculation; so to make both ends meet, and incidentally a good living, he also performs his part with the shears when the lambs come to market."

Nor was Erdnase the only person to make this connection. Volumes have been written on the kinship between gambling (especially poker) and finance. Both require nerves of steel and a deep understanding of, and tolerance for, risk. Both encourage bluffing and the occasional random ploy designed to throw your opponents off balance. Both are guided as much by luck as by skill—with people frequently confusing the two—and fueled by greed. Both favor those with privileged information. Both tend to enrich the few at the expense of the many. Both can mint you a fortune overnight and bankrupt you twice as fast.

"Almost anything that's used at the card table can be used in magic," Wes had me know. "The amount of overlap is tremendous." What's more, because gambling sleights are some of the most demanding moves in magic, mastering them means you can pretty much do anything. So my first assignment in those early days with Wes was all about learning to think and act like a cheat.

"The first thing I'm gonna have you do is try and learn this false cut," Wes said during one of our early meetings, as he broke the deck into three stacks and shifted them around in a way that looked chaotic but was carefully orchestrated to bring the cards back to their original order. Erdnase called this move Fancy Blind Cut to Retain Complete Stock. (Erdnase was bad with names.) After demonstrating the move, Wes coached me. "Cut the top. Okay. Cut the third. When you do it, you want to come

to a point where the deck is seemingly square." I reversed the top card so I could keep track of what I was doing—if the faceup card isn't on top after the move, you know you've done something wrong. Meanwhile, Wes continued to spout suggestions.

"Try to get a cleaner release," he said. "It'll take some work to become smooth. You want the thing to be smooth, but sloppy. If you do this right it seems like you don't care, and the less you seem to care the less likely you're trying to do something."

"Is this right?" I asked.

"Again," he barked. "A little crisper."

I worked on this one move for a good thirty minutes. Eventually Wes looked over at my hands and nodded. "You're lifting before you come out with that third, and to me that looks too studied," he said. "But other than that you seem to be doing okay."

Wes showed me a dozen other false cuts: the Cooper cut (invented by a hermit in North Carolina), the Slydini cut (after the great Tony Slydini), a bluff cut, and several by Wes himself. "You'll still see cheats all over use it," he said of another. "This will fly in almost any situation. It's an optical illusion that has to do with the continuity of motion."

"Didn't Frank Garcia have a thing like that?" asked one of the old guys sitting at the table.

Wes grunted. "I'll show you that in a minute."

After false cuts came a lesson in how to rig the shuffle—an essential skill for any card cheat. A rigged shuffle is a move that preserves the order of the cards or arranges them in a particular sequence under the guise of shuffling. Wes showed me a number of diabolical false shuffles, one of which he'd pieced together from two separate slices of Erdnase, and which turned out to be incredibly useful for my Ambitious Card routine.

Once the deck has been shuffled and cut, it's time to deal the cards, and this is where crooked deals come into play. A crooked deal is one in which you pretend to deal cards off the top of the deck while actually dealing from somewhere farther down in the pack. Wes taught me to deal seconds (that is, to deal the second card from the top), bottoms (i.e., the bottom card instead of the top), and, toughest of all, middles (in which a card from the center of the deck is secretly dealt down)— although the only one I was able to master was the so-called strike second deal. The others were just too tough.

To do a strike second, you push the top card over a hair with your thumb, pivoting it to the right and back, exposing the top right edge of the card beneath it. This exposed edge is called a brief. The right hand swoops in as if it is about to peel off the top card, but instead the ball of the right thumb contacts ("strikes") the exposed brief and deals down the second card. When done smoothly and at speed, the strike second is almost undetectable. Expert hustlers like Wes can catch a very fine brief of about a sixteenth of an inch. But Wes prefers an even more deceptive move known as the New Theory second deal. Here the top card is pushed far off to the side and then pulled back just before the (second) card is taken. It's all in the timing. Wes showed me his one-handed version, wrist bobbing gracefully up and down as cards fell gently to the table—a perfect subterfuge. The room echoed with murmurs of admiration. "That's New Theory," said Wes.

Wes also taught me how to secretly glimpse cards in the deck, the equivalent of inside information, which, when combined with false shuffles and crooked deals, gives you a frightening advantage over other players. You might, for instance, glimpse an ace or two and control them to the top of the deck, then secretly deal seconds to everyone except yourself, although

this is likely to arouse suspicion—it looks bad if you get too many aces when you're the one dealing—so it's best to have a partner you can deal the aces to instead.

Finally, I learned about switching cards, the least common category of gambling maneuvers, because of the risks involved. There are dozens of methods for improving your hand by replacing it with a better one—including the hand-mucking technique I'd seen Wes showing Jack Diamond on the day we met. "Guy I taught this to made a hundred thousand a year in Puerto Rico with just this one move," Wes said with a satisfied look on his face. Wes showed me several ingenious methods for palming cards off the top and bottom of the deck, and he engaged the table in a lengthy diatribe on the proper action of the thumb during the top palm. "Vernon preached that you should not move your thumb," he said, weighing his words, "and Vernon was wrong." A hush fell over the table.

"Are you sure you're allowed to say that?" asked one guy. There was a rustle of laughter.

Wes glared at him. "Yes," he said gravely. "I was one of his direct students, and I argued with him about it. So I have the right to say it."

You don't mess with Wes when it comes to Dai Vernon—or anything else for that matter, as Doug Edwards will tell you.

Like Vernon, Wes had devoted years to mastering the weapons of the cardsharp. He could quote *The Expert at the Card Table* chapter and verse, and when he did, his voice took on an almost ecclesiastical tone. As with all things, Wes had strong opinions about the book. I'd learned this the first time we spoke, when he informed me of all the errors in Erdnase. Looking back, I realized how foolish I'd been trying to impress him with my brand-new, unworn copy. I'd brought a knife—nay, a red plastic water pistol—to a gunfight.

A century after the book was published in 1902, magicians are still mining *The Expert at the Card Table* for material. When David Blaine riffles through the faces of the cards and says, "Just remember one," he's doing Erdnase. The hardcore card guys pore over the book much in the way that rabbinical scholars study the Talmud, arguing over every phrase, unpacking every word.

And just as no one knows who wrote the Talmud, no one knows who Erdnase was, despite intense effort on the part of many magicians to ascertain his identity. One theory is that Erdnase was a small-time swindler surnamed Andrews (S. W. Erdnase spelled backward is E. S. Andrews) who was wanted for murder and shot himself when the long arm of the law finally caught up with him. Others have suggested that the author was a well-educated man of high social standing, a pillar of the community who hid behind an alias to shield his reputation. (This would explain the inkhorn prose.) Spanish maestro Juan Tamariz, leader of the Madrid School, is of the view that the nineteenth-century Peruvian magician L'Homme Masqué, a shadowy figure who lived by his wits and never performed without a mask, wrote the book. In the absence of any definitive evidence, the hunt continues.

Inspired by Wes's own obsession with the book, I began reading my leatherette-bound pocket edition of Erdnase on the subway and at school. The dense descriptions and highly technical passages were tough to follow, like a physics book, and the gilt edges and ribbon placeholder often led people to mistake it for the Bible. "Bless you," an old woman said on the train one morning, eyeing the little tome. "It's so nice to see a young boy reading the good book." Stifling the urge to stand up and start preaching from the legerdemain section, I flashed her an innocent altar boy look. *Hallelujah.*

· · ·

REFINED OVER DECADES, THE MOVES I learned from Wes are behind the high-stakes hustles run by top card mechanics all around the world, professional thieves who earn a living by robbing other players blind in dimly lit rooms rank with the smell of cigar smoke, scotch, and testosterone. More often than not, these men are freelancers for hire. Some rich heel will decide to rig his home game, so he rings in a mechanic to cheat for his team. The buy-ins will range anywhere from a few hundred dollars to a hundred grand.

Wes had spent a good deal of time in this shady milieu, and our conversations often consisted of my listening to him reminisce about the many cheats he'd known. One such story concerned a Brooklyn man who played with a group of loan sharks in the back room of a pizzeria not unlike Rustico II. "These guys would hurt you because they didn't think twice about hurting people," Wes explained. This particular hustler worked the game all by himself, without a partner, and he wore a safari jacket loaded with zippered compartments. In one of these compartments he would hide a prearranged deck, called a cooler. All night he'd play clean, no moves, until finally, after he'd put in the hours and it was time to get paid, he'd point at the wall clock and yell, "Holy shit! Look at the time! This has gotta be the last one, guys!" While everyone turned to look at the clock, he'd reach in his pocket and switch in the cooler. "It was one move," Wes snorted. "And that was a week's pay."

A more popular scam these days, although the idea is at least a century old, is something known as the dealback. In a dealback scam, the dealer and one or more of the players conspire to steal the pot by secretly recycling hands back into play. A prearranged signaling system is used to orchestrate the

moves. Let's say you're playing Texas Hold 'Em. The hands are dealt, a pair of cards to each player. You look at your hand and commit it to memory—then you fold. The dealer casually scoops up your cards, controls them to the bottom of the deck, and in the next round deals those cards off the bottom to one of the other players—usually the person with the biggest chip stack. As a result, you now know their hole cards. Over the course of an evening, this is a crushing advantage.

The same technique can be used to recycle a good hand after a bad flop—the first three faceup community cards. Say you've got black pocket aces—normally a premium hand, except that the flop is all hearts. This is a dicey situation. Another heart, and your aces are toilet paper next to a flush draw on the board. So instead of playing your hand, you fold while covertly signaling the dealer to give you back your aces in the next round. In a single cycle of betting, this gives you a slight edge, but over the long haul, it's devastating.

A similar set of principles is behind the sophisticated scams used to cheat in real casinos, although it's much more difficult to cheat at a casino than in a private game because of the many countermeasures in place designed to thwart illicit play. For one, casinos have expensive security systems and paid personnel who monitor the games closely. Furthermore, casinos keep mathematically precise tabs on how much money each table gives out. Any anomalies trigger alarm bells and prompt a phalanx of bull-necked men with earpieces to crack their knuckles and flex their guns. Gambling is all about statistical certainty. "Luck may be a fickle mistress," observes gaming expert David Britland, in his book *Phantoms of the Card Table*, "but probability is a firm friend, at least if you are a casino owner." From a large number of random events—each spin of the wheel, each roll of the dice, each turn of the card—a predictable pattern

emerges, like the image in a pointillist painting. In physics, this is the essence of the second law of thermodynamics, which governs, among others things, the flow of heat, the decay of order into chaos, and perhaps even the directionality of time. Unlike Newton's equations, the second law is not a deterministic set of rules that governs the behavior of the universe, but rather a statement about what's most likely to happen over time when your sample size is extremely large—the so-called thermodynamic limit. That said, you wouldn't want to bet against it, because the same probabilistic laws also prevail at the casino. Which is why, when one blackjack table is paying out more than the rest, the evidence points to cheating. Crooked dealers know this, and in order to evade suspicion, they'll take in as much as they give out. In the casino universe, luck is conserved. When a shady dealer engineers a bit of good fortune here, by delivering good cards to his confederate, he has to eliminate it elsewhere by dealing bad cards to another player. If a cheater wins big thanks to the dealer's largesse, you can be fairly certain the cards will fall cruelly for the unsuspecting businessman who sits down at the same table a few moments later. Like the stock market, it's a zero sum game, and someone has to foot the bill.

As I BECAME MORE VERSED in card magic, I began to see my monthly poker game in an entirely different light. Temptation was everywhere, each hand an opportunity for dishonest play. It became difficult to follow the action, because all I could think about was how easy it would be to cheat. I never did, though. Well, not *exactly*.

I got the idea from Wes. Back when he was honing his chops, he would go to games and cheat the entire time. But

he'd do so in such a way as to avoid giving himself an edge. "I lacked the larceny but not the skills," he told me. "I just wanted to see if the moves would fly." Like a good scientist, Wes devised a method to test out his technology of deception under fire. "The only way to know if what you're doing works at a game with money on the table is to test it in a game with money on the table. So I came up with a solution that satisfied my ethical constraints and at the same time satisfied my intellectual curiosity." The solution for Wes was to execute the moves merely as a means of practicing the sleights, but without profiting from them. This way, he could test his mettle without compromising his integrity or feeling like a crook.

It seemed like a good strategy, and one night, while playing poker at a friend's house in the West Village, I decided to give it a try. There were eight players in all, mostly writers and actors. We were playing Texas Hold 'Em, and the host had a casino table in his living room, which gave a nice sense of verisimilitude to the game. Scotch was poured and, in a less androgenic vein, freshly baked cookies were served.

I lay low at first, not wanting to arouse suspicion early on in the game. I was doing well for once, catching good hands on the board and making sound position bets. I even won a couple of pots with all-in preflop raises. Before long I was up a couple hundred bucks—all the more reason not to cheat. But by then, everyone had settled in and was a little drunk, and I was feeling cocky, so I decided to make my move.

"These are mixed," said Nathan, the curly-haired novelist to my right, as he passed me the deck. It was my turn to deal. I sailed the first two cards off the top, then switched to dealing seconds for the rest of the players. Little did they know, but they were receiving the wrong cards. Then I dealt myself the top card and went back to dealing seconds. I didn't know what

any of these cards actually were, because I hadn't peeked at them prior to the deal, so there was no advantage to be gained from all this trickery. But, like Wes before me, I wanted to see if the moves would pass muster.

Everything was going smoothly until I dealt player number three, a successful comedian named John, his second hole card. This time my hands slipped as I executed the move, applying a bit too much pressure, and two cards came whirling out instead of one, giving John an extra card. Not only that, but I'd left a third card behind, sticking partway out of the deck, pulled loose by the excess friction. Wes had warned me about these so-called hangers. I was fairly certain that no one in the room was packing heat. Nevertheless, my heart was pounding against my rib cage as John gave me a puzzled look.

"Oops," I said quickly, trying to cover. "Sorry about that. Don't drink and deal, right?"

He shrugged it off, and I took a deep breath. That was a close one.

I played it safe for the next hour, letting my courage recharge. Once my confidence came back, I went for something even bolder. I copped a card off the bottom of the deck and palmed it for an entire hand, then tossed it into the muck (the discard pile) without checking what it was. Emboldened by this shade, I threw in some false shuffles when it was my turn to mix the cards. I did a Zarrow—a brilliant fake riffle shuffle invented by an accountant from New Jersey—and one of Eddie Marlo's favorite false cuts. I played this way the entire night—cheating on and off without actually cheating—just to see if anyone would notice.

And no one did.

It's not like I was playing for big money. Hundred-dollar buy-in, table stakes, Baby No Limit–type stuff. On a good

night, the winner went home with a few hundred dollars. But when is it ever about the money? Hardcore hustlers say they're in it for the cash, but somehow I doubt that. When you consider the risks involved and the effort it takes, there are easier ways to make a living. Like getting a job.

But it's an incredible rush. I felt as if I were freebasing rocket fuel during the game, which made for an exciting evening. Even Texas Hold 'Em is too slow for an adult ADD case like me. I lack the patience to be any good at legit poker. Even though I wasn't benefitting from these sneaky moves, I knew they'd be hard to explain away were I to get caught. This was at once frightening and exhilarating.

A lot of the motivation behind cheating must come from the charge you get. To truly understand the psychology of a cheater, you need to see the world like a con artist. In this worldview, everything is rigged—the casino, politics, Wall Street, life—and there are only two types of people: grifters and suckers. (It's a lot like in magic, where you're either a magician or a layperson.) If you look around the table and don't see a sucker, then, according to an old saying, the sucker is you. It's fool or be fooled, only the stakes are higher.

One experienced hustler told me a story about a young cheater who regularly risked his life bilking dangerous men out of their hard-earned lucre in no-limit games, and who had recently done a one-year stretch in prison for trying to rig a slot machine. "The funny thing is," the old hustler told me, "this guy has a heart of gold. You can leave your wallet full of hundred-dollar bills on the table, and he wouldn't take anything out of it. Or, if you dropped it, he would hunt you down to give it back. But when it comes to playing in a game, there's just something about it that is an addiction. It's hard to resist."

It seemed odd at the time, but I'd come face-to-face with my first magic-related ethical dilemma: to cheat or not to cheat, that was the question, and trying to answer it triggered a bizarre mix of emotions. What began as cautious curiosity had escalated into a gale-force adrenaline rush. But now, during my victory lap, moral qualms were nipping at my heels. Call it hustler's remorse. Even though I'd stolen nothing, I couldn't shake the lurking feeling that I'd somehow crossed a line, and what troubled me most about it was that part of me liked it. I'd fooled everyone at the table that night, and like any well-plotted deception, this sent a surge of euphoria rippling through my veins.

The next day I immediately bragged about my exploits to Wes, further potentiating the high. "Cool," he said. "That's the thing to do when you're learning. You find out if your technique stands up. And you find out whether you got the cojones or not." Afterward, I wondered if I could resist the temptation to cheat in future games. Would I ever be able to play straight again? In gaining these new skills, had I not also lost something? This much was clear: I'd tasted a powerful new drug, and I wanted more.

THE TOUCH ANALYST

After working with Wes for a while, I decided to seek out the man widely regarded as the world's greatest card cheat. I was inspired by a story I read about Wes's own teacher, Dai Vernon. Back in 1932, Vernon had traveled to Missouri in pursuit of a grifter named Allen Kennedy who had reputedly mastered the center deal—that is, secretly dealing from the middle of the pack. At the time, many magicians, including Vernon, considered center dealing to be the holy grail of gambling sleight—the reason being that if you can deal from the middle, you never have to worry about the cut. After a lengthy search, Vernon caught up with Kennedy and traded some of his A material for the move. (Vernon was pathologically secretive, so he must have wanted the information very badly.) Years later, Vernon bequeathed the Kennedy center deal to members of his innermost tribe. The man I sought was one of them.

His name was Richard Turner, and as luck would have it, he was scheduled to give a closed-door lecture for the Society of American Magicians in New York. Though unknown outside the realm of magic and gambling, Turner was said to be a card handler without equal, a man whose prowess with a deck bordered on the supernatural. No less a technician than Vernon had singled him out as the most gifted card mechanic he'd ever encountered in his eight-decade career—better even than Kennedy himself. "Richard Turner does things with cards that nobody else in the world can do," Vernon once said.

I wanted to know what made Turner so good, and maybe pick up a trick or two in the process. I also wanted to see if he measured up to the hype. The stories that circulated about him were far-fetched, to say the least, and as I had learned early on, the world of magic is filled with half-truths and hucksterism— or what Jeff McBride calls "fakelore." (The word *famous* in a magician's title means about as much as it does when attached to the name of a New York pizzeria.) But what most raised doubts in my mind was the astonishing fact that Richard Turner, the greatest living card cheat and quite possibly the sharpest card handler of all time, was blind.

WITH HIS BLACK STETSON HAT, lizard-skin boots, and wide Doc Holliday moustache the texture of dried tumbleweed, Richard Turner looks like a saloonkeeper from the Badlands, a Victorian-era cowboy, or a ghost town tour guide. When I first saw this apparition the night of the lecture, as he came striding into a sterile auditorium in the back of the Mount Sinai Medical Center on Madison Avenue—the SAM's new bat cave—I checked his hip for the holster and six-shooter, seemingly the only things missing from his getup. Nope, no holster, just a

solid gold belt buckle in the shape of a five-card poker hand—three aces and two eights, the so-called dead man's hand.

Still, Turner *is* licensed to carry a firearm. Nearly three decades ago, when the top organized crime families in New York and overseas were pursuing him relentlessly, offering him millions to work for them and threatening to kill him if he declined, he was armed for his own protection by the head of the San Diego SWAT team.

What the mob wanted so badly—what they were willing to kill for—was Richard Turner's sense of touch. It's an underappreciated sense, really, in this audiovisual age, but within the rarified domain of the professional cardsharp, a finely tuned sense of touch is everything. In Turner's case it almost got him killed, and after witnessing a demonstration of his Midas-like abilities the night of the SAM lecture, along with a dozen or so other local magicians who'd come to watch him perform, I understood why.

"Do as I do," Turner opened, in a warm antebellum drawl, flashing a bandit's grin as he offered a deck to the volunteer he'd chosen from the crowd, a blonde woman in her mid-thirties with light, freckled skin. "When you play poker, blackjack, bridge—whatever your game—you wanna make sure the cards are very evenly mixed. Let's start with some simple cuts. Takes no skill to do this." Turner started to cut the cards, gradually speeding up as he spoke while his volunteer did her best to keep up. "Now alternate it. Now try a flying three-way. Now try a one-two-three-four-five-six-seven way. Or strip cutting, as in the casino." The audience chuckled as Turner's hands moved in a blur and his volunteer tried in vain to follow. "No skill at all," she cracked wryly, as Turner moved on to a series of shuffles, each one more intricate than the last. The woman stood haplessly by, no longer trying, a portrait of defeat. Ignoring her and addressing himself to the audience, Turner went on.

"Aaaright," he said. "Now you're ready for the way they shuffle in a casino. Just give it a closed riffle shuffle. Perfect. Now how 'bout the faro shuffle? Break 'em in half and lace 'em up every other card, then bridge 'em down." There was more laughter as Turner split the deck exactly in half and zippered the two stacks with one hand, then executed an acrobatic one-handed flip-around cut. He paused. "Well, I've shown you half a dozen ways of shuffling and cutting," he said. "The deck should be pretty evenly mixed, right?" He smiled triumphantly and spread the deck face up on the table to reveal the cards in pristine numerical order. "Does that look even?" Everyone in the room shrieked and clapped, a boisterous uproar that lasted close to a minute. As he waited for the clamor to subside, Turner fished a toothpick from his pocket, leaned back in his chair, and calmly began picking at his teeth.

This was only the beginning. Turner could do simultaneous perfect one-handed shuffles with a deck in each hand. His crooked deals—seconds, middles, bottoms—were the most deceptive I'd ever seen. His one-handed middle deal—the hardest of all the shady deals—looked legit from every angle. He even did an impossible Greek deal—a second-from-the-bottom deal used to circumvent the cut card placed underneath decks at casinos. He dealt blackjacks to another volunteer, the only other woman present, from a deck she'd shuffled and cut, his hands moving in slow motion so we could study his every move.

But the effect that destroyed every magician in the house that night may well have been the simplest. A spectator picked a card, replaced it in the deck, and shuffled, and yet somehow Turner was able to locate the card and control it to the top—a feat nobody in the world can explain, I have heard, and one that has baffled card experts, magicians, and casino personnel alike.

Not bad for a guy who's legally blind.

Actually, Turner's vision is six grades below the cutoff for blindness, the result of a rare degenerative tissue disease (called birdshot chorioretinopathy) that began ravaging his retinas at age nine. "The macula is pretty much dissolved," he told me later, referring to the oval cluster of nerve cells near the center of the eye. "And the rest of the retina looks like someone took a shotgun with birdshot and blew it full of holes." (Hence the disease's evocative name.)

Most other people with this disease would probably have given up on the dream of becoming a world-class card manipulator, a goal Turner had set his mind on at age seven after watching an episode of the TV show *Maverick*. But Turner kept at it. He practiced day and night. He ate and drank and slept with cards in his hand. He still sleeps with his cards, and five years ago, when forced to undergo hernia surgery, Turner clutched a deck while on the operating table. To hear Turner tell it, his abilities are not something he developed in spite of his disability, but rather because of it. "I have to do it all by touch," he says. "Which is a real blessing."

Watching Turner baffle a roomful of experts put me in mind of what is often said about people who lose one or more of their primary senses: that their surviving senses compensate by becoming sharper. We now know that this compensatory response is rooted in a phenomenon known as brain plasticity, whereby neurons regenerate and reorganize themselves in response to trauma or a change in the environment. Once viewed as a calcified mass of unalterable circuitry, the human brain turns out to be surprisingly supple, even in adulthood, and the study of brain plasticity has become a central theme of modern neuroscience.

Indeed, what Turner lost in vision he seems to have re-

couped in an almost superhuman tactile ability. It's as though he sees with his fingers. Give him a pile of cards, and he can tell you exactly how many there are by running his index finger along the edges. Turner is so good, in fact, that he consults for numerous casinos as well as for the United States Playing Card Company, the world's largest card manufacturer.

His title: Touch Analyst.

THE NOTION THAT BLIND PEOPLE develop enhanced nonvisual abilities to make up for their lack of sight goes way back, to a time long before we knew anything about neuroplasticity. In the realm of semimyth, Homer was said to be blind, as was the prophet Tiresias. The Talmud references the memory feats of the blind and the trust placed in them by rabbinic scholars as reliable authorities on obscure passages. In his eighteenth-century *Letter on the Blind for the Use of Those Who See*, the French philosopher Denis Diderot describes a blind man capable of recognizing voices with astounding accuracy. Throughout history, blind musicians have been mythologized as miracles of sensory adaptation, a view that is still common today, and which is given credence by the likes of Ray Charles, Stevie Wonder, and Andrea Bocelli.

Until recently, however, the evidence was mostly anecdotal. Only in the last decade or so have scientists systematically matched up the blind and the nonblind in head-to-head tests, peering into their brains to see what, if anything, is different. The results, even after discounting for the accumulated wisdom of history, have revolutionized the way neuroscientists think about the human mind.

Consider, for starters, how much better blind people can hear compared to most. As has now been shown in dozens of

studies, the blind beat the nonblind on virtually every measure of acoustic ability. Blind people are better at speech recognition, sound identification, and auditory localization, even with one ear plugged. They hear changes in pitch that are ten times smaller than anything a seeing person can manage. (This is why some of the best piano tuners are blind.) Perfect pitch—the ability to identify notes without external reference tones—is three times more common among blind musicians than among those who can see, and this is true even for blind musicians who begin their musical training later in life. And when it comes to memory, the Talmud is right. People who lose their vision early on have exceptional short- and long-term memories, for words as well as for sounds. Studies have also shown that their brains are unusually immune to false memories.

Where tactile sensations are concerned, the blind not only read with their fingers—using the Braille alphabet—but they can recognize and remember raised letters and embossed pictures by feel with remarkable precision. They are able to sense minute differences in texture that are imperceptible to most people. Their fingers can feel, for instance, the difference between a single groove and a pair of parallel grooves, even when the two grooves are separated by a fraction of a millimeter. Such extraordinary sensitivity to size, gradations of shape, and texture has allowed the blind paleontologist Geerat Vermeij, one of the world's foremost experts on mollusks, to trace the evolution of several new species that had gone overlooked by his colleagues, simply by turning the shells over in his hands and feeling subtle differences in their forms. Turner has the same kind of hypersensitivity. "When I feel a card, it's like those cards are a quarter of an inch thick," he tells people. "The cards multiply in size." He says a similar thing about typing on his BlackBerry. "It's like I'm looking at something that's about

two and a half feet across." And when he types, he moves his head from side to side, because the letters appear on a giant screen in his mind.

Armed with fMRI machines and PET scanners, neuroscientists recently zoomed in on the brains of blind subjects to see what was going on under the hood during these amazing perceptual feats. What they found came as a shock. As expected, Braille reading and other touch-related tasks engaged the somatosensory cortex, the zone of gray matter that processes tactile sensations. This was true of everyone, not just the blind. But when the blind participants read Braille, something unexpected occurred: the visual cortex, the part of the brain dedicated to vision, lit up as well. Although they lived in total darkness, the inner eye of the blind subjects was firing on all cylinders, exhibiting all the features of cognitive engagement—increased blood flow, a cascade of metabolic activity, and a shower of electrical impulses—that one would normally observe in a seeing person whose eyes are glued to a book or a baseball game. The story these scans told was unmistakable: the blind subjects were *seeing* with their fingers.

Not only that, but the visual cortex was found to be the driving force behind their superior abilities. Performance on nonvisual tasks was directly correlated with the level of activity in the visual cortex—the more active it was, the better they did—and temporarily disabling the visual cortex with a Marvel-esque machine called a transcranial magnetic stimulator, which beams a magnetic field into select brain regions, rendered them unable to read Braille and identify embossed letters. Playing the same prank on people who can see, meanwhile, has no impact on their sense of touch; it hampers only their vision. A parallel strand of research has found that people who are born blind lose the ability to read Braille if a stroke damages

both hemispheres of their visual cortex, even if their tactile system remains unharmed. Perhaps this is why blind people such as Turner frequently speak of touch in visual terms. "When I touch something," he says, "I'm seeing it in front of me in full scale. If I touch a pen, instantly I see a pen. If I touch a comb, I see a comb." More than just fanciful metaphor, this language hints at the underlying neural correlates at work.

This apparent crossover between the visual and tactile channels took neuroscientists by surprise in part because the vast majority of them had long believed in a fixed division of labor between major brain regions. Each primary cortex was thought to handle a single sensory modality. The visual cortex dealt exclusively with vision, the auditory cortex dealt exclusively with sound, and so forth. If for whatever reason the optical feed were severed, the visual cortex would forever lie fallow, sealed off from the world. Cross-modal plasticity, in which one higher-level brain region takes over for another, was thought to be impossible, an assumption that seemed reasonable enough given that signals from the optic nerve travel to the brain along distinct pathways, separate from those of the other senses. But time and again we find that the brain is full of tricks.

"NAME ANY FOUR OF A kind."

I looked at the cards spread out on the table in a long ribbon. "All right," I said. "I'll choose the nines."

"Take out the nines," Turner said.

I extracted the nines from the spread and held them in my right hand.

"Close up the deck, and put your nines on top."

I did as I was told.

"Now cut the deck and square it up real nice and clean."

I cocked my head to one side. If I cut and squared, how could he possibly know where the nines were? Turner was unfazed.

"All right," he drawled, picking up the deck. "Your cards are somewhere, depending on where you cut them, right?"

I nodded. Then I remembered he was blind. "Yes, that's right," I said.

"Now, what poker games are you familiar with?"

"Well, I play Hold 'Em a lot," I said.

"Okay, give me a number of players."

I paused for a moment to think. "Six players."

"Okay, in Hold 'Em we have what are called the pocket cards," he said, dealing two facedown cards to each of the six imaginary players, counting them off out loud. "And we have the board." He dealt a faceup card in the middle of the table. "What's that card?

I looked at it. "A nine."

Turner burned a card off the top and tabled a second one face up. "What's that?

"A nine."

"There's a burn, there's a turn," he rejoined, dealing another. "What's that?"

I heaved a puzzled sigh. "A nine."

He dealt one last card, and there were now four nines in a neat row on the table.

Although I had no idea how Turner had located the cards, I knew this was the famous middle deal, the sleight Vernon had traveled to Missouri to learn from Allen Kennedy.

"That's a tough move, right?" I asked, knowing full well what the answer was.

Turned nodded. "Oh, it's a very tough move," he said. "But it's not the toughest."

I shrugged. What could possibly be more difficult?

It was just after noon and we were sitting in Turner's kitchen. After watching him floor everyone at the SAM, I'd asked Turner if I could pay him a visit in San Antonio, where he lives with his wife, Kim, and their teenage son, Asa Spades. Turner had invited me to spend the day with him at his home—a two-story, four-bedroom brick abode in the brushwood hills on the outskirts of town, not far from where I went to high school.

The house was crammed with antique furniture, work-out equipment, photographs of magicians, and trophies and plaques Turner had won either at cards or karate. (He's a sixth-degree black belt.) A backyard swimming pool hemmed in by an enormous teak deck was visible through the sliding glass doors in the kitchen. It was a sparkling day, clear blue skies as far as the eye could see.

Turner grew up in San Diego, California, the eldest of five children. His father was a welder from Tennessee who worked in factories, while his mother, a Michigan native, stayed at home with the kids. Turner was seven when he started playing cards with his four younger siblings, two sisters and two brothers. They played poker, rummy, gin rummy, crazy eights, hearts, spades, war. The games changed, but one thing stayed the same—Turner never lost. "I would start coming up with ways to make sure I always won," he told me. "And it kept perpetuating itself. I started getting a reputation. My sister Lori never trusted me. I would catch her hiding cards under the throw carpet." When his family wasn't available to play with him he would stack aces against an imaginary opponent. "I would shoot him with my toy gun after he called me a cheater," Turner joked.

On the first day of ninth grade, Turner's English teacher caught him doing tricks for the boy sitting next to him. She

confiscated his cards and sent him to the back of the room. But the punishment didn't take. Before long he was hustling his classmates at poker and gin and paying other students to do his homework with the winnings. He even hatched a game he called massage poker, which he used to score rubdowns from female classmates. "There would be a thirty-second ante," he explained. "You could bet between fifteen and sixty seconds, and at the end of the hand the winner would get a massage anywhere you wanted."

By the time he was old enough to drink, Turner could deal middles and bottoms and run up a stack during the shuffle, moves very few people in the world knew how to do. "I would think of it in my head," he told me. "I've read two books in my life: Erdnase, and it was from an audiocassette version, and then somebody read to me from a book called *Seconds, Centers and Bottoms*, by Marlo. That was it. That was the only reading I ever did."

Turner met Dai Vernon when he was twenty-one, at the Magic Castle in Los Angeles. Impressed with Turner's abilities and his pathological work ethic, Vernon took Turner under his wing. The two became close friends and worked together for seventeen years. "He would share with me things that he didn't share with anyone else," Turner recalls. "I was very, very fortunate." Turner and his wife threw Vernon his ninety-eighth birthday party, two months before he died.

By the early eighties, Turner had gained enough notoriety as a card handler to attract the attention of the world's top crime syndicates. First to come calling was R.D., a New York Mafia kingpin who offered Turner $2,000 a day to cheat for him on the LA circuit. "We played cards, and he was a good second dealer and a good mucker," Turner recalls. "Then I started showing him what I could do, and he said, 'You can

do by yourself what it takes four of my mechanics to do together.'" R.D. followed Turner around for six years. Then one day, Turner heard R.D.'s name on the nightly news. The FBI had raided a mob operation in San Diego, and R.D. was being carted off to jail.

After that came the Saudis, with million-dollar offers to play for oil money. But Turner knew better. "A situation like that, and you're a hundred percent used," he said. Translation: "They kill you when they're done with you." Scarier still was a diamond merchant from South Africa who wanted Turner to brace games outside Sun City. More than a quarter of a century later you can still hear the faint echo of fear in Turner's voice as he recalls a cross-country flight on which he found Mr. Diamond, as he calls him, sitting across the aisle. "Hello, Richard," he said. "I wanted to talk to you about doing a little business together."

"This guy knew about me in ways he shouldn't have," Turner remembers. "I'd be on the road performing here and there, or doing shows, and he would know where I was. He would call me up in my hotel room, 'Richard, I'm downstairs. Let me buy you dinner.'" Mr. Diamond offered Turner hundreds of thousands of dollars a year, a five-carat diamond pinky ring worth $70,000—"I knew if I took it, then he'd have me"—and a spot on *The Tonight Show*. After Turner refused, Mr. Diamond made one last bid. "If you ever want to have your wife or anyone else killed," he said, "I can arrange that for you. It'll be an accident. An explosion. No one would know."

Fearing for his family's safety, Turner handed Mr. Diamond's business card over to the captain of the San Diego SWAT team, a man named Charles Curtis, who one year earlier had helped track down Texas serial killer Henry Lee Lucas. Curtis armed Turner with a Walther PPK (James Bond's gun)

and taught him how to handle it in tight situations. Turner keeps the pistol stashed away in a thick vault in his living room.

Scorning mob money, Turner continued to earn a living legally—performing gambling demonstrations as a magician aboard riverboat casinos, lecturing, and consulting. From 1979 until 1984, he performed aboard the *Ruben E. Lee*, then moved to Fort Worth to work at a nightclub named Billy Bob's. In 1991, the same year he met his second wife, Kim, he spent another brief stint on the water. They married the following year, in a small ceremony in San Diego. Vernon was one of the guests. A painting of the two, embracing like brothers-in-arms, hangs above the mantel in Turner's living room.

Turner's relationship with the U.S. Playing Card Company began in 1988, when he noticed that something was off about the Bicycle cards he'd been using for almost two decades. "The cards had really gone down in their quality," he told me. "And I said, 'Hey, you guys are screwing us. This is not the same card you've been making.'" He was right. Earlier that year the US-PCC had begun subcontracting their paper. As a result, their cards were being printed on cheaper stock. Five years later, the USPCC made another change to their production cycle, this time to the way they cut the paper. This didn't escape Turner's notice, either. "I said, 'You guys are changing the way you're cutting your paper. You're not cutting the same way you've been cutting them for a hundred years. These are not traditionally cut.'"

Traditionally cut means the blade goes through the face of the card rather than the back, leaving a rounded edge on the face and a rough edge on the back. Shuffling facedown is easier when the rough edge is on the back, and most people, including all casino dealers, shuffle facedown. If the rough edge is on the wrong side, the cards tend to bind up when they are

shuffled. Turner illustrated this for me using my cards, which were not traditionally cut.

"Are these faceup right now?" he asked.

I paused for a moment, then remembered that he couldn't see. "Yeah, those are faceup."

He meshed them together. "See how nicely they shuffle when they're faceup? Do it facedown and they don't go anywhere. You have to force them."

I tried to interlace the cards facedown, and sure enough, they refused to cooperate.

When Turner brought this issue to the attention of the USPCC, the company's executives didn't believe him at first. At the time, they had no idea that changes to the production process had affected the quality of their cards. "We didn't know that we'd changed anything," Lance Merrell, the company's director of R&D, later told me. "This wasn't even on our radar."

Rather than make an enemy of Turner, the USPCC gave him a job and a title. "Once I learned that he had a heightened sense of feel," Merrell recalls, "I realized we could use that to fine-tune our process." Turner's job as touch analyst is to test-drive decks from different runs, rate them on a scale of one to ten, and report back on any irregularities he finds. Like Vermeij with his mollusks, Turner does it all by touch. His caliper-like fingers can sense the thickness of the paper stock to within a thousandth of an inch. He can detect tiny fluctuations in the level of embossing. Using his fingernail as a stylus, he once counted the number of embossed ridges on a card and sent the result to Merrell. "I didn't even know how to count them without a microscope," Merrell told me. "I had to go to the manufacturer of the embossing product and ask how many lines per inch he used. And Turner was right." Turner can even pick up

subtle variations in the moisture level of the paper and the ink, along with changes to the chemical composition of the coating used to block out mold. "His touch sensitivity is incredible," says Merrell. "I don't even know how to describe it. He's like Rain Man."

For his personal use, Turner has the USPCC make cards to his own specifications, punched the old way, but with mandolins on the backs instead of angels, because the company jealously guards the integrity of its trademark. (Bicycle decks are the most recognized cards in the world.) As part of his compensation, Turner has received a lifetime supply.

When he handed me one of his decks and I shuffled them, I could feel the difference immediately. They were smoother, sturdier, and the edges meshed together with ease.

"Oh, wow, these just go like butter," I rhapsodized, unaware of how ridiculous I must have sounded to Turner. "So nice."

"It's like having an instrument," he explained. "A better instrument's going to play nicer." Turner has his Mandolin decks delivered to his house by the gross and is allowed to sell them online at a premium, another perk of his relationship with the USPCC. "The top card men, they all use my cards," he said.

It was time for another trick. Once again using my deck, Turner spread the pack facedown (as if it mattered), and I plucked out a card—the ace of hearts. Turner squared up the spread and asked me to call out "stop" as he cut small blocks of about five cards each onto the table.

"Okay," I said, after a while. "Stop."

"Drop your card."

I placed my card onto the stack, and Turner continued dumping cards on top, burying it in the middle of the deck.

"Square 'em up," he said. "And cut 'em."

I cut the deck.

"Cut 'em again. Give it a shuffle."

"Really?"

Turned nodded, and I shuffled the cards.

"Give it another cut, finish it, and hand me the deck."

I cut one last time and pushed the deck toward him. As he searched the table with his hands for the cards, I mentally reviewed what had just taken place. I'd dropped the ace into the deck, cut twice, shuffled, and cut one final time.

"You can't ask for any tougher sets of circumstance," he said, as if sensing my thoughts. "I'm just going to try cutting the card right out of the middle."

I hunched over and trained my eyes on his hands, close enough to smell the lanolin-and-mango lotion he applies three times daily to keep his skin moist and supple. With his fingers on the edges of the pack, Turner slowly cut the deck without lifting it off the table, and a lone card swiveled out from the center. There was no need to turn it over, but I did anyway.

"Oh, man!" I screamed, unable not to. "I don't even know where to begin with that."

Turner let out a big bowlegged laugh. Then he grew quiet. "I fooled Vernon with that one," he said, his cloudy blue eyes staring off into nothingness. "I fooled everybody across the world with it."

WHAT ABOUT THE REST OF US? Can anyone learn to see with his or her fingers? To a certain extent, we already do. Most of us just don't realize it. Experiments have found, for instance, that the brain's representation of nearby objects depends on their location with respect to the hand, and that amputation

of a hand distorts spatial perception, hindering one's ability to locate objects.

As with most skills, practice helps. In a recent experiment, neuroscientists at McMaster University set out to determine whether blind people have a keener sense of touch because they can't see or because they rely heavily on their fingers in their daily lives. The researchers measured tactile sensitivity in the fingers and lower lips of blind subjects and in normal-sighted adults. As it turned out, the blind had extrasensitive fingers, but their lips were no different from those of the nonblind. Not only that, but finger sensitivity was greatest among the most experienced Braille readers—and only in their reading fingers; sensitivity was average elsewhere on the hand. The scientists concluded that practice alone can supercharge one's sense of touch.

Besides learning Braille—which is extraordinarily difficult to do, especially as an adult—there are a number of more practical ways you can develop your tactile skills. You can practice identifying common objects by feel. You can teach yourself to navigate your home with your eyes closed. Children can be taught to hone their touch through tactile recreation—playing with textured objects, identifying raised letters and numbers by feel, running obstacle courses without looking. (This sort of play is an integral part of the Montessori method.) "Finger sensitivity is much like the sense of hearing," notes vision impairment expert Maureen Duffy. "Over time, you will gain awareness and learn to use your sense of touch to distinguish items and features of items."

In Turner's case, sheer obsession probably played as big a role as anything in the actualization of his talents. He started going blind relatively late in life, and it was a gradual process. At age fourteen he still had minimal peripheral vision, about

20/400, and for several years after that he could still tell the color of a card by holding it off to the side of his face.

But Turner's devotion to a pack of playing cards is without equal. When he's in the car or at the movies, he shuffles on a small felt-covered plastic support in his lap. He regularly falls asleep while shuffling and palming cards on his living room sofa. "Hell, I've done that once or twice," Jason England, one of Turner's close friends, told me. "Richard does it once a week." At the grocery store, he shuffles on the plastic ledge at the checkout counter. When he goes to church, he shuffles an inconspicuous blank deck (white on both sides), which his wife holds for him in her zippered Bible. On the rare occasion that she fails to bring them, he shuffles the donation envelopes. And if you take away his cards, he shuffles nothing—as if playing air guitar, except with an imaginary deck of cards instead of an imaginary axe.

Apparently one of the few times he will put down the cards is if he's doing karate. (A hardcore fitness buff, Turner, now fifty-eight, wears the same size pants he did in high school.) "But notice both things [cards and karate] involve his hands," England pointed out. "It's not that he can't put the cards down, it's that if he puts the cards down, something else has to come up. He just can't sit still and not do something with his hands." Turner, it seems, has been addicted to tactile sensation his entire life. Touch has become his primary connection to the world. "It's all he knows," England told me. "Seventeen hours a day since he was nine."

By his own estimates, Turner has logged more than 135,000 hours of practice—the equivalent of 24-hour days for 15 years. He's performed his signature second deal more than 5 million times in front of a live audience. (Imagine a basketball player shooting that many free throws.) "In practice, I stopped count-

ing at forty-three million. Now I just estimate that it's somewhere between fifty and sixty million. That's why nobody else has ever been able to do this. Who's gonna sit there and do it eighteen times in a row each day and then do that year after year?"

I sure wasn't. But after hanging out with Turner, I decided it might be a good idea to step back for a moment and focus on my hands. Next to the brain, the hand is the most important evolutionary adaptation in human history, our main interface with the world. Hands shape not only our environment but also the way we perceive it. Would we ever have adopted the decimal system, for instance, if we didn't have ten fingers? Unlikely. Most anthropologists think that the base ten numbering system, developed some five thousand years ago, caught on in large part because our ancestors counted on their fingers. Our hands, with their seventy-odd muscles and fifty-four bones (more than any other part of the body other than the spine), are astonishingly versatile. Concert pianists can strike the ivory at a hummingbird-like rate of twenty keystrokes per second. Experienced mountain climbers grip rock fissures with their fingertips, at pressures of eighty pounds per square inch. No other organ system performs such a wide range of functions. "It is in the human hand," wrote Charles Bell, the Scottish anatomist, "that we have the consummation of all perfection as an instrument."

Like pianists and competitive table tennis players, magicians live by their hands. (It's called sleight of *hand*, after all.) "You have to transform your hands, to break them in," wrote Arturo De Ascanio, the patriarch of Spanish close-up, "and that requires practice." Magic requires strong fingers, delicate motor skills, and ample flexibility in one's tendons. Not surprisingly, big hands tend to be an asset in most cases, although

there are exceptions. One notable exception is the fake deal (seconds, middles, bottoms), where long fingers can get in the way. To circumvent this problem, some early cheats would amputate the ends of their own fingers. As a result, one finds a number of "missing finger deals" in the literature.

I wasn't quite ready to cut off my fingers, but I did want to make them stronger and more dexterous. Some hand abilities are genetic. Only about 60 percent of people, for instance, can bend their little finger at the first joint without moving their ring finger. But mostly it's practice, so I began a daily exercise routine for my hands, called Finger Fitness, developed by a former musician from Cincinnati named Greg Irwin. Finger Fitness, as I learned from Irwin's training manuals, is like calisthenics for your hands. It consists of a series of movements—some of which, quite frankly, look hilarious—designed to isolate your hand muscles and increase strength, dexterity, finger independence, and overall range of motion.

It starts with stretches and warm-ups that look a bit like jumping jacks—you cross and uncross your fingers in alternating pairs. Then you steeple your palms prayer-style, but with your fingers splayed out, and fold down the index fingers of both hands so that your right finger is closest to you. After that, you switch the fingers so that your left first finger is now closest to you. You then repeat this motion with your middle finger, ring finger, and pinky. Once you've folded all four fingers, you reverse the motion and go the other way, back toward the index finger.

Eventually you do this with all your fingers, up and down the hands, in various patterns—two at a time, three at a time, every other finger. As you build up speed, it starts to look like your fingers are dancing a can-can. The Finger Fitness program also includes a series of taps and folds, bends and splits,

finger push-ups, finger shuffles, and variations on the *Star Trek* Vulcan V salute, all of which can be linked together into a total hand workout. Irwin has even choreographed the moves into a musical number he calls Finger Ballet, which he's performed on *The Tonight Show* and at the Magic Castle in Hollywood.

Even without the tiny tutus, Finger Fitness can help just about anyone who works with their hands. Typists type faster. Guitarists shred more like Slash. A number of surgeons have embraced the program. Pending the results of a controlled study on Irwin's exercise routines, Winston-Salem University may soon make Finger Fitness a standard part of their dental school, as many aspiring dentists lack the necessary fine motor skills.

Finger Fitness has also shown promise in helping those who suffer from repetitive strain injuries (RSI)—an umbrella term for symptoms of discomfort and disability caused by prolonged, repetitious use of the hands. RSIs account for roughly half of all workplace illness, costing U.S. businesses $20 billion annually, more than back injuries. Carpal tunnel syndrome, the most frequently diagnosed RSI, affects millions of Americans and has become the most commonly reported work-related medical problem in America. Operations to treat carpal tunnel syndrome are now among the most frequent surgical procedures, with some 260,000 operations performed each year.

But by far Irwin's most vocal enthusiasts are magicians. The first time I saw his finger routine was at a lecture by card pioneers Dan and Dave Buck, otherwise known as the Buck Twins, whose finger-blistering Extreme Card Manipulation (XCM) system puts incredible strain on the hands. Thanks in part to Irwin, finger manipulation has carved out its own little niche within the world of so-called Extreme Hand Sports—a subgenre of magic that includes XCM, pen spinning, cup

stacking, and ring manipulation, and which has its own conventions and online forums and championships.

In the end, Finger Fitness is designed to make your hands more efficient at learning new skills. "I look at finger fitness as like jumping jacks or sit-ups or push-ups," Irwin explained to me over the phone. "None of those is football, but it'll certainly help you play football better. And what's great about finger fitness is that you can incorporate it into your daily schedule." (When Irwin and I finally met, at the 2009 World Championships in Beijing, and we shook hands, he uncurled his digits one by one in a graceful, if somewhat creepy, finger flourish.)

In addition to doing Finger Fitness, I designed a workout to help me with palming. Take a coin, press it into the center of your palm, and hold it there by a slight contraction of the muscles at the base of the thumb (the thenar). This is the classic palm, the most important concealment in all of coin magic. (According to J. B. Bobo's *Modern Coin Magic*, the coin worker's Bible, "This is one of the most difficult of all concealments to master but one of magic's finest secrets. The layman cannot imagine it possible to conceal a coin this way.")

I'd palm coins in both my hands and squeeze them repeatedly: three sets of one hundred reps, every day. I'd whale on my thenars until they were bruised stiff, then practice rolling a coin through my fingers to loosen up the tendons and increase my agility—that, and it looked cool. (Turner, incidentally, holds the world record for coin rolls: eight coins at a time in one hand.) I practiced with rings. I worked on speed and evenness and tried to synchronize both hands in one unbroken ten-finger roll.

As time went by, I could feel the difference in my fingers. Little by little, my palm muscles grew larger. My hands began changing shape, adapting to their new abilities. (I was also bit-

ten by a radioactive spider around this time, but I don't think that had anything to do with it.) People complimented my increasingly confident handshake (then asked me to let go), and I felt like a stud flexing my pinky finger in front of the ladies.

I began noticing that I would pick up new moves more quickly, and that manual tasks unrelated to magic—like writing for long hours on the computer or playing stretchy chords on the guitar—became more manageable. I felt more in tune with my hands, more aware of the area surrounding them, what psychologists call the action space. As a result, I became less accident-prone (though I'm still a klutz) and more ambidextrous.

To further sharpen my sense of touch, I started blindfolding myself during practice sessions. Studies have found that visual deprivation causes almost immediate changes in the brain. In one study, blindfolded adults picked up tactile cues in their visual cortex after just five days. Another group of researchers has shown that people become more touch-sensitive after ninety minutes of sitting in a pitch-black room. Under the right conditions, anyone can learn to see with their fingers.

In fact, touch is a powerful and precise sensory tool. It's our first sense to develop—we enter the world through touch—and the cornerstone of the infant-parent relationship. The skin is the largest organ of the body, about the size of a twin mattress when spread out, comprising more than 15 percent of the body by weight. The tiny whorls and ridges that make up our fingerprints likely evolved for two reasons: to improve our grip and to aid in the perception of texture. ("Texture information plays a huge role in our ability to identify objects by touch," observes Sliman Bensmaia, a neuroscientist at the University of Chicago.) The density of nerve endings in the fingertips is higher than anywhere on the flesh, with the possible exception

of the male foreskin, and baseline laboratory measurements reveal that the average person can quickly and accurately identify hundreds of objects—the buttery leather of a broken-in baseball glove, the bristles of a toothbrush, the roughness of an emery board, the softness of a sweater—by feel alone.

Even more striking, touch can convey subtle nuances of meaning. In 2006, psychologists at the University of California, Berkeley, and DePauw University discovered that a five-second touch on the arm of a blindfolded stranger can signal highly specific emotions, including love, fear, anger, disgust, sympathy, and gratitude. Accuracy rates were comparable to and in some cases better than those seen in studies of facial expressions and verbal communication. The researchers concluded that "the tactile signaling system is just as differentiated, if not more so, than the face and voice."

In the complex grammar of touch, the meaning of an action depends on subtle variations in velocity, pressure, location, abruptness, and duration. When stroking someone's arm, for instance, a few extra seconds can turn a show of sympathy into a gesture of love, while a slight variation in pressure can mean the difference between anger and fear. Despite all this complexity, the language of touch is remarkably universal. Like magic, it transcends culture, age, and gender, and often bypasses the rational side of the brain.

Minor tactile cues can exert a measurable influence on our judgment, our perception of people and places, our decisions and social behaviors, even our willingness to part with cash. Waiters and waitresses who casually touch customers on the hand or shoulder for a second or even less at the end of a meal earn bigger tips and boost their restaurants' ratings, as measured by exit surveys. A friendly pat on the shoulder from a broker makes clients less risk-averse. The chance that a grocery

store shopper will agree to sample a new treat increases by 28 percent when the product demonstrator touches them lightly on the upper arm during the request. Shoppers who've been touched leave the store later, spend more, and rate the store more favorably on average. A slight, unobtrusive tap on the arm makes random strangers more willing to participate in mall intercept interviews and street surveys and predisposes them to bum you a smoke or comply with marketing requests. By promoting group cohesion, interpersonal touch also improves the performance of sports teams and enriches family life.

Even an act as simple as holding a warm drink can make a difference in how we perceive others. In a study at Yale, psychologists found that we tend to see strangers in a kinder light, and are more giving ourselves, when holding something warm. In an analogous vein, a study at the University of Toronto found that volunteers who were asked to recall a time in their lives when they'd experienced rejection felt five degrees colder than those who summoned memories of acceptance and approval.

Cognitive scientists think these results stem from the fact that rudimentary material concepts like warmth, hardness, heaviness, and roughness—which we learn during infancy, when touch is our primary scaffolding to the world—form the basis for abstract psychosocial concepts like *warmhearted, hard bargain, weighty matters,* and *rough times.* That the language of emotion, or feeling, is so often cast in tactile terms—"my hands are tied," "a touching story," "can't handle the truth," "between a rock and a hard place," "the gravity of a situation"—is also telling.

These figurative links are embedded in our brains at the cellular level. The fact that people conflate physical warmth (holding a hot cup of coffee) with interpersonal warmth (generosity and caring) aligns with recent studies implicat-

ing the insular cortex—a small chunk of gray matter in the midbrain—in the processing of both physical temperature and emotional warmth, especially trust and compassion. The same cluster of brain cells that springs to life when the sun warms your skin, in other words, also lights up when you feel affection toward a friend or loved one.

The picture that begins to emerge from this research is one of mind and body working in concert as an integrated system. This idea is central to an emerging field known as embodied cognition, which seeks to redefine the relationship between the body and the brain. Embodied cognition does away with the Cartesian view of a disembodied consciousness—the brain in a vat, so to speak—in favor of a model wherein abstract thoughts and physical sensations are inextricably linked.

Embodied cognition helps explain, for instance, why slouching tends to make you sad, or why people who reflect on their own misdeeds feel physically dirty. In the embodied viewpoint, your body actively shapes your mind-set. High-level concepts are grounded in the flesh. Feedback from our muscles helps us process information and regulate our emotions. Our hands, meanwhile, are intelligent devices, extensions of our consciousness.

After doing my exercises awhile, I could feel my own hands becoming more intelligent. I was able to detect the subtle ridged milling around the edges of coins and the wearing of the patina. I became more conscious of the edges of cards. I could sense the humidity in a deck from the way the cards bent. (Cards are like barometers, highly sensitive to weather conditions.) I could estimate the size of a block of cards to within three or four cards, just by feel. Eventually I got to the point where I could reliably cut the deck exactly in half most of the time—and I could tell if I was off by just one card.

Turner's tactile sensitivity was of course sharper than mine by several orders of magnitude, allowing him to cut straight to any card one-handed, but this minor breakthrough nonetheless helped me realize how little I had appreciated my sense of touch. In a world swamped by vision, touch is an undervalued commodity, a second-class sensation. But for Turner, it has brought the world to him. I recalled his parting words, when I asked him if he thought of his blindness as a gift. "You bet," he said, smiling. "The mind can adapt in so many ways. And the thing is, you can apply that to so many other areas. I think we totally discount the power of the mind."

THE HYPE

A wiry man in a tattered gray North Face coat and black skullcap worked the cards on a makeshift table made from cardboard boxes. His arms crisscrossed Charleston style as he mixed two black Bee-brand jokers and a red queen. "I'm gonna hide it—you try and find it. I'm gonna hide it—you try and find it." A cordon of onlookers—three men and two women of different ethnic backgrounds—were placing bets, clacking and hooting at the action, while a pair of lookout men stood at the flanks. The police had already shown up twice, momentarily dispersing the mob in what seemed like a well-choreographed dance. Minutes later they regrouped and fired up the game again. Someone was on the take.

It was a chilly March afternoon in New York, though about five degrees warmer in the crush of people trolling Canal Street, haggling over counterfeit bling, bootleg CDs,

contraband pashminas. A tiny, energetic Chinese woman screeched from the street corner, "Dee-vee-dee-dee-vee-dee-dee-vee-dee!" The sidewalk was littered with all manner of urban spoor: cigarette butts, ATM receipts, half-eaten sticks of street meat, cardboard boxes trampled flat. It was the boxes that had led me to them.

After my encounters with card mechanics like Richard Turner, and my own flirtation with cheating, I'd felt I was inching closer to the thin line that separates magic from crime. Finally I decided to take the plunge and investigate the shady realm where magic meets corruption, and where sleight of hand is employed for illegal ends.

I'd started coming to Canal Street a few months earlier on a tip from David Roth, the greatest living coin magician and a New York native. (Roth also mentioned that he had been the magic sales rep at FAO Schwarz from 1978 until 1988, meaning that in all likelihood he had sold my father the magic kit that started me down this path.) Ten years ago, said Roth, the home of the three-card monte—that classic unwinnable street scam involving three cards and giant cojones—was Times Square, a once-throbbing red-light district since bleached to a hazy shade of pink during Rudy Giuliani's quality-of-life crusade. For a time it seemed that the monte might disappear completely. But the hustlers merely resurfaced fifty blocks south, in what has proved to be a boon. Not even amid the neon prurience of the old Times Square was the monte man more in his element than in the cash-only fool's paradise that is Canal Street west of the Bowery. "Some of the best monte workers I've seen are in New York," Roth told me with a hint of pride in his voice. "They're very, *very* good."

My research had proved him right. By my estimates, a single monte mob can rake in up to $10,000 in cash over the

course of an afternoon. After casing Canal Street for several months, I'd decided it was time to make contact. I wanted to see if I could approach the monte guys and gain their trust as a fellow practitioner of magic. After all, didn't we speak a common language: the language of trickery? "You don't want to do that," Roth had told me over the phone. "That's very dangerous." Wes echoed this viewpoint when I mentioned it to him at the pizzeria. The monte mobs, he told me, were violent gang members who often did their postgraduate work in prison. It was no more a game to them than armed robbery or drug dealing. If they so much as suspected that I posed a danger to their operation, I was liable to be stabbed or even shot. But my mind was already made up.

I'd been watching the action for five minutes when a guy with Gotti hair and D&G shades and a girl under his arm bellied up to the game. The crowd quickly hemmed them in. A graying man with an unfiltered cigarette between his lips pulled up next to him. "I just won two hundred bucks," he said. "But he won't let me play no more." After a series of bets by some of the other players, the operator turned his head, and while he wasn't looking, one of the onlookers put a big fat bend in the corner of the red queen. A mistake? The money card would be easy to follow with that crimp in it. Any bet would be a lock. At least that's what it *looked* like.

"Two black and one red. Win on the red, only on the red, never the black." The operator slung the cards. "Just point and you win." The sucker pointed at the bent card, and the operator lifted his head. "You win—it's yours! You got the money? A hundred dollars?"

He spread open his wallet. "I only got twenty."

"You gotta have a hundred to play." He eyed the girl. "I bet she's got eighty."

The sucker squared his shoulders and stared at his girl-friend as if he were about to propose. "Baby, I fucking picked the red one. Give me some money!" Reluctantly, she took out her wallet and counted four twenties. He grabbed the bills and slammed the wad down on the box. In a blink, the card was turned over. Not a red queen but a black joker. His face went white. "Double or nothin'!" screamed the operator. "Double or nothin'!" The mark was put on the send to a nearby cash machine—the monte mob was conveniently stationed in front of a Citibank—and he came back minutes later, eager to redeem himself. I wanted to stop him, but I knew better. In less than a minute he was down by $500. "I'm gonna be sick," said the girl, putting her hands to her mouth. Flushed with rage, the mark made a grab for the money, but the wall men swiftly boxed him out. He shouldered up against them, heaving his chest, and for a moment it looked as if there might be violence. "Let's go, baby," his girlfriend said, pulling at his bicep. "Baby, let's go."

All of a sudden someone yelled, "Veeeee!"—for Vice—and the crowd dispersed. This was my chance, I thought. I trailed the operator and one of his accomplices, a husky Afri-can American man in work boots and jeans, down the street.

"Hey, man," I said, overtaking them. "You do magic?"

They turned and looked at me as if I were nuts. "What'd you say?"

"I'm a magician," I said and unholstered my cards.

"Oh, yeah?" The operator thumbed his nose and looked around. "Well, I'm a magician too." (I *knew* it!)

"I know, I've seen your work," I said, trying to act cool. "You're good."

My plan, as I'd formulated it in my head prior to chasing after him, was to see if I couldn't use magic to win his trust.

But when his partner crossed his arms and gave me a threatening look, I began to wonder if I hadn't made a terrible mistake.

"Um . . . name a card," I said squeakily, trying not to show fear.

"What?" he asked, looking at me askance.

"Name any card," I said again. "Out loud."

"You want me to say it out loud?"

I nodded as he looked at his partner, then back at me. "Queen of clubs," he said.

"Cool. Do you want me to do it fast or slow?"

"Better do it quick cuz I gotta go," he said, looking back toward the corner, where the crew had started to regroup.

"Fast it is." I waved my hand over the deck and executed a pass to bring the queen to the top, my heart racing. For a second I thought I'd messed up. I turned over the top card and—*phew*—there was the queen. The operator looked at me, then down at the cards, then back up at me again. The tension in his face faded, and he grinned, revealing a row of gold teeth.

"Damn! This boy's good!" He laughed and extended his hand.

I shook it and smiled. "I want to learn your game," I said, still clutching the deck in my left hand.

He tilted his head slightly and squinted. "You don't wanna learn this," he whispered, as he turned to leave. "Motherfucker go to *jail* for this shit."

I FIRST ENCOUNTERED THE THREE-CARD monte when I was eleven years old, while in Spain visiting relatives. I was walking down La Rambla, the tree-lined promenade in the heart of Barcelona, when I spotted a large group of people crowded around a clumsy-looking man in a faded blue suit. He had oily

hair and a thin moustache, and he was tossing cards on a flat-tened piece of cardboard. Everyone around him was cheering and waving money. They all seemed to be having a good time. I was drawn in quickly, and before long I found myself laying down my entire January allowance on what I thought was a queen. I was sure of it, in fact, because the corner of the card was clearly bent. Moments earlier, I'd seen one of the bystand-ers bend it.

In my mind I was already spending the winnings. I'd de-cided I was going to use the money to buy my mother a brace-let she wanted. I couldn't wait to tell my father, who was off buying newspapers at a nearby kiosk. He'd be so proud of me. Today was our lucky day.

When I turned the card over and saw it was a joker instead of the queen, my stomach lurched and everything around me seemed to fall silent. I looked up at the man behind the cards. His eyes were now cold and menacing, his teeth flashing in a sinister smile as he snatched up the cash. Blinking back tears, I staggered off without a word, terrified of the scolding I was sure to receive.

It was an expensive lesson, but if anything it only stoked my curiosity. To me, the monte man was an irresistible character, a timeless trickster who'd changed little since the days of gin mills and frontier train lots. He was a criminal, for sure, but also an excellent magician, using sleight of hand to steal money from his audience. And the greatest trick of all, the pièce de résistance, was that the audience never suspected he was a ma-gician.

The monte has been a fixture of New York City's crimi-nal underworld for well over a century. The *New York Times* first reported on the scam back in 1870, noting that Coney Island had been overrun with "glib-tongued" monte men who

conned greenhorns fresh off the steamboat landing. The article described in detail how one well-heeled visitor lost his watch to the game, and the author made the following observation, as valid today as it was then: "It is absolutely certain that anyone dealing with them will be gulled and cheated."

How is it, then, that nearly a century and a half later, in an age of identity theft and high-tech hoaxes, a scam like the three-card monte—one of the oldest tricks in the book—is still going strong? Clearly it isn't the moves themselves that make it so seductive, but the psychology of the scam, the uncanny way in which the con man jailbreaks our insecurities and flatters our intelligence, stokes our greed and clouds our judgment, inflates our trust while raising our expectations.

These talents, of course, are no more unique to Canal Street than they are to Wall Street. We see them on television, in shopping malls, and on used-car lots, in Washington and on the campaign trail; the same psychological sleights of hand—bait and switch, shortchange, pump and dump—used to artificially inflate stock prices, hide off-balance debt from shareholders, sell wars to Congress, and convince consumers that they need things like ThighMasters and Psychic Friends and that Cocoa Puffs really are part of a nutritious breakfast.

"Whatever we want," notes attorney Steve Weisman, "there's a scam for it." An expert on investment fraud and identity theft, Weisman has studied everything from bank robbers to Ponzi schemes to mortgage fraud. But whether it's shell games or shell companies, he tells me, almost every confidence scheme shares certain universal features. "The scam artist appeals to the desire for a quick and easy solution to life's problems. They appeal to our greed and sometimes they exploit that little kernel of dishonesty everyone has. And when people get greedy, they get manipulated."

The monte and its sister the shell game are often cited as generic metaphors for every brand of hustle. But the monte is more than a metaphor; it's a model, a recipe for persuading people to entertain risky or even ethically dubious propositions, whether it be the Nigerian bank scam—which, along with its variants, costs Americans more than $200 million a year—or Bernie Madoff's $65 billion Ponzi scheme. "The person on the street doing the three-card monte is doing things differently than Bernie Madoff, but it's the same psychology," says Weisman. "Madoff was able to use the same principles magicians use. He misdirected people. He forced their choices. When people go to a magic show, they want to be fooled. With a Ponzi scheme, when something is too good to be true, they want to believe it." Understand the monte, in other words, and you'll understand not just a great magic trick, but also the basic architecture of every hustle.

THE THREE-CARD MONTE PROBABLY ARRIVED in Europe by way of gypsies, who fanned out west from the Balkans across the Continent during the fourteenth century, their bindles loaded with clever little takedown games that yielded a profit in the chaos of medieval streets and marketplaces—hence the word *gyp*. By the seventeenth century, the monte had taken root across most of Western Europe. One finds references to the classic street scam in the Spanish literature of that era and in French works going back to Louis XV. By the mid-1800s the scam had become enough of a nuisance in Paris to incur a citywide ban. Jean-Eugène Robert-Houdin, the father of modern magic, in his 1861 treatise on con games, *Les Tricheries des Grecs Dévoilées*—in typical French fashion, he blamed the Greeks—provided a detailed account of the monte, which he

saw being dealt directly on the cobblestone streets, and of con men who hooked suckers by "playing the peasant"—that is, feigning ineptitude. Now as then, this little gambit is the heart of the hustle.

But the three-card monte truly came of age in America—so fully, in fact, and with such gusto, that it practically deserves U.S. citizenship. No Old World scam ever rivaled the exploits of the great American bunko artists, in whose hands the three-card monte and the shells became the foundations of the first great criminal empires, forerunners of the modern Mafia. As icons go, the monte deserves a place alongside baseball, apple pie, McDonald's, Elvis, nickel-plated handguns, and crack cocaine. America will forever be the scam's spiritual home. This scam is your scam. This scam is my scam. This scam was made for you and me.

The monte first appeared on American soil in New Orleans during the early 1830s and soon found its way north, aboard the steamboats paddling up the Mississippi. (The word *monte* comes from a popular Mexican card game, *el Monte*, and was used to make the scam sound more legit.) It was a time of big scores. In the early 1850s, a four-man monte mob cleared what today would be $25 million on a three-year stint aboard the riverboats. The leader of the group, a glandular giant named George Devol, who got his start fleecing soldiers during the Mexican-American War, raked in twice that much during his career, though he squandered it all and died penniless. One of Devol's protégés, an African American steward named Pinckney Pinchback, used his prodigious monte war chest to bankroll a political career that eventually landed him a seat in the U.S. Senate, although he wasn't allowed to sit in it because of his race.

When the steamboat racket dried up during the Civil War,

monte men rode the rails out west, spreading the scam along the American frontier. By the mid- to late-1800s, mining camps from Colorado to Alaska were overrun with monte mobs, gambling supply companies were selling ready-made monte kits to aspiring crooks, and Pinkerton agents were being stationed on train cars to protect the passengers from men with names such as Rattlesnake Jack McGee, Slim-Jim Foster, Louis Posey Jeffers, Clubfoot Hall, Jew Mose, Doc Baggs, Dad Ryan, Cowboy Tripp, and my personal favorite, Big Alexander.

Then there was the pitiless Benjamin Marks, a former Civil War courier who, in 1867, at age nineteen, hiked from Iowa to Wyoming dealing monte on a wooden plank slung from his neck. An ancestor of the modern mob boss, Marks built a small empire out of con games and shady business deals. He erected his infamous Elks Grove casino and brothel, remnants of which are still standing, on the county line, so that dodging police raids was a simple matter of moving to a room in another jurisdiction.

But Marks's greatest legacy was an idea that would revolutionize con games and forever change the face of price point retail. The concept sprang to his mind in 1870, after he arrived in Cheyenne with dreams of a big score only to find the outdoor gambling tents overcrowded with rival grifters. Marks needed a better way to trap his victims, so he leased a small storefront and filled the window with luxury goods priced at preposterous discounts. He called it The Dollar Store. Once inside, bargain hunters were quickly shepherded away from the window and steered toward the back of the room, where a game of three-card monte was being dealt on the face of a wooden barrel. "Since no customer ever left the monte game with any money," notes one historian, "none of the merchandise was ever sold."

Marks's flagship venture was a huge success, and it spawned a raft of imitators. Dollar stores began cropping up all around the country. Eventually someone figured out that they could make just as much money selling junk as they could illegally scamming their customers, so they went legit.

Marks's dollar shop was also a crude prototype for the sophisticated "big store" scams that flourished during the early twentieth century: the suite of offices with the fake safe, the fly-by-night investment house, the sham betting parlor. In these elaborate long cons—memorialized in such films as *The Sting, Grifters, The Spanish Prisoner*, and *Boiler Room*—a sucker's better judgment is beguiled away by fancy set pieces and a cast of well-trained shills. Though less common than in the past, these types of hustles are still being run today.

I HAVE HEARD IT SAID that there are only four things you need to fear in California—earth, air, fire, and water. The day I found myself driving north on 101 bound for the Magic Castle in Hollywood, it was fire—and, to a lesser extent, air—that was wreaking havoc on the West Coast. Governor Schwarzenegger, the voice on the radio told me, had declared a state of emergency in Los Angeles, Santa Barbara, and Orange counties as a scourge of wildfires, fanned by the dry Santa Ana winds, lashed across Southern California, charring thousands of acres of land and engulfing hundreds of homes. It was the worst fire to hit LA since 1970.

At the rental lot, I'd found my car peppered with ash, and for a moment I thought someone had been puffing a cigar on the roof. (The Governator himself, perhaps?) But it was nature flouting the smoking ban and using the City of Angels as an ashtray, pelting soot and smoldering embers down into the LA

basin and shawling the wide lap of the valley in a doom-gray smog. A shrill carbon stink clung to the air like a bad habit.

If anything, I'd come to LA to learn how *not* to get burned. After watching the New York monte men run their rough hustle on crowded sidewalks, I was convinced that anyone could fall victim to the scam. These guys weren't pulling in chump change either. They were making lawyers' fees—and lying half as much.

I'd made some headway studying the Canal Street mobs and practicing on my own, but I needed to go deeper. I wanted to understand the scam at its core. How does the con man control your thinking? How does he hook your interest? How does one master these powerful tactics of social influence and develop a feel for the hustle? And, most important, how could I use these principles to improve my magic?

I'd decided it probably wasn't such a good idea to keep hanging around the monte men on Canal Street, so instead I'd signed up for a class on street scams, three thousand miles from my home, at the Magic Castle in Los Angeles. It met every Monday for four consecutive weeks, and this was my third trip out west this month. The class was run by a group of magicians and former con artists who called themselves the School for Scoundrels—by all accounts the world's leading experts on the short con.

The school's motto: Inspiring Confidence Worldwide.

BUILT FROM THE RUINS OF an old Victorian mansion, the Magic Castle looks exactly like what you would expect a magic castle to look like. Spooky, strange, cartoonishly gothic, it looms above the hillside, a stark outcropping of turrets and crenellation, ornately trimmed gables, steep roof pitches with

zinc cresting and wraparound balconies. A driveway lined with cypress snakes up the hill, bringing you to a pair of mahogany doors set beneath glass-and-iron friezework.

Dimly lit by torchères scavenged from old MGM sets, the Castle's interior is a cabinet of curios, a pastiche so dense it spills over into burlesque. *Harry Potter*-esque paintings follow your footsteps with their eyes. The furniture seems to shuffle around and reposition itself of its own volition. Barstools change size while you're sitting in them. Near the main salon bar, a piano-playing ghost named Irma serenades guests—and even takes requests. The rooms are dark, decorated with stained glass from fallen churches and doors from dead mansions.

When you first step into the Castle's red-flocked antechamber, it looks like a dead end—until someone stands before a gilded owl and says, "Open sesame," which cracks open a secret passageway hidden behind a wall of bookcases. The owl's eyes blink red, heralding your entry. The Castle also has its own hotel, but it's a bit pricey, so I was staying at a cheaper place down the street.

The first time I'd ever been to the Castle was with my father, some twenty years ago, and to this day it's one of my fondest memories. Returning after all these years sent pulses of excitement jolting across my every synapse. The goose bumps on my arms had goose bumps on their arms.

The scams workshop was being held at the far back of the Castle, next to the library, in an area called the Inner Circle. The course was being taught under the auspices of the Castle's Magic University, and the irony that in taking it I would be missing my classes at Columbia University did not escape me.

This sector of the Castle also contained a ballroom, reserved for special events; a bar once featured in the film *Hello, Dolly!*; and a trove of memorabilia. A framed advertisement for

the early-twentieth-century American stage illusionist Charles Carter, aka "Carter the Great," graced the entryway. Next to it hung a poster of the turbaned mentalist Alexander, a vaudeville star who performed under the stage name The Man Who Knows. There was a lifelike model of a Harry Kellar levitation in a glass display case, a black box with a Pepper's Ghost—one of the first optical illusions—and a rare portrait of close-up legend Charlie Miller, modern master of the cup and balls, on the western wall.

There were ten students in all. The classroom, with its track lighting and plastic deck chairs and individual folding tables, had a distinct adult-education vibe. Everyone except Whit Haydn, our teacher, looked as if they'd come directly from work. I was sitting next to a middle-aged man who was wearing a tie with gold coins on it, and a husband and wife from Temecula who were taking the class as a team. Couples who scam together stay together, I guess.

Whit "Pop" Haydn, the handsome, silver-tongued rogue who runs the School for Scoundrels, wore a black knee-length frontier wool frock coat, broad in the shoulders and tapered at the waist, over a gunmetal gray brocade waistcoat with pearl buttons, a scarlet silk cravat tied in a four-in-hand knot, and a black derby. Everything about him was round: his face, his eyes, his torso. His straw-colored hair was slicked back over his perfectly round head. Golden double Albert watch chains, centered by an oval stone, hung over the convex curve of his belly. Even his voice was round, slow and smooth with southern ease. Listening to him talk was like drinking sweet tea from a Mason jar, or watching pie cool on a windowsill. Calm and comforting, it lulled you into complacency.

The only straight lines on him were the vertical strands of his moustache, orderly as a column of soldiers or crop rows,

the ends waxed so sharp they could pop a balloon. I imagined him grooming them with a comb of whalebone or jade. On his right hand was a heavy gold ring engraved with a question mark. "It stands for the dilemma of magic," he told me when I asked him about it later. "In magic, you're never supposed to know the answer. It should always be a question."

Cons and questions have long been Haydn's specialty. He shuffled shells on the streets of New York before becoming a full-fledged magician—an honest cheat, as he likes to say. Haydn founded the School for Scoundrels in 1996, together with magician and champion pool player Chef Anton, and the two of them would be our teachers tonight. Other faculty members included Bob Sheets—the porkpied man I'd seen demo'ing a shell game at the Magic Olympics—and British busker Gazzo, formerly a member of the notorious Cracker Parker monte mob in London, which worked the con from the early 1950s to the late '70s. Before a stroke partially disabled his left hand, Gazzo was one of the top card men in the world.

Looking out at the audience, Haydn pulled a gold fob watch from his vest pocket and checked the hour: 7:30 p.m. Time to start. He cleared his throat. "How do we develop our grift sense?" he began, face ruddy, eyes asquint—"grift sense" being the con man's knack for getting inside people's heads. This, of course, was the million-dollar question. And the answer, according to Whit, was to study the classics.

There are three classic street scams: the fast-and-loose, the three-card monte, and the shell game. The fast-and-loose is a primitive hustle that dates back to the Middle Ages and survives only in print. (Shakespeare makes several references to it.) We'd covered it during the first scams class and were now knee deep into the monte.

Whit and Chef passed out cards and coached us one-on-one as we went through the moves. We learned the proper way to mix the cards and how to switch the queen for a joker. We practiced secretly unbending the corner of a card while bending the corner of another. We learned how to make a queen and a joker look like two jokers. We learned the three different types of monte bends—the one I'd seen on Canal Street, Whit told me, was called the snake bend. Whit taught us how to cover the bad viewing angles—the worst being directly to your left, at around nine o'clock. We learned Gazzo's famous Charleston maneuver, a fake switch designed to lure in the mark. We learned different tosses, throwing patterns, and switches. Special attention was given to Dai Vernon's Optical Move and John Scarne's devious Monte Slide.

With our teachers looking on and offering suggestions, we practiced switching out cards in the act of turning them face up. Though it may sound counterintuitive, this sort of move isn't used to switch the money card for a loser if the sucker guesses right. That's too chancy when cash is at stake. Instead, Whit explained, it's used to make you think you were right when, in actuality, you guessed wrong. Say the mark gets cold feet just before laying down a large wager. The con man doesn't want him thinking he would've lost, so he switches the joker for the queen. The classic bit of gab here is "You had the eyes, my friend, but not the heart."

"When you're developing a magic trick," Chef explained, "to make the trick really powerful, to really kick someone's butt, you have to understand what they're thinking each and every step of the way. And then you have to be able to make sure they're going down the path that you want them to go down, that takes them off a cliff. And that's what a good con man does. This is true in every magic trick. If you want to hold

people's attention, you let them think they know something. You let them have a hint, so they think they're following you. Now they want to prove that they've got it. They're hooked for the next time."

In essence, the monte is something more than a con. It's a form of theater. There's a large cast, and everyone plays a role. The performance is blocked and scripted, precisely choreographed, a well-orchestrated act. The actors have to draw in a crowd, seize their attention, and keep them watching. And it must be seamless enough that the sucker doesn't realize it's a performance—or that he's the hapless star. "The practitioners of these ancient swindles have much to teach us," Whit said. "Our study of street swindling can lead us into a better understanding of what we are trying to accomplish as magicians and how best to go about it."

A typical monte operation requires a mob of about eight co-conspirators, each playing an assigned role: an operator, or broadtosser,* who deals the cards and executes the sleights; a pair of beefy lookout men at the wings, keeping an eye out for cops; and four or five confederates, called shills—preferably of mixed ethnicity and gender—who reel in and embroil the victims. Sometimes there's also a smoother, who sooths the sting after you lose. The mobs I'd seen on Canal Street ran it by the book, with each person playing his or her part to the note.

As a potential sucker draws near, the mob sizes him up to see if he looks like someone with cash. If so, they'll clear a path and let him approach the game. Then they'll close in around him like an amoeba swallowing its prey. Once the sucker is

*Monte operators are called broadtossers not, as is sometimes claimed, because they frequently use queens as money cards, but because of their preference for broad-faced poker decks over narrower bridge cards, the wider cards affording better overall handling.

isolated from the herd, the mob begins to run a series of well-rehearsed plays, like a football team. Each play builds up the sucker's confidence and chips away at his scruples, setting him up for the final takedown.

Before each round of betting, the operator shows all three cards and throws them facedown in a row on the table, with the money card (usually a queen) in the middle. The other two cards will be a pair of jokers or low-number cards. After the cards are on the table, the operator mixes them, often very quickly, as though trying to confuse you. In reality, he makes sure it's easy to follow the queen. The mix only looks like sleight of hand. The real sleight—the one that actually fools you—is an invisible switch executed while tossing the cards on the table. This deadly move, called the hype, is reserved for the moment when the sucker is willing to hazard a large chunk of change.

To further lower your guard, the operator will typically feign incompetence. Often he'll pretend to be half-blind or drunk or stoned or just plain stupid. Like the bird that feigns injury to lure predators away from its nestlings, the con man snares his victims by playing the fool. The broadtosser for London's Cracker Parker mob wore thick glasses and a hearing aid. On Canal Street, the operator's ragged clothing and chaotic movements give him an air of drunken recklessness.

To set the game a-rollin', one of the shills will bet and win, while another will lose, apparently fooled by the mix. The sucker, for his part, has no trouble following the action. One of the shills may now turn to the mark and say something like "They won't let me play anymore, because I was winning." Then he'll hold out some cash and ask the mark to bet for him. If he agrees, the operator will let him win. Now he's felt the money in his hands and the thrill of victory. His greed starts to simmer.

At this point the operator feigns a slip-up. Maybe he'll drop the cards or look away for whatever reason, and while he's distracted one of the shills will lift up the cards and show everyone the queen. The cheating shill bets and wins. He'll try cheating a second time, but now the operator spots him. Rather than call him out on it, though, he waits until the cheater is distracted and swaps the queen for another card. Everyone sees this except the cheater, who can't believe it when he loses. All of this is an act, of course.

The biggest myth about the three-card monte is that it works because the sucker doesn't realize it's a scam. In fact, the monte depends on the sucker realizing it's a scam—and then wanting in on it. The con man flatters the sucker's intelligence, encouraging him in his conviction that the game is rigged. Convinced he sees all the angles, the sucker thinks he can beat the hustler at his own game. As a wise old grifter once said, "Gyps and cons are all cases of the biter being bitten."

Another common misconception about the monte is that the operator will let you win once or twice to butter you up for a big take. This almost never happens. If you happen to lay a wager on the queen, a shill will quickly swoop in with more money and outbet you. "I take the highest bet," the operator will say as the shill claims the payout. Or perhaps the shill will *lose*. Either way, it bolsters your confidence and raises the stakes. Oftentimes, as one shill outbets you, your friend—the one you bet for earlier—will come in closer and whisper some wisdom in your ear. "Those two are in on it," he'll say. "Every time you win, he comes in and shuts you out." The good-con-man/bad-con-man routine is a common scam strategy. In a popular jewelry heist, for example, a fake cop will pretend to bust the thief and confiscate the merchandise as evidence.

To seal the deal, the operator will usually throw out a veiled insult, known as an ego hook, in order to rile up the mark and make him feel like he's got something to prove. "When I did the shell game on the streets in New York back in '68," Whit told us while elaborating on the finer points of ego hooks, "my southern accent seemed to really piss them off. 'You know what, I already took you for forty bucks. Why don't you just sit back and watch for a while, get a better handle on the game, let me play with these Puerto Rican boys.' Oh God, they'd get so mad." He slammed an invisible wad of money on the table and howled. ("You gotta have a hundred to play," the Canal Street operator had told his bridge-and-tunnel target, before looking at the girlfriend and adding, "I bet she's got eighty." Oooh *zing*.)

This same sort of technique is frequently used in marketing and sales. When car dealers chide potential clients for consulting with their spouses before signing a purchase agreement—"You need to ask your *wife* for permission?"—they are employing an ego hook. In the monte, it's no different. The con man arouses the sucker's anger and invokes his insecurities while offering an easy way to mollify both. Meanwhile, money is flying around in sweeps of green, inflaming the sucker's avarice. He's up against the ropes. It's time for the final takedown.

Still playing the fool, the broadtosser turns his head once more and one of his shills—most likely your "friend"—picks up the queen and bends the corner. (In thieves' cant, this is called a lug.) He turns to you and winks. *Now we've got him.* The broadtosser wheels back around, failing to notice the obvious bend. He tosses the cards like before—only this time he pulls a switch, bending the corner of another card and unbending the queen in an invisible instant. This move is imperceptible even to the trained eye, so the operator signals the location

of the queen to his accomplices by means of a secret code, like a catcher signaling the pitcher. If the ace is on the right, he might say, "You can't get paid off if you been laid off." If it's in the middle: "I'm gonna hide it, you try and find it." And if it's on the left: "I don't get mad when I lose." All of these are stock phrases you will hear on Canal Street.

The hardest thing for the sucker to do at this point is not bet. "He's convinced that he got it right," Chef explained. Usually he can't get his money out fast enough. He thinks he's got the edge. His juices are flowing. He's found a sure thing—a phrase that, incidentally, arose with street hustlers.

He puts his finger on the bent card and hands over the cash—it's a $100 minimum bet in New York, but I've seen people shell out as much as $500. This is the only time the operator will let him touch the cards. "Turn it over yourself," he says, stepping back from the game so no one suspects a last-minute switch. The sucker turns it over, but to his dismay, he finds a joker smiling up at him, scorning his lack of judgment.

Who's the fool now?

Upon seeing the card, he usually yowls like someone who's just been kicked in the gut. Chef calls this the bent corner moment. "Of all the things in three-card monte," he said, "the bent corner will give you the ultimate joy." Reality starts to penetrate as the money vanishes into the hands of the operator. The sucker's whole world is collapsing. But before he has time to reconstruct the chain of events that led him to this calamity, someone yells out, "Cops!" and the crowd evaporates like a puff of smoke. *Poof*, gone.

What recourse does the victim have at this point? The law, unfortunately, won't offer much in the way of justice. The flat-foots in the bunko squad know the sucker got burned trying to outgamble someone he thought was half-blind or smashed or

stupid. "Cops don't really have any sympathy for the victims," Whit explained. "They know as well as anybody that the victim was trying to take unfair advantage of the other guy."

About the only time the police will take action is if nearby merchants—a dollar store, say—complain that the monte mobs are crowding the sidewalk or robbing them of potential customers. Just to make sure the sucker doesn't go to the police, a friendly smoother will usually come around and pat the victim on the shoulder. "Oh man," he'll say. "They got you, too? It's gambling, you know. Can't tell the cops." This is known as cooling out the mark.

The poor sap has no one to blame but himself, and more often than not he knows it. I've seen suckers curse and cry and even laugh, but violence is rare. (If a hey rube does develop, in come the burly lookouts.) Most of the time the sucker walks off in a daze. All the fight goes out of him the moment he sees that joker smiling up at him.

The whole scam, from zero to payday, takes less than ten minutes. The mob waits for the heat to die down, and then regroups. In one afternoon, a lone crew can swindle dozens of victims, with two or three crews usually working a block. Though it may look like an anachronism, the monte mob is an efficient small business. Some ringleaders even offer their employees free transportation to and from work.

Don't get me wrong. I'm not trying to romanticize street crime or elegize con artists as noble thieves. These are conniving and often ruthless people. But there's a reason why, as scam expert Steve Weisman likes to point out, con artists are the only criminals we refer to as *artists*. It's one thing to steal a wallet at gunpoint or snatch a purse. It's quite another to convince a person to empty his wallet and walk away without pressing charges. This takes a considerably lighter touch.

* * *

AFTER THE MONTE CLASS LET out, I elected (with nary a pang of guilt) to go to Las Vegas for a few days and see some magic. Driving east through the desert, I couldn't get scams out of my head. Everywhere I looked, I saw rip-offs. Why do car rental agencies urge you to buy optional insurance when in most cases your own insurance, or credit card, covers any damage? Why does jock itch cream cost more than athlete's foot medication, even though they're the same thing? Is it because companies know they can charge a premium for a more embarrassing product? Why do Americans spend $8 billion each year on bottled water, when the two top-selling brands (Aquafina and Dasani) come from municipal sources? Why do so many investors buy mutual funds when most funds underperform the markets they're supposed to one-up? (There are more funds than stocks. Think about that for a moment.)

Cruising down Interstate 15, I came upon a sign that read SPEED LIMIT 70 MPH ENFORCED BY AIRCRAFT and wondered if that, too, was a scam. What were they going to do, shoot a missile at my car if I was speeding? I felt bad for those poor suckers who joined the navy with visions of piloting F-14s off aircraft carriers, only to wind up on traffic detail in the middle of the desert. *Sorry, son, but the highway to the danger zone is* literally *a highway, and the danger zone is actually a reduced-speed zone.* The recruiting ads were wise to leave out that part.

It dawned on me that one often encounters these types of signs along desolate or shoulderless stretches of road where squad cars have no place to hide. Could it be that law enforcement agencies were using warning signs as scarecrows, posting them in lieu of patrolling black spots, hyping high-tech en-

forcement in areas where they couldn't snare you? Was it all a big highway bluff?

Local law enforcement agencies are strongly incentivized to dole out as many tickets as possible, much in the way that credit card companies routinely solicit clients with a history of late payments who will likely shell out an arm and a leg in interest. (I know: I'm one of them.) Traffic tickets are big business, generating much-needed state and municipal income. In the United States, more than 55 million traffic violations are issued annually, accounting for roughly 50 percent of all state court cases. By one estimate, speeding tickets bring in more than $6 billion a year.

It's no secret that law enforcement agencies alter their policing practices in response to financial pressures and incentives. Research shows that cops issue more moving violations in years following a drop in local government revenue. When asked in 2010 why his officers were writing more than three times as many tickets as they did the previous year, the police chief of Canton, Ohio—the speed trap capital of America, and host of the yearly International Battle of Magicians—answered with a candor that might once have created a scandal but is now welcomed for its refreshing lack of guile. "You could say that it was born out of the deteriorating economy," he told reporters. "We were facing layoffs, and we were trying to think outside the box. I'll be very blunt about that: It does save jobs. It was kind of a no-brainer." And yet, while a slump in local government revenue leads to a ticketing spree, a rise in road casualties does not. (This trend isn't limited to traffic tickets, either. The proportion of drug busts among total arrests increases by 20 percent when the agencies making the arrests are allowed to keep whatever assets they seize—be it cars, money, or weapons.)

Only 3 percent of traffic tickets are contested in court, even though there's a 75 percent chance that the ticketing officer won't show at the trial, in which case the scales of justice will likely tip in your favor. (If they radar you from an airplane, the cop *and* the pilot must appear in court.) Still, fighting a ticket is a headache. If you live far from the jurisdiction in which the citation was issued, it may not be feasible at all. Unfortunately, paying the fine is a legal admission of guilt and will jack up your premiums. No one loves speeding tickets more than insurance companies. On average, a single citation will drive up your premiums by $900 over the course of three years. According to one estimate, auto insurers accrue an extra $37 billion annually from speeding tickets. No wonder Geico used to donate radar guns to police departments.

The all-time award for highway robbery goes to a tiny speck of dust on the map called New Rome, Ohio, population sixty, the most infamous speed trap in America, king of the small-town traffic scam. By exploiting a precipitous and well-concealed drop in the speed limit from forty-five to thirty-five miles per hour along the thousand-foot stretch of its main road, New Rome's fourteen-man police force wrote thousands of citations each year, raking in $400,000 annually in fines, most of which was siphoned back to the village lawmen. For years this fast-cash bonanza worked like gangbusters, swelling local coffers and enriching the town's tiny police force. So epic were the city's exploits that they made national news. But all empires must run their course, and in the end New Rome crumbled beneath the weight of its imperial ambitions. In 2004, citing rampant corruption, a local judge legally dissolved the town, swatting it off the map with a swoop of his gavel. *Poof*, gone.

But the spirit of New Rome lives on in the Great Republic. After the crash of '08, facing stalled revenues and spurred on

by a bad case of fiscal road rage, major jurisdictions across the country are taking a page from the small-town playbook in hopes that fines and court fees will jump-start the rusted engine of economic prosperity. On the brink of insolvency, California, already the fourth most radar-happy state, has stamped a thirty-nine-dollar surcharge on all traffic tickets in order to fund the renovation of forty-one courthouses. Facing budget shortfalls, Arizona added speed cameras on highways to generate a projected $90 million. (They were later turned off amid thunderous public outcry.) And in 2009, cash-strapped Colorado doubled fines for speeding in work zones in the hope of raising an extra $3 million per quarter.

WHILE IN VEGAS, I TOOK in nine magic shows and, on the final night, went to an event called Wonderground, a monthly spectacle of magic, music, and performance art, now in its tenth year, emceed by kimono'd Man of a Thousand Masks and founder of the Mystery School, Jeff McBride.

I walked in at around midnight. Onstage, the celebrated fakir Zamora was about to show a roomful of wide-eyed faces how he came to be known as The Torture King. Thin, muscular, shirtless, and sweating, he brandished a long metal skewer. "What I'm about to show you may be too intense for some," he said as he swung back his gray ponytail, flexed his left bicep, and jammed the spike through the meat of his arm. High-pitched screams and low intestinal groans drowned out the DJ's trance mix as Zamora pushed the metal deep into the muscle, feeding it into his flesh until it poked through to the other side. He grabbed both ends and pulled the skewer back and forth like dental floss. "Oh get the fuck out of here!" yelled a man in the third row, and I'm pretty sure he meant it. A vanguard

of the modern sideshow revival, Zamora ate fire, slept on beds of knives, walked on broken glass. He'd once put 106 pins in his body. "I could have done twice as many," he said. "But the cameraman fainted."

After Zamora's act, the lights dimmed and the music turned tribal—a squall of ocarina over water drums. The chairs were cleared away, and Jeff McBride, in chieftain's robes, took the floor. Standing at the center of the room, McBride lit a small goblet of fire on a circular table draped with red cloth. "What we're doing here is very ancient and very tribal," he said loftily, eyes aflicker. "Some of us have been doing this for thousands and thousands of years, so welcome to this fellowship." No rings, though.

Electronic bass kicked in, and it was party time. Everyone clapped in unison. Psychedelic films were projected on a large screen. A pointillism of lights danced on the ceiling. People wore capes and powdered makeup, black boots and PVC. A lachrymose woman with dreadlocks was selling art at a small stand. A hippie with a long rattail was doing coin tricks at a nearby table. I saw a gangly man in a loose gray suit and wide-brimmed hat who looked like William S. Burroughs circa *Naked Lunch*. There was a drunken midget. A whiff of stage smoke brought sandalwood attars drifting over the fainter smell of incense. Bumping into Jeff McBride on the dance floor, I asked him why New York, with its twin magic fraternities, never hosted such parties. "They're old and boring," he said, twirling his cane, and flitted off with a smile.

STILL SPINNING FROM MY TRIP to Las Vegas—*Fear and Loathing* it wasn't, but it was still pretty weird—I sped back to LA for the final day of the scams class. Our last lesson was on the shell

game, an old con that challenges the sucker to locate a pea-size ball beneath one of three shells. Like the monte, this game can be found all over the world. On the street, you'll often see it played with bottle caps or matchboxes and balled-up wads of paper or foil from a pack of cigarettes.

The shell game is essentially the con man's version of the cups and balls—the oldest recorded magic trick, dating back to Roman conjurors known as *acetabularii* (literally, "cuppers")— but it's a no-frills version with one aim in mind: to get the poke. Like the monte, the shell game was spread by gypsy mountebanks across medieval Europe. It, too, became pervasive during the Renaissance, when grifters started using thimbles and dried peas, instead of the heavier cups and balls, making the scam more portable. "The advantage of this is you didn't have to carry those heavy props around with you," Whit explained. "You didn't have to set up in the marketplace. You could just walk into the local tavern." Thimbleriggers were ever present in England throughout the 1700s, and Robert-Houdin, in his 1861 book *Card-Sharpers*, gives an account of seeing a magician fleece an entire French tavern with three soup bowls and a crust of bread. (Robert-Houdin affectionately called these sorts of cons "little feats of crafty science.")

Many of the great American bunko artists got their start shuffling shells. During the California gold rush, a vicious man named Lucky Bill Thornton made millions skinning prospectors with three brass cups shaped like walnuts and a small cork ball he manipulated with his long fingernails. Thornton rode across the scuffed frontier in a wagon train with a tray suspended from his shoulders and a pair of thirteen-year-old girls he'd kidnapped along the way. When the girls' father finally caught up with them and threatened to kill Thornton, the two sisters, having apparently fallen under the con man's

spell, pleaded for their assailant's life. The father, himself a man of some cunning, offered to spare Thornton on the condition that he wed one of the girls. Forced to choose between death and matrimony, Lucky Bill took to his heels, trailing dust in his wake. But his luck eventually ran out and in 1858 he was hanged as a murderer and a horse thief.

Along with the monte, shell game operations financed the earliest American crime syndicates, engines of corruption that laid waste to entire cities. The greatest operator of them all was Soapy Smith, a one-time cattle drover and marksman who learned the shell game at age twenty from a sideshow roustabout named Clubfoot Hall (after Clubfoot took him for a month's wages). Smith parlayed small-time hustles like the shells into a criminal empire that stretched from Denver to Alaska and employed hundreds of trained grifters. Smith was the richest and most feared outlaw of his day.

To modern magicians like Whit Haydn, Soapy Smith stands out as the finest con artist ever to trim suckers with a "tripe and keister" (a portable tripod and display case used by traveling grifters). "He was the true master of the game," Haydn told us. "He had a lot of gangs out doing the same thing, taking people for just a little bit of money at a time, not for the big stings. And that was what created the first American gangster."

Every year, on July 8, Soapy Smith's great-grandson, a longtime friend of the School for Scoundrels, hauls his great-grandfather's tombstone to the Magic Castle for the annual Soapy Smith Party, a ye olde casino night where winners get a free set of sterling silver shells. A portrait of Soapy Smith—dark beard, gray suit, Winchester rifle—painted in 1898, shortly before he was gunned down in broad daylight by a victim of the monte, hangs outside the door to the Magic Castle's classroom,

where today, his disciples were about to show us the real work on the shell game.

"Everybody knows the secret of this trick," Whit said, rolling his eyes. "That's what makes them such suckers." He took a sip of wine—he always had a glass of white handy—and removed his coat, revealing French cuffs with opal-and-gold links and a paisley arm garter that matched his vest. He produced a small deerskin sack, laid it on the table, and withdrew a set of shiny silver shells. "I've been playing this game a long time," he said. A tight-lipped grin lifted the tips of his moustache. "I had my nuts cast in silver." He clinked two of the shells together and they chimed brightly. *Diiiiing!*

In essence, the psychology of the shell game is identical to that of the monte—with the same cast of shills and the same crooked come-ons—except that instead of the hype and the lug, the operator "accidentally" flashes the pea under one shell and surreptitiously steals it out at the critical moment when the sucker is willing to lay down a lot of coin. Just like the monte, it only looks like betting. In reality: you can't win.

When I was a child, around ten, I had a set of shells, and I used to do a very basic version of the game for friends and family. I knew one move, which was how to palm out the pea and load it under a different shell. (It fooled my dad, at least.) Since then, I've seen it played on the street many times. But I'd never seen anything like what Whit showed us. After he'd fooled us all several times, he put the pea underneath a shell and covered it with an overturned shot glass. Then he had the woman from Temecula place her finger on the glass. I waited for the move, some sleight or feint—but nothing came. Whit never went near the glass. And yet, when it was lifted, the pea was gone. "Don't feel bad," Whit said with a smile. "Everybody falls for that one."

An hour into the class, Chef walked in sporting a new haircut and distributed shells to all the students. The sets we used had been specially crafted by the School for Scoundrels, with the discriminating con man in mind. They were easy to grip, with sharp handling, plush suspension, and a full gloss undercoating. The pea slid in and out silently without rocking the shell back and forth, thanks to a ground-hugging curve on the rear lower fascia called a Chanin dip—like a spoiler or diffuser trim. Whit had rooted through an entire bushel of walnuts before finding the perfect shell from which to cast his mold. Though originally designed for magicians, the School for Scoundrels shell sets—which come in plastic, pewter, bronze, and executive-class sterling silver—have been spotted in the hands of actual street hustlers halfway across the globe. To Whit, this was the ultimate testimonial.

We started practicing the basic moves, while Chef walked around giving us tips.

"Don't put your finger over the shell," he told the class as we slid our shells around like bumper cars. "Try to get in the habit of holding it off-center, at two o'clock, so you show as much of the shell as possible."

We learned how to steal and load on the same move, how to turn over the shells and show both hands empty while secretly holding the pea. We learned Soapy Smith–inspired methods using multiple peas. Though it may sound counterintuitive, this tactic is actually quite deadly, because it allows you to split a person's attention. "Soapy Smith would bring out three shells and a pea and he would secretly have another pea hidden in his hand," Whit explained.

We learned how to flash the pea under one shell, show the other two shells empty, and then secretly drop the extra pea under one of the empty shells, a move called the Sheets

acquitment—after Bob Sheets. "This is a very insidious idea," Whit chuckled. "Magicians fall for this."

We learned hooks and come-ons, and then we learned about magnetic shells and peas with little iron filings in them and other gimmicks like hollowed-out poker chips and hollow pens and magnetic cigars for hiding extra peas, and by the end of the workshop I felt like an expert. I was ready to bid farewell to Squaresville and spend the rest of my life on the grift. I bought a set of plastic shells from Chef. He was the businessman to Whit's gentleman scholar. No matter what, I thought, I'll never starve.

The following day, I lit out for Malibu to see the antiquities at the Getty Villa museum. After a walk through the peristyle and a long soul-searching stare at the ocean from the balcony, I found myself in a gallery that housed a number of ancient cups and ceremonial vessels. I wondered if some of these cups had been used by the *acetabularii* of old, outside the great walls of the Colosseum or in the clamor of the Forum.

Afterward, I drove to the shore and walked along the beach. It was just after 5:00 p.m., and the late sun shone with the grainy light of old photographs. I stooped by the edge of the water and watched the light dance on the surface of the waves. A spur of rocks trailed off in the distance. A few gulls tacked downwind.

For a long while now I'd felt like I was edging away from the real world and toward the margins of society. Not long ago I'd been gainfully employed, tethered to a straight job and my own little quadrant of office space. Then came the looser, more polyrhythmic life of a grad student. But even that seemed structured compared with where I was now, skipping classes at Columbia, commuting for the past month between Vegas and New York, living on what seemed like the periphery of adult life.

I was still receiving e-mails about grad student mixers and meet-the-speakers and particle fests and particle seminars and messages from the nanotechnology lab I'd quit working in so I could devote more time to magic. I was still trying to keep a foot in that world—showing up for the occasional class when I could fit it into my ever-busier schedule as a budding magician, cramming madly for the qualifying exams—even though that world had never seemed more distant. I hadn't seen my physics buddies in eons. We used to hang out almost every day. It was a weird feeling, and the farther I traveled down this road, the weirder it got and the less likely it seemed I'd ever return.

Chapter Six

BREAKING THE CODE

After I returned to New York, it occurred to me that being a magician is a bit like working for the CIA, in that you're not supposed to tell anyone what it is that you do. Here I was eagerly stockpiling secrets and tricks that I could use to amaze people, but if I were to breathe a word about the secrets themselves to anyone outside a close-knit network of hidden assemblies and solemn compacts, I'd be ostracized, condemned as a traitor for breaking the magician's code.

And yet, there's something about this rule that seems at odds with the modern world. We live in an age of openness and oversharing, Wikipedia and Google, Facebook, YouTube, and the talk show tell-all. The lines separating public and private domains have long since evaporated. The curative power of baring your soul has meanwhile become the cornerstone of modern psychoanalysis, the legacy of Freud and Jung. The no-

tion that letting it all out leads to resolution and prevents secrets from going postal on your psyche has been embraced by mainstream psychologists and New Age belief systems alike. Secrecy, we're told, is the enemy of inner peace. Talk it out. Join a group. Free your mind. (Still, nearly half of all patients lie to their therapists.) But does any of this have its roots in empirical research?

As it turns out, science has a lot to tell us about secrecy. For one, as University of Texas at Austin psychologist James Pennebaker has observed, secrecy is hard work. Holding on to a secret in an interview sets off the same physiological cues that ping a polygraph—accelerated heart rate, increased sweating—which suggests that, as with other forms of deception, deliberately concealing information is stressful. Experimenters have also found that after keeping something secret, people tend to show signs of physical exhaustion, and that hiding a secret word hinders a person's ability to name the color in which it's printed. Secrecy is taxing, in other words; it takes psychic effort. Like any mental challenge, it's an active process. Secrecy is a performance.

Conversely, unburdening yourself of a secret turns out to be something of a de-stressor. People with skeleton-free closets get sick less often and are more content on average than those who keep things bottled up, a finding that, in general, holds up even after controlling for factors such as past traumas and levels of social support. One study reported that gay men who hide their sexual orientation have an unusually high incidence of cancer and infectious diseases, and when researchers at UCLA tracked a cohort of HIV-positive gay men over a nine-year period, they found that the disease progressed more slowly among men who were open about their sexuality compared with those who were in the closet. Even just writing about a secret trauma on a scrap

of paper and burning it has been found to reap some physical and psychological rewards.

Imaging studies hint at the neural correlates of catharsis. Immediately after a person divulges a secret grief, EEG readings record increased firing rates between the neurons of the right and left cerebral hemispheres. Translation: the mind is suppler, like the body after yoga. Confession isn't just good for the soul. It's good for your brain as well.

In romantic relationships, secrecy is an aphrodisiac, enhancing desire much in the way that parental prohibitions lend enchantment to a forbidden love—the so-called Romeo and Juliet effect. In one experiment, Wegner found that pairs of strangers sitting at a crowded table who brushed ankles in secret became more attracted to one another than those who brushed ankles openly or not at all. (A cautious type, Wegner had his secret footsiers leave the lab through separate doors—you know, just in case.)

The magnetic nature of secrecy has been invoked to explain the astonishingly high levels of infidelity among married couples. Why does cheating occur in more than a third of all marriages? Perhaps the covert nature of an extramarital affair, the plotting and intrigue, artificially enhances arousal, sustaining a dalliance that might wither in the harsh light of day. Secrecy has aftereffects, too. People are more likely to think about an old flame if the relationship was secret at the time. (When it comes to cheating, whether in the bedroom or at the card table, it's never just about sex *or* money.)

Keeping a magic trick secret clearly isn't the same thing as hiding a childhood trauma or an extramarital affair. Nonetheless, the double-edged nature of secrecy goes a long way toward explaining what makes magic, and the people who practice it, so unusual.

Many professions have trade secrets, but in most, secrecy is not the defining characteristic of that profession. Few crafts so fiercely demarcate the line between the artist and the audience as magic does. Musicians don't worry about people learning their songs, or their techniques. Writers don't worry that readers will question the omniscient point of view. (Indeed, many of them have sought to undermine it in much of postmodern fiction.) The film industry knows its viewers can be trusted not to read—or, for the most part, write—movie spoilers. And nobody complains about behind-the-scenes footage ruining films. Magic stands alone in demanding blanket ignorance from its audience. This is different from the willing suspension of disbelief that one brings to fiction. Magic is inseparable from deception.

In magic, secret knowledge endows you with control over people's perceptions of reality and, in turn, power over their thoughts. It can also be a tool for controlling how people perceive *you*. Through secrecy, you can fashion a new identity, one that is more interesting than your own. Secrecy allows you to become a different person. But the reliance on secrets comes at a cost, because it tends to set up an adversarial relationship between the magician and the audience. Performing magic puts you in the awkward position of having to deceive the very people whose approval you seek to win. "The secret puts a barrier between men," wrote sociologist Georg Simmel, "but, at the same time, it creates the tempting challenge to break through it, by gossip or confession—and this challenge accompanies its psychology like a constant overtone." Magicians court the spotlight while living in constant fear of exposure. They regard magic tricks as being like quantum states—destroyed by the very act of examining them up close. Magicians trumpet the secrecy of their art, almost daring the viewer to lift the veil, and yet they are furious when someone actually does.

I learned this the hard way, after publishing an article on the Magic Olympics in *Harper's* magazine. It was a gearhead piece, written in the style of a sports commentary, with play-by-play action—rather like some of the descriptions I've provided in this book—and a few exposures along the way. If you truly want to understand magic, I reasoned, it helps to familiarize yourself with some of the methods behind it. Can you fully appreciate a baseball game, for instance, if you don't know the difference between a curveball and a slider? Or what it means to hit a homer with the bases loaded in the bottom of the ninth?

When Frank Zappa disbanded The Mothers, he said it was because he got tired of fans clapping for the wrong reasons. I often think about this at magic shows, where you can sometimes tell the magicians from the laypeople based solely on when they clap. Laypeople applaud the effects, while magicians clap during the seemingly uneventful moments, when the secret moves occur. To the untrained eye, it's as if the magicians are clapping at nothing.

The elegant Spanish conjuror and member of the Madrid School Rafael Benatar, a true magician's magician, has taken this idea to its logical extreme with a card routine in which nothing magical happens. In fact, it's made up of a series of demanding sleights that perfectly cancel each other out—he'll do, for instance, a double lift (to show the second card from the top as though it were the top card) followed by a second deal (to deal down the second card while pretending to deal off the top). The second deal thus nullifies the double lift. Magicians go wild every time he performs it.

Magic has come a long way from rabbits in hats and ladies in halves. Yet most people have no clue how much skill and creativity and hard work goes into it, because magic is all about

art concealing art. (As François de La Rochefoucauld said, "It is a great ability to be able to conceal one's ability.") As a result, magic exists in a kind of vacuum. My goal in writing the *Harper's* article was to pump some life into this vacuum, and I figured magicians on the whole would be pleased.

I couldn't have been more wrong.

As soon as the piece came out, *Harper's* was bombarded with complaints from angry magicians frothing about the code of secrecy and the oath I'd signed when I joined the Society of American Magicians. (It's true: I had signed an oath.) I was skewered in the magic press, flamed in online magic forums and e-zines and blogs. "He's just another nitwit who'll be shortly forgotten," sneered the editor of *Genii* magazine, one of the top trade journals. "We'll all still be here." The magic quarterly *Antinomy* ran a hit piece about me in which the author, a magician from Michigan, implied that I was a drug addict. (Totally not true—I can quit anytime.) And this was only the beginning.

Things came to a head at a Friday night SAM workshop manned by the usual quota of dusty diehards and salty old sourdoughs. As soon as I walked in, eye daggers were thrown my way and tense murmurs eddied around the room. Ken Schwabe, former president of the local parent assembly and current chairman of the lecture committee, pulled aside the leader of the workshop, a gray-haired man named George, and the two of them shuffled to the back of the room. I could see them peering over at me from time to time as they whispered in each other's ears. George approached me a few minutes later. "Are you writing this up for publication?" he asked. I shook my head. Another compeer protested my presence. Grudgingly, they let it pass. But the fat was in the flames.

Then came the letter.

It was the end of October, in the middle of National Magic

Week, the week of Houdini's death. (It used to be National Magic Day, but I guess they decided one day wasn't enough.) It arrived by certified mail and was printed on heavy, important-looking stock. Initially I thought they might be offering me an award, recognizing me for my service to the magical arts. But when I read the letter, standing by a wall of P.O. boxes, my heart sank.

Dear Mr. Stone,

I have received several complaints from members of the Society of American Magicians concerning the article which you wrote and was subsequently published in the July 2008 issue of *Harper's* magazine.

In this article you blatantly exposed the secret, not only of your own act, but the acts of several other magicians as well. By doing so, you have acted in opposition to the SAM's Code of Ethics and Oath and are subject to disciplinary action under our By-Laws, Article XI, Section I.

We hereby ask for your resignation from the Society of American Magicians or we will begin disciplinary action seeking your expulsion from the Society.

We request your reply no later than November 15th 2008, or we will begin official action.

Marc DeSouza
Chairman—Ethics Committee
The Society of American Magicians

I could feel the blood draining from my face as I finished the letter. At that moment you could have knocked me over with a feather, or a very light magic wand. I stood there in shock, trembling, my heart filled with panic. I felt as if I'd been punched in the face. Were they serious? Was this some kind of joke? Was I really being expelled?

The fact that it took place during National Magic Week was especially harsh, like being dumped on Valentine's Day. I'd always known secrecy was important to magicians, but I had no idea just how serious the issue was until now.

I've made a huge mistake.

As the days passed and I recovered my presence of mind, the sting of rejection gradually subsided, and in its place indignation welled up like a volcano. I'd been a loyal, dues-paying member for over three years. I regularly attended meetings and ceremonies and was an active participant at lectures and workshops. I dutifully carried my laminated SAM membership card in my wallet next to my driver's license and student ID. Many fellow SAM members were friends of mine, people I hung out with on a regular basis. Imagine my horror, then, at finding out that these very same individuals now wanted me excommunicated. How dare they!

I decided I wasn't going to go down without a fight. But first, I needed to know my rights. I combed through every syllable of the SAM's lengthy constitution and bylaws in search of some loophole or legal hook on which to mount a defense. This took a while. Once I'd familiarized myself with the nuances of magic law, I contacted a lawyer, who helped me formalize my intent by drafting the following letter, dated November 13, 2008.

Dear Mr. DeSouza:

Pursuant to your letter of October 24, 2008, please note that I respectfully decline to tender my resignation to the Society of American Magicians. The facts as they stand do not warrant my expulsion.

Please note further that pursuant to Article XI, Section 4 of the General Bylaws of the Society of American Magicians, I hereby request a formal hearing to provide me an opportunity to rebut the charges levied against me, at which hearing, pursuant to Article XI, Section 4c(6), I am privileged to be present.

I further reserve all rights which may be afforded to me by said bylaws, and note in closing my disappointment that the board has decided upon this course of action.

Please reply with a hearing date by December 24, 2008. If I do not hear from you, I shall consider this matter closed.

Very truly yours,
Alexander R. Stone
Parent Assembly Number 1

My fingers trembled and my heart pounded out the *Law & Order* theme song—*Dun Dun. Da-da-da-da-DUUUUM*—as I gave the letter to the postal worker, who stamped it certified and handed me a confirmation slip. There was no turning back now. I'd crossed the Maginot Line.

This was war.

• • •

I WASN'T THE FIRST PERSON to have run afoul of the Exposure Police, and I comforted myself with the knowledge that I was in good company. In the twilight of his career, the Vaudeville-era great David Devant was exiled from London's Magic Circle, a club he'd cofounded, after he published *Our Magic*, a mainstream book about his own material, now considered to be a landmark text. (Today, the highest honor in British magic is the David Devant award.) The Magic Circle—whose motto is *Indocilis Privata Loqui* (literally, "Not Prone to Divulge Secrets")—is notoriously doctrinaire. Even Prince Charles was required to pass an initiation exam before he became a member. In 2003 the Magic Circle expelled a crop of affiliates involved with a BBC special called *The Secrets of Magic*. Among those forced to resign was Magic Olympian Etienne Pradier, who took third place at the 2003 Games in The Hague.

No one is immune. When a museum in Appleton, Wisconsin, opened a show that included an interactive exhibit on the Metamorphosis, a famous illusion in which Houdini would magically switch places with his assistant after being locked inside a trunk, the curator was inundated with angry protests, and Sidney Radner, the magician and retired rug salesman who had leased the museum his collection of Houdini artifacts, eventually withdrew his patronage. The exhibit closed, and the collection was sold off at auction.

The mother of all exposures was perpetrated by the notorious Masked Magician, who first appeared on Fox in the late nineties with a prime-time series called *Breaking the Magician's Code: Magic's Biggest Secrets Finally Revealed*, a show that has now run for over a decade. The first installment drew a record-breaking twenty-four million viewers—beating out the World

Series as the highest-rated event in the network's history. It spawned imitations in Asia and Latin America and live arena shows across the country.

Magicians reacted as though it were the End of Days. They filed lawsuits, held vigils, penned high-toned remonstrances in newspapers and magazines, quoted Edmund Burke on evil. A coalition formed, frantically urging viewers to tune out, talk to their kids, and boycott the show's corporate sponsors (Taco Bell, Circuit City, Pizza Hut, Miracle-Gro, Disney Video, Motel 6, Church's Chicken, McDonald's, Home Depot, and Jack in the Box).

One magician likened the fight against exposure to the civil rights movement and compared the SAM's inaction to Neville Chamberlain's appeasement of Hitler. A member of the board of directors at the Magic Castle in Hollywood drew an analogy between the Masked Magician special and the iceberg that took down the *Titanic.* "This time, the situation is serious," wrote a respected columnist in *Genii* magazine, echoing the consensus. "It's like destroying Santa Claus or the Easter Bunny," fumed Jonathan Pendragon of the acclaimed Pendragon duo. "These people are trying to kill us," brayed another.

The Masked Magician, whose real name is Val Valentino, received death threats and was blackballed from the magic community. Demands for his scalp reverberated throughout the blogosphere. He was eternally banned from the Magic Castle by diktat of the board of trustees. And in September 2010, Criss Angel—who, incidentally, has exposed a few tricks on his prime-time special—booted Valentino from a premiere party at the Luxor in Vegas for the sixth season of Angel's show, *Mindfreak.* Quoth Angel: "Get that piece of shit out of here."

Time and again, when it comes to the question of exposure, reactionary voices have dominated the discourse. But is

all this hand-wringing justified? Does exposure truly pose an existential threat to magic? Are secrets really the sole source of the magician's power?

WHEN YOU PURCHASE A TRICK, you're typically paying for the secret. With the exception of large-scale illusions, the props are incidental. What you're buying is a piece of intellectual property. But magic secrets are an unusual form of intellectual property, one that isn't protected by conventional legal safeguards. You can't copyright a magic trick, and patenting the method behind an effect automatically makes it part of the public record. John Nevil Maskelyne learned this the hard way when, in 1875, he patented his celebrated Psycho, a robot that played cards and did math. Soon after, a journalist dug up the patent and published the method in *Macmillan's Magazine*. Maskelyne, his secret now on newsstands everywhere, was outraged. Similarly, in 1933, the R. J. Reynolds Tobacco Company exposed Horace Goldin's Sawing a Woman in Half in an ad for Camel cigarettes. The ad was part of an aggressive marketing campaign—with full-color promotions in more than a thousand newspapers—that tipped the methods behind thirty-nine classic tricks. What, if anything, this had to do with cigarettes was never explained. "It's fun to be fooled," ran the slogan; "it's more fun to know." Goldin took R. J. Reynolds to court, charging them with unfair competition, but the judge tossed the suit, citing a patent Goldin had filed in 1923. A number of similar cases have failed after it was revealed that the plaintiff's trick was already in print. Not surprisingly, very few effects are patented.

Magicians occupy a phantom zone in intellectual property law, one they share with fashion designers and chefs. (You can't

copyright shoes,* for example, or recipes.) But that doesn't stop them from invoking their own unofficial laws. In the absence of legal protection, the world of magic is governed by a set of professional norms, as with the medieval guilds.

In addition to enforcing the secrecy rule, the magic community routinely sanctions those who pirate other people's work. In a world without the protection of trademarks, attribution becomes paramount. Proper credit is the coin of the realm. This is why, in print and at magic lectures and on DVDs, tricks are meticulously footnoted. Every move has a history behind it and a surname attached to it: Vernon lift, Hofzinser cull, Tenkai palm, Bobo switch, Ramsay subtlety, L'Homme Masqué load, Ascanio spread, Chariler cut, Elmsley count, Green angle separation, Tamariz perpendicular control. The history and bloodline of moves are in turn vigorously claimed and fiercely debated. (It was this kind of debate that led to the fistfight between Wes James and Doug Edwards.)

Magic is a science of ideas, and some of the most respected magicians never perform. Much like physicists, who generally fall into one of two categories—theorists and experimentalists— magicians are usually either inventors or performers. There are those who do both, but by and large the big names—Angel, Copperfield, Blaine—farm out their R&D. The inventors never become household names, but they are highly esteemed within the guild. Few laypeople have heard of Jim Steinmeyer, for instance, the genius behind many of David Copperfield's most celebrated illusions, or Paul Harris, the man who taught

*Though some have tried. In April 2011, French footwear designer Christian Louboutin sued rival Yves Saint Laurent for issuing a red-soled shoe, claiming that red soles were his trademark. A federal court dismissed the case. "Awarding one participant in the designer shoe market a monopoly on the color red," wrote the judge, "would impermissibly hinder competition among other participants."

David Blaine much of what he knows. But among magicians these guys are gods.

Anyone found in breach of the plagiarism rule faces punishment by a brand of collective action. A few years back, a company in England called Illusions Plus started copying another magician's material. Legally there was nothing the injured party could do. But the guild banded together and came to his aid. Magic journals stopped printing the company's ads, and working pros boycotted its products. Soon enough, Illusions Plus went the way of Lehman Brothers.

A code of ethics, enshrined in the statutes of the societies, undergirds the discipline. All the major magical orders require neophytes to swear an oath of secrecy and agree to the code. If this sounds a bit like the Masons, it's no coincidence. There's a long-standing connection between magic and the old fraternal orders. No fewer than nineteen of the past presidents of the IBM and the SAM were Masons, and every year the Masons hold secret closed-door meetings, known as the Invisible Lodge, at the national SAM and IBM conventions. I know this because I've tried to infiltrate the Invisible Lodge on several occasions, and each time I was rebuffed by a white-haired man wearing the emblem of the Scottish Rite (a double-headed eagle).

The party line, magic's central dogma, is that any form of exposure—even of one's own material—undermines the art. Exposure is seen as a form of vandalism. It deadens the mystery and tarnishes the brand, shrinking all the grandeur in magic to the scale of an intellectual puzzle. Spectators lose interest, and magicians lose their jobs. If a little knowledge is a dangerous thing, a lot of knowledge is a death sentence.

In reality, the facts are more complicated. During the golden age of stage magic, in the late nineteenth and early twentieth

centuries, magicians routinely exposed one another's tricks as they jockeyed for top billing. A big name like Maskelyne would debut an illusion only to have his rivals publish a pamphlet on the method the following month. As a result, magicians were constantly inventing new tricks to stay ahead of the curve. I don't think it's any coincidence that the golden age of stage magic was also the golden age of exposures, because exposure drives innovation. Much in the way that market-oriented competition among businesses fosters economic growth by forcing companies to evolve, exposure compels magicians to modernize their acts and invent new material. Secrecy, meanwhile, is a license to be lazy. Like monopolies in the marketplace, it breeds stagnation.

There are more books on magic than there are about any other branch of entertainment—be it movies, theater, or dance—and yet, in a way, every magic book constitutes an act of treason, antithetical to the secrecy pledge. (Not surprisingly, many of the books in the magic canon were initially condemned as breaches of faith.) If exposure is so harmful, why isn't magic dead? And by publishing your material, don't you renounce all claims to secrecy?

Magicians sell their secrets. They put out lecture notes and DVDs. They open magic stores. They sell their products online, often on the same websites where they advertise their shows. And yet these same magicians are outraged when their secrets are leaked in a forum not intended solely for members of the guild. To me this is a bit like locking the windows on a house with no door. If I'd published my article in *Magic* magazine or *Genii*, no one would have batted an eye. The scandal came about because I wrote the article for *Harper's*, a mainstream magazine for laypeople.

Not long ago, a friend of mine was over at my apartment,

and she noticed an issue of *Genii* sitting on my coffee table. Leafing through it, she asked, "Can anyone subscribe? What's to stop people from learning the secrets?" It was an understandable reaction. The way many magicians talk, you'd think they carried their secrets around in briefcases handcuffed to their wrists. Magic journals may not be on newsstands, but they're available by mail or online, and in theory, anyone can subscribe. In practice, though, it's a self-selecting audience. Only magic geeks subscribe to magic magazines. I myself subscribe to five— six, if you count the one in Spanish.

In truth, attempts to demystify magic only tend to heighten people's curiosity. Practically every classic trick has been exposed at one time or another. For better or for worse, magicians still saw women in half, even though Goldin's method has been public for some time. Anyone can learn how most levitations work, but try finding a Vegas magic show that doesn't feature some type of floating effect. I've been asked countless times if I know how David Copperfield made the Statue of Liberty disappear, the biggest illusion in history, even though the secret is a mouse click away. Charles Hoffman's "Think-a-Drink," which was first exposed more than fifty years ago, is now the signature trick of New York society conjuror Steve Cohen, who banks $1 million a year doing private gigs and a weekly show at the Waldorf=Astoria.

There's an unwritten rule in magic that you're never supposed to repeat an effect for the same audience. But in practice people can be deceived again and again by the same effect, even after it's been exposed. In the early eighties, when a rogue prestidigitator went on British television and exposed a simple thumb tip vanish to prime-time audiences, magicians everywhere began tilting at the nearest windmill. But the next day, veteran TV entertainer Paul Daniels went on the same show

and did the same vanish with a minor variation in handling, and it fooled everyone. (Paul Daniels is such a legend in the UK that if you address a letter to "Paul Daniels the Magician, England," it will reach him.)

Clever magicians have always known how to dodge exposure, or even use it to their advantage. The innovative duo Penn and Teller will often reveal the secret to a trick and then fry the audience with the same effect done a different way. At one show, they taught the audience three different card sleights during the first act—you could just hear the old guard gasping in horror—and then had virtuoso close-up magician Jamy Ian Swiss mill about the crowd at intermission performing card tricks using only those three sleights. Not one person caught on.

Penn and Teller also do a version of the cups and balls using clear cups—and it still fools you. Not only that, but Teller has found that even after watching this effect, people are still fooled by the classic opaque version. This illustrates a general principle: magic tricks can fool you even after you know the secret, because they exploit perceptual mechanisms that are etched into our brains. Clearly there's more to magic than not knowing.

The ancien régime wigged out when Penn and Teller hit the scene in the early 1980s. "Penn and Teller take the mystery out of magic," seethed David Berglas, president of the Magic Circle. "We'd rather keep our secrets and not have them exposed." But to the young duo, playing to an audience's intelligence—while still fooling them—was a way of elevating the art. After my article appeared, I spoke to Teller about my scrape with the SAM. "If magicians are pissed at you you're doing something right," he said. "It means you're on the side of the public." He told me that magicians gave him hell when he and Penn first started out, and concluded, "It's a tempest in a teapot." The

brilliant New York City magician Simon Lovell, who has a long-running Saturday night show in SoHo, sang a similar, if bluer, tune. "Oh, fuck them," he said, when I told him I was being kicked out of the SAM. "Their average age is dead."

In the aftermath of the Masked Magician, rumors of the death of magic turned out to be greatly exaggerated. Attendance at the Magic Castle remained as high as ever. Criss Angel managed to score a ten-year, $100 million contract at the Luxor, even though several of his tricks had been leaked. David Copperfield maintained his perch atop the Vegas hierarchy, despite being outed on at least three illusions. In my own neck of the woods, demand for local magicians had only gone up. "I got more work after that," Asi Wind, a brilliant New York performer, told me. Like most members of the younger generation, he was unfazed. "You think you can explain my magic in a thirty-minute show?" Then he laughed.

When *Breaking the Magician's Code* first aired, there were no prime-time magic shows. Today there are several. One of them, *Masters of Illusion*, airs back-to-back with *Breaking the Magician's Code*, something that has left many magicians scratching their heads. Wouldn't the two shows mutually annihilate each other, like matter and antimatter? Isn't the network shooting itself in the foot? The fact that they coexist strongly suggests that they share an audience. Clearly, in the eyes of most viewers, the two shows complement each other.

The main problem with the militant antiexposure stance is that it sells magic short. It portrays magic as a stagnant enterprise with a handful of secrets that might easily be exhausted. In reality, the field of magic is rapidly evolving. Each week, there are new moves, new palms, new sleights. Even people who devote all their time to magic can't keep up. Methods have become so advanced that one needs years of experience and

an extensive back catalog of technical know-how just to hang. Perhaps there was a time when you could learn all there was to know about magic, but that day passed at least a century ago. Eventually you realize that there's no danger of overfishing the sea of tricks; there are enough secrets to last a million years. We'll run out of melodies before we run out of magic. Even if you could somehow learn everything today, tomorrow you'd be out of date. And if magicians are constantly fooling one another with new ideas, what hope does the layperson have?

Take the Ambitious Card, for instance, the famous trick that fooled Houdini. It's one of magic's oldest and most popular effects. The classic method has been written about and exposed countless times. And yet experts still fool each other with it, in part because every magician makes it his own. (Shawn Farquhar, the Canadian I followed at the Magic Olympics in Stockholm, would go on to win the Grand Prix in close-up at the 2009 World Championships in Beijing with his trademark Ambitious Card routine.) Like any great trick, the Ambitious Card provides an almost limitless canvas on which magicians can vaunt their creativity. The same goes for the linking rings, the cups and balls, the Metamorphosis—all the classics.

Masked Magician hysteria also fails to give the audience enough credit. It infantilizes the spectators by implying that they can't be trusted not to step on their own fun, arrogating to the performer the power to decide what's in an audience's best interest. The "loose lips sink tricks" credo suggests that there is only one way to enjoy magic: through the eyes of Peter Pan. But why does everyone have to see magic the same way?

Once again Penn and Teller cut to the chase, this time with a routine in which the audience members get to decide for themselves whether to learn the secret or keep the trick a mystery. (Those who don't want to know the secret are given

blindfolds.) By inviting the audience to exercise agency over their own experience, this routine challenges the accepted notion that magic can only be enjoyed from behind a veil of ignorance.

When I hear Jeremiahs like Berglas fulminating against exposure in a way that suggests to magicians and laypeople alike that magic stopped evolving a hundred years ago, I think of Max Planck, who was told by a college professor that he should leave physics because all the important discoveries had already been made. "Physics is finished," Planck's professor scoffed. "It's a dead end street." Good thing Planck didn't listen, because twenty years later he helped discover quantum mechanics, the greatest revolution in physics since Newton.

Physics is dead. Long live physics.

Magic is a science as well as an art, and in science, knowledge serves only to deepen the mystery. Each new find opens vistas on an uncharted territory at the edge of human understanding. Nestled within each answer lies another riddle in an endless web of unknowns. "The vastness of the heavens stretches my imagination—stuck on this carousel my little eye can catch one-million-year-old light. A vast pattern—of which I am a part . . . what is the pattern, or the meaning, or the why? It does not do harm to the mystery to know a little about it." This from physicist Richard Feynman, and it seems to me that it applies as much to magic as it does to physics.

Magic is dead. Long live magic.

I HALF EXPECTED THE NEXT letter to arrive by homing pigeon or Hedwig the Owl. I waited for it with bated breath, on pins and needles and even a few steak knives. In the meantime, I began readying my defense. I'd decided I was going to make

it a test case, a referendum on secrecy. I'd probably lose, but who knew? Maybe I'd manage to sway some liberal activist judge toward my rejectionist view of the magician's code. I had visions of the Scopes trial. I fantasized about retaining Alan Dershowitz to represent me. I was preparing an amicus brief even though I had no idea what an amicus brief was. I had selected a philosopher friend as my co-counsel, along with a human rights lawyer from D.C. whom I'd met at a Halloween party. (I was Anton Chigurh, the killer in *No Country for Old Men*, and she was Vincent van Gogh's *Starry Night*.) Court drawings would show my legal team—which I'd determined would include at least one clown—badgering the "ethics chairman" and those immaterial witnesses who'd lodged complaints against me wilting under the cross.

But it never happened.

December 24 came and went without incident. No letter. No owls. Nothing. The Society had backed away from the case. I'd called their bluff, stared them down with my legalese-laden letter, seizing victory before the first crack of the gavel. Case dismissed.

Well . . . sort of. My membership at the local assembly had lapsed, and Tom Klem, the head of our local order, was refusing to let me pay my dues. I'd paid them late in the past, so this was the board's way of ousting me on a technicality, ex parte and without a hearing. But my membership in the National Assembly remained valid, which was far more important.

Still, I felt uneasy. Even though I'd been granted a reprieve (more or less), the whole ordeal had cast a pall over my year of magical thinking. Not helping matters much was the fact that Richard M. Dooley, former president of the National Assembly, was denying any knowledge of having signed my Magic Olympics entry form. (He not only signed it, but also mailed it

for me.) Maybe he forgot or was too ashamed at having rubber-stamped a loser—not to mention a traitor. After the Olympics, a new president had taken office. Had Dooley been cashiered because of me? I was told this was not the case, but I had my doubts.

IN THE AFTERMATH OF THE SAM debacle, I made myself scarce at Rustico II on Saturdays. I knew Wes's stance on exposure. "I never give away principles," he had told me once, when I broached the issue. And his feelings toward Penn and Teller were far from affectionate. "I have problems with some of the ethics of the stuff they do," he said plainly. I decided it was best to lie low until the dust settled. But I could only duck Wes for so long. He was my teacher, after all. Eventually I had to face him.

I went to Rustico II expecting the worse. This was a man, after all, who'd cold-cocked a guy over a one-hundred-year-old trick involving an egg. Here I'd broken magic's cardinal rule—I'd given away secrets! I literally feared for my safety.

But Wes, as always, was full of surprises. He welcomed me at the table without any hesitation, offering me a seat next to him as if nothing had happened. I was shocked. Of all the people who'd read my article, he was the last person from whom I'd expected a show of mercy.

Moved by his kindness, I all but broke down. I told him I felt awful about the incident and regretted the article—all of which was true. He put his arm on my shoulder and measured out a smile. "I know," he said, softly, with a flicker of approval. "I know." He'd just come back from a cigarette break, and I could smell freshly smoked Pall Mall menthols on his breath. Minty death. "But it's good to hear you say it." After that, all was forgiven.

We spent the rest of the afternoon talking about an Italian coin expert named Giacomo Bertini, who was in town for the elite FFFF convention and was giving a lecture and teaching a workshop at the SAM later that week. "I'll tell you one thing," Wes wheezed. "He's got the best classic palm I've ever seen. It doesn't look like anything. It really doesn't." As with everything, Wes knew the score. He had a copy of an underground DVD containing some of Bertini's top-secret material, which had been put out by a close-up worker in Chicago. Bertini had now become somewhat of a star on the international coin circuit.

Afterward, I contacted Ken Schwabe about making arrangements to see Bertini. "This is unofficial," Ken said, very hush-hush. "I'm not speaking to you now as chairman of the lecture committee, because the workshop is not actually affiliated with the SAM." The upshot was that I could attend the workshop, because that was Ken's pet project, but if I showed up at the SAM lecture, I'd be greeted with torches and pitchforks.

The workshop was held at an undisclosed location. Only after being screened by Bertini and paying the fee was I given the address. Apparently they were worried about party crashers, something I honestly wouldn't have expected at a six-hour Saturday afternoon coin workshop given in Italian.

I met Ken in person to give him the cash. He counted it twice, discreet as a drug dealer, and told me in cloak-and-dagger tones that it was nonrefundable. I was to await further notice. That night he e-mailed me the coordinates of the secret location, which of course turned out to be the same place we always met.

The workshop was well worth the price of admission. Bertini was a brilliant thinker, and his technique was mathematically

exact. Around hour five, I started wondering what the motivations were for devoting so much time and effort to something so esoteric. By now I'd spent enough of my life sessioning with magic fiends to know that the Bertinis of the world weren't in it for money or fame. Listening to Bertini go on at length about the proper handling of the classic palm—the angle of the coin, the attitude of the fingers, all laid out with millimetric precision—I realized that his was a life devoted to the rendering of an aesthetic vision. I imagined that, for him, the coins were like abstract symbols in a mathematical equation, representations of an ideal reality, one of infinite dimensions. "This right here is as powerful as the Statue of Liberty," a wise magician once said to me as he raised a half dollar in the air and held it up to the light. "Size doesn't matter."

As I left the workshop that night still cradling these thoughts, I ran into a WASPy man in his mid-forties with floppy gray hair and blue eyes whom we'll call John. My article had not pleased him. "You made a lot of enemies," he told me bitterly. "Much bigger than you might know." He was speaking very fast and almost in a whisper. "You're just a loose cannon, and it's really dangerous." He paused, and his voice got even quieter. "The signal you're sending out is that you don't give a fuck."

We walked outside and he quickly worked himself into a rage. Standing in the middle of the street, he read me the riot act, and I stood there and took it. The thing that had angered him the most—even more than the exposure—was the fact that in my byline I'd identified myself as a professional rather than as an amateur. This, to him, was inexcusable. "Don't ever pass yourself off as a pro ever again," he hissed at me. "It's rude and wrong and you lied."

Several minutes later, after he'd vented most of his anger, we

began to have a more measured discussion. Even though he'd bawled me out in the middle of Ninety-sixth Street, I appreciated his candor, and it was clear to me that it came from a place of genuine passion. Also, I'd seen his chops and he was clearly very skilled. (He'd trained with the great Slydini.) We shared a cross-town bus—he also lived on the Upper West Side—and talked about the ethics of magic.

It was John's view that if magicians wanted to keep their material secret, they shouldn't publish it at all, not even in professional journals. I admired the consistency of his position, even though it was a little radical. "I'm a secretive SOB," he said, shrugging. "I couldn't be more old guard. I grew up in a place where it was one old man telling one young man a big secret. I'm a relic. But I get it that there really is this active conflict now. This whole information thing. We don't understand the full ramifications of a fully searchable database."

He apologized for yelling at me, and I apologized for playing fast and loose with the honor code, and by the time the bus emerged from Central Park we were like old friends. "Love the craft," he urged me as we stepped off the bus and prepared to go our separate ways. "That's the main thing. We all wanna be somebody else. But the job of the artist is to be who you are."

This sort of fealty to the craft for its own sake was something I may not have given enough credit when I published my article. Then again, what discourse does beauty have with secrecy? Magic is so much more than a collection of techniques. And art requires honesty as well as imagination. So, while I regretted having offended the people who'd devoted their lives to magic, as time went by I also felt a renewed commitment to rethink the traditions many of them espoused.

With this in mind, I decided to start my own magic society. Columbia had a club for just about everything—chess, video

games, anime, motorsports, model UN, Latin dance, Klezmer music—but nothing for magicians. This struck me as an egregious oversight on behalf of the student activities office—one I aimed to redress.

In forming my on-campus magic society, I reached out to clubs I thought might have a similar target demographic, including the Columbia science fiction club, the kung fu society, and the women's water polo team. I decided at the outset that ours would be a magic society cast from a different mold. There would be no oaths and no rituals. Anyone could join. The only requirement was an interest in magic and a willingness to learn.

Two people showed up to the inaugural meeting of the Columbia Magic Society, a female undergraduate from China named Yintiang who spoke very little English, and an enthusiastic French MBA student named Jean who wanted to learn magic so he could meet women. On the first day, I taught them the rudiments of my Ambitious Card routine. They both seemed thrilled.

It started out small but grew quickly. At the second meeting, there were twice as many people. Over the next several months, our numbers doubled again. Soon we had our own little community of aspiring magicians.

I realized that, going forward, many magicians would see me as an apostate, just as John had. But if anything, being blackballed from my local society only strengthened my resolve, fanning the flames of my obsession and drawing me ever deeper into this bizarre world.

IT'S ANNOYING AND I
ASKED YOU TO STOP

One of my biggest fears is that someday I'll be audited. Not because my taxes aren't in perfect order—I'm very OCD about saving receipts and keeping track of my expenses, a habit I learned from my father—but because it would bring me face-to-face with a very difficult and decidedly lose-lose dilemma in which I'd have to choose between going to jail for tax fraud and disclosing to another adult, in naked detail, just how much money I've spent on magic over the years. (That, and I'd have to fess up to eating at Arby's multiple times while traveling to magic conventions.)

"Mr. Stone," the auditor would say, "According to our records, you spent more money last year on—no, wait, this can't be right—you spent more on magic than on food or rent?"

Then he'd ask me what a topit was, and instead of explaining to him that it's a pouch sewn into the lining of your coat for vanishing small objects, I'd tell him it was a secret, citing the magician's code, and spend the next several years behind bars. Okay, so maybe that's not *exactly* how it would go down, but it wouldn't be pretty.

Decks of cards were one of my biggest expenses. I was up to a pack-a-day habit. (I liked my cards crisp and new, and I found that they quickly wore out from all the abuse I put them through.) It didn't help that I'd developed a taste for Richard Turner's traditionally cut Mandolin cards as well as fancy Tally-Ho decks, with their glossy linoid finish and stylish fanbacks, over regular old Bicycles. I now ordered them online in bulk.

I had a filing cabinet full of magic pamphlets and racks full of magic-related magazines. My e-mail in-box was perpetually flooded with tantalizing subject lines from all the magic newsletters and websites I'd subscribed to.

> *If you could REALLY bend coins, THIS is what it would look like.*
> *Stop your heartbeat in public.*
> *Create fire with your mind.*
> *Reveal a phone number . . . on your spectator's SKIN.*
> *Cut yourself IN HALF.*
> *Vacuum cleaner + deck of cards = ULTRA clean vanish.*

(And my personal favorite . . .)

> *Universal Nut. This is much more than a pocket puzzle!*

Pretty soon I needed a separate bookcase just for my magic library, and my media console could no longer hold all my

magic DVDs. I did the math once, and it was shocking. A Ducati 1198 Superbike—that's what I could've bought with the money I'd spent on tricks.

Then there was the human toll. I missed family events and weddings and major social occasions. My friends, initially delighted by my obsession (free magic!), soon grew weary of it (lots of free magic). Before long they would only agree to go out with me if I promised not to do card tricks the entire time.

The Columbia University physics department wasn't too thrilled, either. For my final presentation in Condensed Matter Physics, I performed a card trick wherein the ace of spades, which I shot out of the deck one-handed, was supposed to represent the photons emitted during nuclear magnetic resonance—the physics behind MRI. It didn't make much sense, quite frankly, and my teacher, a long-haired Japanese man, seemed truly perplexed.

A far more glaring insubordination occurred midway through my first semester, when I begged my Quantum Mechanics professor—a prodigy named Norman Howard Christ (rhymes with "tryst"), who completed his PhD in one year, at age twenty-two, and wore the same outfit (white shirt, tie, beltless charcoal slacks) every single day—to postpone our class's midterm by a full week so I could attend a five-day workshop on card and coin magic in Las Vegas. He reluctantly agreed, which was a small miracle in and of itself, but I wasn't exactly scoring any points with him or the other professors in my department by flying off to "magic camp" during exam week. It didn't take long before word got around that I was spending more time doing magic than physics, and my grades mirrored this inauspicious duality.

When in the spring of 2008, during my second semester, the dean of the physics department called me into his office to

discuss my lackluster performance on the graduate qualifying exams, pushing his thin wire frames up the long beak of his nose and holding my test at arm's length like a soiled diaper as he said, "We hear you're also a . . . magician?" I prayed for an earthquake or an aneurysm just to end the excruciating awkwardness of the situation. (If my wish had come true, the coroner would have found a Kennedy half dollar palmed in my rigor-mortised right hand.)

Magic was even getting me in trouble with the woman I'd started dating roughly a year and a half after Rachel left.

"It's annoying and I asked you to stop and you wouldn't," she screamed at me one night after we got home from drinks at a squeaky clean martini bar on the Upper East Side. She was standing on the threshold of the bedroom—the angry spot—her hips cocked and her straight brown hair half-obscuring her face. "I feel like I'm constantly having to be supportive of your magic."

"Well, you know, it's just addicting," I said, shimmying the half dollar in my right hand from back finger clip into classic palm, then transferring it gracefully into my left hand with the L'Homme Masqué load. "And, you know, I'm in training."

Her eyes flashed hazel in the light. "Well, maybe then you need to not go out with people, and you need to just stay here and do magic all the time."

Which really wasn't fair, considering that we'd met thanks to magic. It was a grad student mixer, and the first words out of my mouth were "Here, hold this," as I handed her a coin. Then I made it vanish and reappear underneath her watch. People often ask me if magic is good for getting girls, and the answer is yes. But it's also good for making them disappear.

I tried explaining to her that there are a lot of ways to enjoy each other's company, like being together and alone at the same time, but she was having none of it.

"It's boring! It's boring for me because I'm not sitting there playing a game."

"I can talk when I have cards in my hands."

"Yeah, but you're distracted."

"I'm not distracted. It's just something I'm doing all the time," I lied. Truth is, I'd been very distracted—at the bar and, before that, at the movies. (I barely remember the plot of *Slumdog Millionaire*.) I was trying to get down that damn push-off double lift from the David Blaine videos. It was *killing* me.

"I tell you what I'm feeling and then you proceed to ignore it. So I'm trying to figure out: Are you choosing to ignore it because you just don't care? Are you ignoring it because you want to piss me off and ultimately this is the mechanism that you trigger to destroy any good thing that we have going? Or are you really just completely unaware? I guess that's what I'm wondering."

Silence hung between us for a long while. Then she stiffened. *"Hello?"*

I snapped out of my daze. "What was number two again?"

We broke up not long after that.

And yet none of this stopped me from embarking on an accelerated Navy SEAL–style training regimen that included daily practice sessions and a steady diet of magic literature. This meant putting my graduate studies officially on hold and taking a leave of absence from one of the top physics programs in the world. At least for now, I had committed myself to studying and writing about magic full time.

When the news got around to my family, they were less than pleased. Even though my father was the one who'd first planted the seeds of my magic obsession, when they finally blossomed he was more than a little freaked out by his creation. This was not a pretty little nosegay, but a *Little Shop of Hor-*

rors monster. In his mind, magic was a fun hobby—nothing more—and once it started getting in the way of my academic life, it became a problem, like a video game addiction or a propensity for exposing oneself in public. I had the distinct sense he was beginning to regret having bought me that magic kit years ago. "I just hope I live long enough to see you get your PhD," he said to me not long after I started at Columbia. At this rate, he would have to live a very long time.

At a family clambake in New Hampshire, one of my cousins, a cheery teacher named Bruce, pulled me aside wearing a serious look and reaffirmed the family consensus. "I hear you're thinking of leaving school to do magic," he said. Before I had a chance to respond, he began shaking his head from side to side. "Don't . . . don't . . . don't," he said, over and over, his head swiveling back and forth like a robot gone haywire. Finally he found his thesis: "Don't do *thaaaaat.*"

But it was too late. Magic had begun bleeding over into every aspect of my life. In the pie chart of my daily activities, it occupied an ever-larger slice. Eventually I had to face the facts. My hobby had metastasized into a full-blown obsession. I was a high-functioning magicaholic.

I practiced everywhere. At the library. In line at the bank. While serving on jury duty. In the waiting room at the doctor's office. At the gym (where I kept a set of magic-lecture notes in my locker). On the subway (where I once dropped a deck of cards on an old lady's head). In the checkout line at the supermarket. I brought cards and coins with me to the movies, much to the annoyance of whoever happened to sit next to me. I'm surprised I was never struck by a car, given how often I walked around in a haze, preoccupied with the latest sleight I was learning. There's something Zen-like about practicing a pass or a double lift over and over until it gels in your hands.

It became a form of meditation for me. Magic was my yoga. And because mastering the art of palming involves learning to conceal objects while your hands are otherwise engaged, I went through much of my daily life with coins palmed in both hands—on the subway, at dinner parties, in the shower.

I'd go to restaurants and do magic for the waitstaff and wind up in the back entertaining the line cooks. I performed for strangers on the train. Whenever I went out, it was a chance to beta test new material. Magic became my primary social outlet.

One night, I got banned from my local bar for doing too much magic.

"Put away the cards," a large, bald-headed bartender told me in the middle of a trick I was doing for a fellow grad student also at the bar. "You can't hustle in here." Evidently, he thought I was trying to con drunk people, monte-style. I assured him it was only magic, but he wouldn't listen.

"I said put away the cards, or you're outta here. I'm not gonna ask again."

I shrugged him off, breezily fanning the deck. It's not like I was dancing half-naked on the pool table or doing bumps of cocaine in the bathroom—both of which I'd seen there in the past. I was doing magic, for heaven's sake! What harm could there possibly be in that? Ignoring him, I resumed my card trick, and he slammed his palms on the wooden bar top, snarling like a rabid dog.

"Get the hell out of here!" he roared. "You're eighty-six'd, you hear me! Get out! And don't come back!"

As I became ever more embroiled in the magic subculture, I also started dressing differently. First came the earrings—silver studs in both ears. Then the leather cuff on my left wrist. Then the ring on my right forefinger.

The ring doubled as a prop. A few years back, an innovative New York close-up expert debuted an effect at Obie O'Brien's FFFF convention in which a ring visibly materializes on your hand. Afterward, when he published the trick, every young magician on the East Coast took to wearing a ring on his index finger. At a party one night in Manhattan, where several of my magician friends had gathered, a young woman inquired about this shared taste in jewelry. "Is that a gay thing?" she asked. Inquiring minds wanted to know.

Gradually, I shucked my urban schoolboy outfit for a more flamboyant punk-hipster look. Progress? Maybe not. My friends said I looked like an aging eighties rocker. I suppose it was all about misdirection. Maybe the rings and studs and wrist cuffs would divert attention away from my crow's feet and the little yarmulke of thinning hair at my crown. Still, it did wonders for my confidence.

With my souped-up look and growing stash of moves, I was a new man. I felt like a caterpillar metamorphosing into a much cooler caterpillar, one that could do amazing tricks. I could visibly penetrate an inflated balloon with a cell phone. I could pass a quarter through a bottle, a cigarette through a quarter, and a pen through a dollar bill. I could transmute the dollar into a C-note and then make it appear inside a lemon. I could shoot fireballs from my hands. I could magically change the color of my shirt. I could apparently dislocate my shoulder and bend my pinky finger in half *the wrong way*. I could link and unlink three borrowed rings, then vanish one of them and make it appear on my shoelace, or inside a lemon. If ever I were asked, I had no trouble making three ropes of different lengths appear to be the same size. I could produce salt in an endless stream from my hand. Or pepper. Or both. I could shred a signed card into julienne strips and restore it by lighting it on

fire. I knew how to change a lemon into an egg and vanish it on command, and whenever anyone wanted to see me pull a fifty-foot rainbow streamer from my mouth, I was only too happy to oblige.

Can you do a trick with this penny?

Sure, I can! Watch it levitate eight inches above my hands and vanish into nothingness. Then appear inside a lemon.

Thanks to Wes, I was performing my Ambitious Card routine on a regular basis, and getting stunned reactions. It had become one of my go-to effects. The cards were now like an extra appendage, an extension of my body—a feeling with which, I imagine, Richard Turner was well acquainted. I was an ace at the three-card monte and could have started my own mob if I'd wanted to. I could rifle cards out of the deck McBride-style—whirring projectiles that spun through the air like helicopter blades—and catch them in my other hand on the descent. I could dead-cut to within three cards and riffle-shuffle one-handed.

I could even do the spin change I'd seen that gorgeous Belgian girl perform in the lobby of the hotel at the Magic Olympics, with which she'd mesmerized the entire late-night crowd and made herself the *objet d'amour* of every straight male within eyeshot. I still had sweaty Botticellian dreams of her spinning cards in a giant clam shell, hair spilling in rivers down her milk white shoulders as a choir of wind nymphs whistled "Kiss from a Rose." (In addition to academic success, financial security, and a normal adult social life, magic had also hijacked my fantasies.) I could only execute one change—not five—and was still struggling to get both hands spinning simultaneously. Even so, I felt pretty cool when I showed the kids at Tannen's and they swayed their heads in awe. "Dude, you do that sick," one of them said. "That's sick." Being sick had never felt so good.

I could now conceal multiple coins in my hand without the coins "talking"—that is, making unwanted noise—and still use that hand to sign autographs or swirl a snifter of brandy. This is an important skill because, to really sell a vanish, you want to convince the audience that your hands are empty, even if they aren't, by means of an unspoken gesture, such as dusting your palms or picking up another object. This sort of ruse is known as an acquitment, or subtlety, and there are hundreds of variants. Perhaps the most famous example, although not widely known as such, is the magic wand. The myth, of course, is that the wand channels the magician's power. But the magic wand's true power is in making the hand that wields it appear otherwise empty. A guilty, or full, hand looks more natural when holding a wand, a psychological subtlety that throws the audience off a palm. The wand is thus said to *acquit* the hand. Of course, almost anything can do the same job as a wand—a pen, a cup, another coin, or even a simple gesture.

I could also release coins from a classic palm one at a time through a slight variation in the pressure of my grip. After I became proficient with half dollars, I upgraded to silver dollars. I could even shoot the coins out of my palms with my hand muscles—a move I first saw at the Magic Castle when I was a kid. It looks like the coin floats out of the hand, as if somehow falling upward. It's done by squeezing the coin with the palm muscles and releasing it under tension. I remember practicing it until my palms were bruised stiff, but my hands were too puny at the time. Now I could launch a coin eight inches vertically, and I was more proud of this accomplishment than I was of having gone to college. Laypeople accused me of using strings and magnets and special coins, which I took as the highest form of flattery—like being asked if you'd had abdominal liposuction when in fact all you'd done were loads of crunches.

Magicians, meanwhile, viewed me with newfound respect. When I showed Wes, the faint seam of a smile wrinkled his long bearded face. "Not bad," he said, and cleared his throat. "But it's no twenty-eight inches." He was referring to Japanese virtuoso Shoot Ogawa's gravity-defying muscle pass, for which he held the world record (twenty-eight inches!) in what has become close-up magic's answer to the Olympic high jump.

I found myself using magic in nonmagic contexts as well. I'd do card moves with credit cards, coin sleights with poker chips or anything vaguely circular. I sleeved pens and phones and cutlery and whatever else would fit in my cuffs. If I'd wanted to, I could've been the ultimate shoplifter.

Even the simple act of paying for things became a magical affair after I replaced my wallet (a present from my father) with a magical "fire wallet" that burst into flames every time I opened it. (After which you can close it back up again and use it like any other wallet.) The fire wallet was a scene-stealer, for sure, and well worth the hundred dollars I'd spent on it, although it may have landed me on an FBI watchlist after I tried to sneak it on an airplane. I probably should have heeded Jeff McBride's advice. "Confetti is the new fire," he often says, citing post-9/11 security measures. "Any trick is better with confetti."

Magicians are notorious for throwing up red flags at airports and border checkpoints, especially when birds are part of their cargo. At the Magic Olympics, a Norwegian dove act named Davido was pulled from the opening stage show at the eleventh hour due to an avian flu scare. If he'd brought his doves into the country, a sullen Davido told me, "they could have killed them at the border." A similar incident occurred a few years earlier, when a precision bird handler from the United States was stopped at the Canadian border and told he

couldn't bring his doves into the country. Unfazed, he released the birds into the air and drove on without them. Reaching the other side of the border, he parked the car and called to his flock. Hearing their master's familiar warble, the trained birds flew back into his trunk on command.

As my confidence grew, I started gigging again. At first these were small shows in living rooms and in the backs of restaurants—fifty dollars here, seventy-five dollars there— much like the bar mitzvahs and birthday parties I did in high school. But as I got better, and my confidence grew, I began charging more. Soon my fee went up to $100 an hour. Before long I was making between $300 and $500 a show—what one friend called "prostitute money." (I guess, in a way, I *was* turning tricks.)

I did a wedding in Williamsburg, Brooklyn, a baby shower on Long Island, a dinner for a detachment of Wall Street stiffs at a posh social club in SoHo, a Halloween party in Tribeca, a law firm Christmas party. I was hired by the Anti-Defamation League, Cornell University, American Express, and a nonprofit organization called Asian Women in Business (which, in addition to hiring me, had also booked a paper cutter named Master Cheng, who made sure I knew that *he* was the main act). It felt great when people paid me to perform. Then again, I imagine just as many would have paid me to stop.

Besides hanging out with Wes, I also met a younger generation of magicians who rejected the orthodoxies of the Society in favor of magic's more experimental side. Among these rebels was John Born, the wunderkind from Kansas I first encountered at Rustico II. In exchange for helping him edit a six-hundred-page manuscript on cheating at Texas Hold 'Em loaded with new techniques, Born shared some exquisite secrets with me. I also met a diminutive twenty-three-year-old graphic

designer with stunning sleight-of-hand chops who was working with the great Paul Harris on a ten-DVD set filled with new material; an amateur who ran a blog on which he bashed the skills of lesser conjurors; and a rising star from Ohio, named Joshua Jay, who wrote a monthly column for *Magic* magazine called "Talk About Tricks."

There was a collective sense of excitement among these young magicians, a feeling that magic was on its way up. To them, the world of magic more closely resembled a cutting-edge science or an avant-garde art movement than the staid, vaudeville-era relic of popular imagination. It crackled with innovation and creativity. When speaking about their craft, they peppered their effusions with adjectives like *new age*, *state-of-the-art*, and *high-end*, as if describing some bold new technology. To hear them tell it, the golden age of magic was upon us.

Magic was evolving at a remarkable pace, in part because it seemed to be tapping into cutting-edge ideas from psychology, behavioral science, and mathematics. This in turn generated a great deal of conceptual excitement among this new breed of conjurors. Not that Wes with his PhD in computer science was an intellectual slouch. But as I was beginning to realize, there were a lot of high-octane intellects in the magic world. As an aspiring physicist, I found this especially seductive, even more so than the dark side of cons and cheats. By now I'd become convinced that physics and magic recruited some of the same cognitive engines. Both require a similar sort of mental gymnastics. Both are profound acts of the imagination. Both encourage you to think critically, challenging you to move beyond the quiet comfort zone of your daily experience.

All that being said, the biggest draw is that it's just plain fun to fool people. Anyone who claims otherwise—that fool-

ing people isn't one of magic's central joys, one of its primary pleasures—is being dishonest. To truly astonish someone, to freak them out so badly they can't sleep at night, to blow their mind and make them question their sanity—that, to me, as to all magicians, is heaven. It's one of the chief upsides to becoming a magician, aside from the fact that black is very slimming.

All that polite blather about magic being a gift that brings joy and smiles is all well and good, but what it's really about is the incredible rush that comes from shattering someone's grip on reality. To see the disbelief in their eyes, that look of sheer bewilderment just before the tension dissipates into laughter and a crackle of applause—what Wes calls the WTF moment—few pleasures can compare.

The real brilliance of those early David Blaine street magic specials was their eye for capturing this definitive moment. The passersby he stopped on the sidewalk were the real stars of his show, and those tight reaction shots of strangers freaking out in the middle of the street while Blaine stood by looking vaguely stoned were as astonishing to watch as any big stage illusion, even after you learned how the tricks were done. For the audiences at home, the main draw was watching people watch Blaine—who appeared to be a total cipher, a weird sort of urban shaman wandering the streets aimlessly and yet making all these incredible things happen. Hiring the co-creator of *Cops* to give the show an unvarnished reality TV feel—distancing it from the shows of blousier magicians like David Copperfield— was also a minor stroke of genius. It's difficult to overstate the influence those shows had on the magic world. Wes's disdain for so-called Blainiacs notwithstanding, David Blaine inspired an entire generation of young magicians—me included—and transformed the way people think about the craft to an extent not seen since Houdini.

The renowned psychologist Paul Ekman, the world's foremost expert on lying and deception, has given a name to the pleasure that we all derive from fooling others. He calls it duping delight. Duping delight is basically the frisson of excitement that comes from pulling off a good lie. Simply put, it's fun to mess with people's minds. How much fun it is, according to Ekman, depends on three factors: the gullibility of the target, the size of the lie, and the amount of respect we win by telling it.

The first of these factors refers to how hard the target is to fool, and it explains why magicians take heightened delight in fooling other magicians. Sure, it's fun to fool laypeople, but they're easy prey. It's far more thrilling to hunt your own kind. As a result, magicians are constantly engineering new ways to dupe one another. A hierarchy of foolmanship, a who-fooled-whom pecking order, rules the conjuror's domain. This gladiatorial spirit in turn drives considerable evolution in the art.

Ekman's second variable concerns the practical difficulties involved in pulling off the lie. In magic, this corresponds to the skill level of the effect and how likely you are to get caught. The third factor, meanwhile, sheds light on why magicians hold tournaments and share war stories. "Criminals have been known to reveal their crime to friends, strangers, even to the police in order to be acknowledged and appreciated as having been clever enough to pull off a particular deceit," Ekman has observed. Magicians are much the same. With magic competitions, which began a half century ago and have since blossomed into a global enterprise, magicians have turned duping delight into a live sporting event.

The siren song of duping delight was what had driven me to compete at the Magic Olympics in Stockholm, and it was also why I was training for the IBM close-up tournament in July

2010. I only hoped that this time around I could make a better run of it. I certainly could do no worse.

In hopes of avoiding another ego-shattering nosedive, I began making frequent pilgrimages in search of secrets. I followed the lecture circuit like a Deadhead. If I had been younger, I would almost certainly have attended Tannen's Magic Camp—a summer retreat for tricksters age twenty and under—and I did consider lying about my age and using makeup. But such drastic measures were unnecessary, because even without Tannen's, there were still plenty of places to go. If anything, I had too many options. Magic has become so specialized that each branch now has its own convention. There's one for mentalists (people who read minds and bend spoons) and one for card cheats who work with gambling sleights. There are two separate coin magic conventions and an annual gathering for people interested in Extreme Card Manipulation, those flashy acrobatic card flourishes. The bizarrists—magician-storytellers who use tricks to conjure up elaborate fairytales—have their own meet-up in Connecticut. And 2009 saw the birth of the first online-only magic conference. There are magic conclaves and cruises, magic charities, and magic ministries. There's something called the Midwest Magic Jubilee. All told, there are over one hundred magic conventions each year. And the number keeps growing.

I went to the IBM convention in Nashville, the SAM in Buffalo, the World Magic Seminar in Vegas, and the Blackpool convention in England, the largest convention in the world. I hit up the International Battle of Magicians in Canton, Ohio, home of the NFL Hall of Fame. I flew to Lima, Peru, for the FLASOMA competition, the Latin Grammies of magic. I attended the inaugural Magic-Con, a convention led by XCM prodigies Dan and Dave Buck and patterned after the TED model.

In the process, I accumulated a frightening amount of plunder: chips from practically every casino on and off the Strip; a scrapbook full of souvenir eight-by-tens; several Rolodexes' worth of business cards; a Magic-Con Moleskine notebook that I used as a diary; an extensive collection of leaky convention pens, badges, lanyards, and pins; and a drawerful of ill-fitting hats and shirts. I could have decorated a Christmas tree with all my name tags. And because every conference is required by law to provide its attendees with souvenir tote bags, I soon had a closetful of those as well.

One of the amusing things about conventioneering is seeing some of the other conferences with which you intersect. At the 2009 IBM, we shared the convention center at the Gaylord Opryland Resort in Nashville with the North American Irish Dancing Championships—tweens in Celtic curls and powder white makeup trotting around with their stage mothers. At the SAM in Buffalo, it was World War II veterans (the U.S.S. *Little Rock* 2009 Reunion), and at times I had trouble distinguishing their wispy pink scalps from those of the magicians. In other cities, I happened upon a porn convention, an electronics expo, a powerlifting exhibition, and—get this—a physics conference. I felt a pang of guilt when I saw physicists hard at work as I teamed up with a group of high school kids who were busy "mindfreaking" unsuspecting guests at the hotel. All the while, Saturdays with Wes in the luxuriant gloom of Rustico II served as my reference point, a place to which I continually returned for guidance.

By the fall of 2009, I'd made major strides, which was encouraging. But I had yet to put together a routine that I could enter at the IBM competition. I needed to start crafting new material soon, or I'd have nothing to show for my efforts come contest time the following summer. Up until now, I'd focused

primarily on the physical side of magic—building my chops and learning new moves, skills Jeff McBride associates with the archetype of the Sorcerer. I'd attained a certain measure of technical mastery, and I was proud of this accomplishment. But magic is more than just a technical pursuit.

Indeed, most of the magicians I'd spoken to stressed the importance of the psychology behind the magic. The refrain I kept hearing was "Magic happens not in the hands of the magician, but in the mind of the spectator." Although I'd gained some insight into the deeper cognitive underpinnings of the art, my knowledge was at best superficial. The path to the realm of the Oracle, McBride reminds us, is a journey inward, an exploration of the hidden mysteries of perception. As I set my sights on the next stage of my voyage, I decided it was time to confront these mysteries head-on. I was further galvanized by a discussion I had about magic and the brain with cognitive scientist and philosopher of the mind William Hirstein. "It's almost as if part of magicians' routine training ought to be a course in neuropsychology," he told me at the end of our talk.

School was about to be in session.

HOW TO STEAL A WATCH

Founded in 1919 as a counterweight to the tide of nationalism and censorship that swept the nation during the First World War, the New School in New York's Greenwich Village has long been a bastion of avant-garde thinking and progressive ideals. Early on it served as a sanctuary for professors fleeing repressive policies at other schools—most notably, Columbia—and during World War II it became a haven for Jewish intellectuals escaping the Nazis. Former students include Jack Kerouac, Marlon Brando, Eleanor Roosevelt, Tennessee Williams, James Baldwin, Norman Rockwell, Marc Jacobs, Tony Curtis, Ani DiFranco, and sexologist Dr. Ruth Westheimer.

The New School currently houses the laboratory of Arien Mack, a research psychologist and pioneer in the field of cognition who for the last twenty years has paved the way for a rig-

orous scientific study of attention and misdirection—the very bedrock of magic.

I'd seen misdirection in action ever since I started doing magic, but I wanted to understand how it actually affects the brain. What are the underlying cognitive mechanisms at work when a person watches a magic show? What role do these mechanisms play in other areas of our lives? And how can a deeper understanding of the psychology of attention be used to enhance one's magic?

I met Professor Mack at her cozy office in the maze of rooms that is the New School's psychology department, housed within a cement tower in downtown Manhattan. On the floor beneath Mack's, in rooms filled with toys and outfitted with small TV sets, infants were being temporarily separated from their mothers to see what attachment type they were—secure, avoidant, ambivalent, or disorganized. (Whichever attachment style you display in infancy can determine the fate of your adult relationships, one of Mack's graduate students explained to me.) There were also labs studying memory, motivation, guilt, shame, racial awareness, kinship, reciprocity, OCD, ADD, and autism. Waiting for the elevator, I'd asked a young researcher what her group was working on. "We look at how the perception of spatial distances affects moral judgments," she said brightly. I showed her a card trick, and she threw me a puzzled look—probably not unlike the one I gave her when she told me her specialty.

A charmingly frank Brooklyn-born skeptic—when I looked at her Facebook profile, I saw that under "Religious views" it read, "confirmed atheist"—Mack has lucid brown eyes, a warm smile, and a highly sensitized bullshit meter. She's one of those academics who can field questions with a gesture—an arch of the eyebrows, a shrug of the shoulders—to let you know if your

thought is worth pursuing or if you're better off keeping quiet, and in this regard she reminded me of my physics professors, only more stylish in her navy slacks, white blouse, and chunky gold jewelry. As I shook her hand, my eyes lingered on her bright orange diving watch.

Having told her a little bit about why I was interested in her research, I soon found myself staring at a black computer monitor inside one of her testing stations, my head cradled between an ophthalmic chin rest and a padded plastic brace. It felt a lot like being at the eye doctor, except instead of a technician asking me which was clearer, one or two, A or B, a British grad student was telling me to hit any key. "Whenever you're ready," he said.

I took a deep breath, turned my focus to the monitor, and pressed the space bar. My task was to watch for a large lopsided cross that appeared in the center of the display and to determine whether the horizontal line or the vertical line was longer. After a series of trials, Mack's grad student asked me if I'd seen anything else while looking at the cross. I sat back and shook my head. I was then shown four pictures—a house, a car, a boat, and an airplane—and asked if any of them looked familiar.

I shook my head again. "Nope."

"If you had to pick one, which one would it be?"

None of them stood out, but I went ahead and picked the car. Wishful thinking, perhaps? The downtown train had been cheek by jowl.

The test I'd just participated in was the latest twist on an experiment Mack had designed years ago to investigate the relationship between perception and attention. The cross, Mack explained, was a distraction. While I watched it, comparing the vertical and horizontal lines, a picture had flashed briefly

on the screen. Under normal circumstances, it would have been obvious, easily spotted by any observer. But because my mind was preoccupied with the cross task, it escaped my notice. Later, when repeating the experiment multiple times sans cross, I spotted the pictures with ease—car, boat, road—and was able to describe them accurately.

Mack first began carrying out this sort of experiment in 1988, with her late colleague Irvin Rock, a psychology professor at the University of California, Berkeley. Her interest began with a simple question: How much of the world do we consciously take in when we aren't paying attention? Mack has since carried out this brand of experiment on hundreds of subjects in an attempt to figure out just how much we notice when we're distracted.

The answer, verified time and again, is next to nothing. In scores of studies, the evidence points to a simple yet astounding fact: inattention all but eliminates conscious experience. Objects and events appearing directly before our eyes, in what psychologists call the zone of fixation, frequently go unnoticed when our attention is elsewhere, as if our vision somehow stops working when we're distracted. Mack and Rock coined the term *inattentional blindness* to describe this astonishing failure of awareness, all the more astonishing for having escaped discovery until recently.

What's more, our vision isn't all that's affected. Audible noises become inaudible, simple words turn to gibberish, and even tactile sensations go unfelt when our attention wanders. "Attention appears to be necessary for all sensory modalities," Mack explained to me in her office. "There is no conscious perception without attention." Even minor distractions can render us deaf and blind, unable to perform simple tasks, regardless of the nature of the distraction. A visual task such as measuring a

cross, in other words, can dull not just your sight but also your hearing and your sense of touch.

Misdirection has an uncanny ability to blind us to the obvious. Perhaps the most famous experimental example is a thirty-second film, created by University of Illinois cognitive scientist Daniel Simons, in which six basketball players—three in white T-shirts and three in black T-shirts—are seen passing a ball. The viewers are instructed to count the number of passes by the white team. Halfway through the film, a woman in a gorilla suit walks on-screen, stops in the middle of the tussle, and beats her chest repeatedly before exiting stage left. The gorilla remains on-screen for a total of nine seconds. Our intuition tells us that anyone not in a coma would notice the gorilla. But as Simons has discovered time and again, most people do not. More than half of all the subjects to whom he's shown the film completely miss the gorilla because they are focused on the passing game. When I later spoke to Simons (whose book, *The Invisible Gorilla*, chronicles this and many other gaps in our awareness), he admitted that even after having screened the film hundreds of times at lectures and conferences all over the world, it still stuns him. "Every time I show the video I still kind of hold my breath because I'm convinced that everyone is going to notice," he said.

Inattentional blindness is shocking for the simple reason that, as Mack put it, "We all think we see what we're looking at"—and in a sense, we do. Technically speaking, everyone sees the gorilla. It's on-screen for nine seconds—thirty thousand times longer than the shortest event a human can perceive. The image enters our pupils, strikes the retina, and barrels down the optic nerve all the way to the brain. Experiments using eye-tracking devices confirm this fact. People who don't perceive the gorilla spend just as long looking directly at it—a full second on average—as those who do.

The same is true when watching magic. People tend to think magicians use misdirection to control where a spectator is looking. While this is certainly true some of the time, misdirection in magic is mostly about controlling a person's attention—which can be totally independent from their gaze. UK psychologists Gustav Kuhn and Benjamin Tatler recently illustrated this with a series of experiments in which subjects watched a magician vanish a cigarette by dropping it in his lap during a moment of misdirection. (This is called lapping in the argot.) Using the same eye-tracking tools Simons employed in his gorilla experiment, they found that a person's odds of spotting the secret method—that is, the lapping—did not depend on where they were looking at the time of the drop. Even those who were staring directly at the magician's hand when he lapped the cigarette failed, in almost all cases, to spot the ditch.

As these experiments demonstrate, seeing *isn't* believing. Just because you look directly at something doesn't mean you will perceive it. If the brain doesn't process a given visual stimulus, it's as though it never existed. Misdirection, in a sense, masks the image, rendering it invisible. Psychologists sometimes call this loss of information "functional blindness," to distinguish it from blindness caused by physiological defects in the structure of the eye, like what Richard Turner has. Inattentional blindness is a cognitive illusion as opposed to a visual one, an illusion not of the eyes but of the mind.

As it turns out, cognitive illusions have staggering real-world consequences. Inattentional blindness, for instance, is why you shouldn't talk on the phone while driving. It's not because your hands are busy, as is commonly thought, but because your mind is busy. The competing cognitive task is what puts you at risk, not the mechanical act of holding the phone to

your ear. At highway speeds, a fraction of a second may be all the time you have to avoid a crash, and anything that widens your reaction gap can drastically increase the odds of an accident. Multitasking—not that other *m*-word your grandmother warned you about—is what makes you go blind.

A wealth of evidence has confirmed that using a phone severely lengthens reaction times and diminishes overall alertness, profoundly impairing one's ability to drive. Studies comparing drivers on cell phones to drunk drivers have found no measurable difference in performance: both are equally dangerous behind the wheel. According to one analysis, published in the prestigious *New England Journal of Medicine*, the use of a phone while operating a motor vehicle quadruples your risk of a collision.

Far from a safety measure, hands-free devices are just as dangerous, if not more so, as regular handheld phones, because they promote a false sense of security while still hogging your attention. Indeed, several experiments have shown that hands-free devices do nothing to reduce the cognitive impairments associated with phone use. And yet many states, such as New York and Maryland, will waive citations issued for driving with a handheld phone if the motorist agrees to purchase a hands-free device.

(You may be wondering if talking on a hands-free phone is any different from chatting with a passenger in the car. It is—for several reasons. For one, the passenger may provide an additional set of eyes with which to watch the road for any imminent dangers. Other reasons include the fact that people who are in the car with you will likely understand if you need to focus and adjust the tempo of the conversation accordingly.)

Brain blindness of a sort not associated with cell phones may also account for the astonishingly high number of mo-

torcycle accidents in the United States (much higher than in many other countries). Most motorcycle accidents on U.S. roads involve cars, and the vast majority of these occur when the car hits the motorcycle: the driver sideswipes the bike during a lane change or cuts off the cycle in mid-turn. In a significant number of these wrecks, the motorists did everything they were supposed to do—they signaled, checked their rearview and side mirrors, looked over their shoulders to make sure nobody was in their blind spot—and yet they still hit the bikes. What happened?

One explanation, Simons has argued, is that the drivers technically saw the motorcycles—that is, the image struck the retina and travelled down the optic nerve—but as with the gorilla, they didn't consciously perceive the motorcycles in time to avoid a collision because they weren't expecting to see them. A series of experiments in Mack's lab has revealed that expectations play a pivotal role in what we perceive and that under certain circumstances the absence of expectation in and of itself is sufficient to induce a temporary state of inattentional blindness. Simons's research confirms this result: we are less likely to notice that which we do not expect. And since motorcycles are far less common in the United States than they are elsewhere, and certainly less common than cars, drivers often don't expect to see motorcyclists, which in turn makes them less accessible to conscious perception.

This interpretation jibes with studies on traffic accidents involving cyclists and pedestrians. Loosely speaking, the safest places to walk and bike are those with lots of pedestrians and cyclists. The reason for this is that the average driver expects to see pedestrians and cyclists in places where they are common and is therefore more likely to register them in time to avoid a collision. In New York City, for example, where there are more

cyclists and pedestrians per square mile than anywhere else in the country, the rate of automobile accidents involving cyclists and pedestrians is well below the national average, most likely because motorists know to look out for them.

If memory is attention in the past tense, as psychologist Daniel Goleman has put it, Mack's work on misdirection also helps shed light on why magic tricks often produce false memories—something virtually every conjuror has seen first-hand. This phenomenon was demonstrated some years back by the American magician John Mulholland when he performed for a group of psychology students during a lecture he gave at a major university. Midway through his talk, Mulholland described—but did not perform—a trick in which a coin teleports across the room. When asked a few weeks later to recount what had happened during the lecture, four out of five students said they remembered a coin traveling instantaneously from one end of the classroom to the other, even though this had never happened. This sort of anomaly can occur because, as has now been verified in dozens of studies, the mere act of imagining an event is enough to produce a false memory of it.

The inherently suggestive nature of magic automatically works in favor of encouraging false recollections, and even the hobbyist knows that spectators will remember all sorts of crazy things. More than once I've stood among a group of magicians trading war stories about spectators who swore they had witnessed true miracles:

> *I just thought of a card and he found it.*
> *The card was flying around the room and bouncing off the walls.*
> *He floated five feet in the air in the middle of my living room.*

Spectators convinced they've once seen the impossible often put me on the spot:

> *Can you make my card fly out of the deck and burst into flames?*
> *No, but I can make it appear inside a lemon!*

Of course, false memories aren't confined to magic. Through the power of suggestion, psychologists have managed to implant all sorts of bogus memories in the minds of normal adults. People have been made to remember objects—buildings and cars and stop signs and electronic equipment—in scenes where no such objects were present. Memories of objects that were present were found to be highly malleable. Cars in a mock crime scene changed color. A yield sign became a stop sign. Mickey Mouse underwent gender reassignment to become Minnie Mouse. In one study, psychologists even managed to instill impossible memories of early infancy, despite the fact that the first two years of everyone's life are opaque to memory, for reasons that are poorly understood. Even when the participants knew they were being fooled, these mnemonic swindles still worked. And once implanted, false memories can be tough to distinguish from real ones, even with the use of brain imaging machines.

The real-world implications of false memories can be quite serious. For one, false memories can undermine the legal system, sending innocent people to prison while acquitting guilty ones. Eyewitness testimony, even in the age of DNA evidence, remains a deciding factor in most criminal cases. But memory research suggests that eyewitness misidentification accounts for roughly 90 percent of wrongful convictions. Many accepted police procedures—lineups, interrogations using leading or ac-

cusatory questions, and the visualization techniques utilized by sketch artists—have been proved to distort memories. In certain extreme cases involving highly suggestible individuals, these methods have triggered fictitious confessions on the part of innocent people who, over the course of an investigation, developed false memories of a crime they did not commit.

In addition to scrambling our memories, misdirection also lowers our gullibility threshold, making us more prone to believe information we know is untrue. Psychologists at the University of Texas at Austin tested this idea by giving mock juries a series of written statements about an alleged criminal. All the participants knew which statements were true and which were false (because they appeared in different color type), but in the course of the trials, some of the jurors were presented with distractions. As it turned out, those who were distracted were far more likely to remember the false statements as facts. Not only that, but when the false statements made the crime seem worse, the addled jurors imposed a much longer prison sentence.

For obvious reasons, we tend not to recall events that our minds fail to register in the first place. It's the tree falling in the forest. Put simply: we don't remember what we didn't notice. Because of this, we tend to overestimate our powers of observation. The gap between what we *think* we notice and what we *actually* notice is a reflection of our tendency to make judgments based on what readily comes to mind, something psychologists call the availability bias. When law enforcement agencies began putting pictures of missing children on the backs of milk cartons, for instance, the perceived rate of childhood abductions, as measured by national surveys, shot up drastically. To this day, parents fear kidnapping more than accidents, even though a child is one hundred times more likely to be killed in an accident than by a kidnapper. People also overstate the risk

of shark attacks and lightning strikes simply because gruesome deaths make memorable headlines. In a similar fashion, we overestimate our powers of observation because we tend not to remember those instances when we failed to notice something.

In magic, when people fail to spot the secret to a trick, they tend to blame their vision, invoking the age-old saying "the hand is quicker than the eye." In fact, the human eye is a blazingly efficient instrument capable of spotting flashes of light as brief as ten milliseconds—that's 1/100th of a second, the shortest time interval on a digital stopwatch. A mere five photons—or quanta of light—are sufficient to trigger a conscious visual response. Magicians have long known that they don't stand a chance of outrunning the audience's eyes. "It is a common mistake to suppose that the quickness of the hand deceives the eyes," observed the superlative English conjuror of the early twentieth century David Devant. "You cannot move your hand so quickly that its passage cannot be followed by anyone who is watching you." The hand, in other words, is decidedly slower than the eye.

A better saying would be "the hand is quicker than the mind," because, again, it's the mind, not the eyeball, that's at fault. A failure to notice, not an inability to see, is what characterizes cognitive illusions such as inattentional blindness. Misdirection, not speed, is the key to most magic tricks. "It's more important to have good cover than it is to have good sleight of hand," scam expert Whit Haydn told me at the Magic Castle. "If your cover is good you can get away with bad sleight of hand." Magicians employ misdirection—be it verbal, visual, or tactile—to force us into multitasking mode, thereby inducing a temporary state of impaired awareness.

When magicians do employ speed, more often than not it's to ensure that a given subterfuge falls within the span of

an inattentional moment. A flash paper explosion or a puff of smoke, for instance, may distract you for only half a second before your focus snaps back to the magician's sleeves, but that's long enough. The glittery showgirls dancing about the stage also serve as instruments of inattentional blindness—drawing our attention (though not necessarily our gaze) away from the illusion at key moments. The same is true when doves fly into the air, as Vegas magician Lance Burton has observed. "At that point," he once told a fellow conjuror, "you can do anything you want."

I offered to show Arien Mack a trick. I removed a red Bicycle deck and asked her to name any card. "Nine of diamonds," she said. I smiled and placed the deck in her left hand. "Hold it tightly," I said, grabbing both her wrists. "Imagine that the nine of diamonds is getting heavier, falling to the bottom of the deck." I shook her wrists back and forth. "Can you feel it, Arien? Would you be impressed if I could get the card to jump out of the pack?" I let go of her wrists and told her to look at the bottom card. She turned the deck over to see the nine of diamonds on the face of the pack. "That's very good," she said, smiling and shaking her head. "I'm impressed."

I said good-bye and made my way for the door. Just as I was about to leave, I spun back around and asked for the time. Mack looked down at her forearm, eyes narrowing, and a baffled expression crept across her face.

"Here," I said, extending my left arm toward her. "Use mine."

Upon seeing her orange diving watch coiled around my wrist, Mack's chin hit her chest. She raised her arms above her head and laughed loudly then dropped them back down into

her lap. "It's amazing what you don't notice when you're distracted, isn't it?" I said, flashing a cheesy grin. Mack straightened in her chair and pushed her tortoiseshell frames up to the bridge of her nose. She looked at me, head angled slightly to the right and back, a playful gleam in her eyes.

"Want to do an experiment?"

OVER THE NEXT SEVERAL WEEKS, I became a fixture in Arien Mack's laboratory, an oddball hanger-on who crashed her weekly group meetings with a deck of cards in hand. Tuesdays with Mack at the New School became as integral to my routine as Saturdays with Wes and Co. at Rustico II. Initially I was concerned that the other members of her lab construed my hyperactive eagerness as the telltale sign of a spectrum disorder. But whatever misgivings they might have had evaporated after a few card tricks.

Designing a psych experiment, I soon learned, is a lot like putting together a magic show. You begin by finding an audience (your test subjects), engaging them under what are typically false pretenses, and then you proceed to mess with their heads. The biggest difference is that *you* have to pay them, although it's amazing the sort of Ludovico-style mind control undergraduates will subject themselves to for five bucks or candy from a stranger.

The experiment Mack and I designed was a test of tactile insensitivity—the tactile analog of inattentional blindness—using the watch steal as the critical stimulus. She'd done some preliminary studies on tactile insensitivity, in which it was revealed that people often don't detect puffs of air on their arms when they're focused on a demanding task. This was interesting, but nowhere near as dramatic as the results of her vi-

sion research. Our goal was to do for tactile insensitivity what her previous work had done for inattentional blindness. Mack was almost as excited about our scheme as I was. "This is the sort of experiment I've been wanting to do for years," she told our group. We dubbed the project the Guerilla Experiment, a nod to Simons's film but also to "guerilla magic," the brand of street magic popularized by David Blaine, in which the magician walks up to random strangers and blows their minds with a few fast, hard-hitting miracles. The name was my idea.

MY FIRST ENCOUNTER WITH THE art of watch stealing had come a few years back, when my father's Seiko was stolen from me by the man who calls himself Magick—a Harley-riding headbanger with long black hair and a prosthetic eye for a finger ring—on one of my Saturday visits to Tannen's. I don't remember any of the other tricks I saw that day. Nothing else compared. How could I have been so gullible? Could anyone, even people with two names, learn to do that?

"Teach me," I pleaded. "I *need* to learn."

A consummate salesman, Magick smiled calmly and pressed a VHS tape into my hands. "Here, man," he said with a sidelong glance. "This is all ya need."

The box cover showed a toothsome Dean Martin type smiling in a tuxedo and wearing seven or eight luxury timepieces on his left arm. It was called *The Watch Steal Video*, and it basically advertised itself as Thievery 101 for a mere $29.95. At that moment I would have thought it cheap at any price. The man on the cover was Chappy Brazil, a legendary New York street performer who moved to Sin City in 1999 and died shortly thereafter under tragic circumstances. In a morbidly ironic twist of fate, Brazil himself fell victim to the consequences of inatten-

tion. The night he finished making *The Watch Steal Video*, Brazil was riding his motorcycle to a friend's house for a screening of the final cut when an LVPD squad car racing to a crime scene failed to notice him and slammed into his bike at pursuit speed, killing him instantly. He was thirty-three years old.

So how exactly do you remove a person's watch without their noticing? It's easier than you might think. The simplest watches to steal are the ones fitted with buckles, which work more or less like a belt. Slightly more challenging are watches with flip clasps; and by far the toughest are the expanding metal bands that have to be pulled over your hand. The Rolex is one of the hardest timepieces to steal. Even so, artful dodgers can pinch Rolexes off rich folk like candy from a baby. "The first watch I ever stole was a Rolex," Magick told me with a chuckle. "I was just like . . . *fuggit.*"

For me, saying *fuggit* was the least of my concerns. Overcoming my instincts and ingrained guilt and ripping into someone's jewelry required pluck of the sort I had not yet managed to acquire. Attempted robbery, even for entertainment purposes, was still attempted robbery, was it not? And although I didn't know this at the time, I've since learned that several successful magicians stopped stealing watches after one or more spectators threatened to press charges. (Rumor has it Jerry Seinfeld once got a guy fired for stealing his watch at a show.)

Watch stealing is far more invasive than the average magic trick, which is why it gets such intense reactions. It's the kind of thing people seldom shrug off. Indeed, it's hard to imagine that something so obvious could ever go unnoticed. Maybe we've learned not to trust our eyes in some cases, but our sense of touch? Few effects so starkly illuminate the holes in our perception. The watch steal is the invisible gorilla of magic.

For such an epic payoff, stealing watches is fairly straight-forward, especially if you stick to the low-hanging fruit and only go for watches with buckles. To steal this type of watch, you make a *C* with your hand and press your thumb against the face of the watch while your middle finger curls around the person's wrist. The tip of the middle finger should more or less align with the tip of the tongue. Most watches have a little loop to hold the tongue down against the band, so first you need to free the tongue by curling your middle finger inward, easing the tongue back out of the loop. Once this is done, your finger goes underneath the tongue and bends it all the way back, at an angle of almost 180 degrees, until the prong comes out of the hole. Once the prong is free, Chappy Brazil advises us to flick it back down and push the tongue slightly askew, just off to the side, so the prong doesn't slip back into one of the holes as you yank the watch off the wrist. Finally, in a quick but fluid motion, you pull your hand away while palming the watch in your curled fingers.

An old Dickensian cutpurse's training tool will help you get your criminal career under way. Grab yourself a broomstick or a mop and wrap a towel or rag around the pole enough times to make it roughly the diameter of a human wrist. Then secure the towel with tape or rubber bands. Strap as many watches as you can find around the pole and practice removing them one-handed without looking. With a little practice—okay, *a lot* of practice—you'll get to the point where you can remove a watch in under five seconds.

As with any magic trick, the mechanics are but a small part of the illusion; psychology is the secret sauce. First and fore-most, you need an excuse to grab your victim's wrist, because if you yank at their watch for no reason they'll almost cer-tainly notice. I usually steal a spectator's watch under the guise

of doing a coin trick. Let's imagine you're that spectator and the watch is on your left wrist. I remove a coin and ask you to hold out both of your hands, palms up. If you're wearing long sleeves, the watch will become exposed as you extend your arms toward me. After placing the coin in your right hand, I'll tell you to close your fists as I grab both wrists and clamp my fingers around the watch.

"I'm going to show you how a coin can teleport," I'll say.

At this point I usually press down on the watch so that your touch receptors adapt to the sensation. The resulting sensory after-impression—literally, neurons still firing—blurs the pressure from the watch with the pressure from my hand, making it harder for you to feel the absence of the watch after it comes off your wrist (although it turns out that, while helpful, this isn't really necessary). As I begin unbuckling the strap, I may move your arms back and forth in short straight lines while saying something like "If I shake hard enough, the coin will jump between your hands." In magic as well as in pickpocketing, it helps to move in quick back-and-forth spurts when you want to shake off a person's focus. If, however, you want them to follow your hand, it's better to move along a smooth, curved trajectory. It's not clear exactly why this is the case, but neuroscientists have hypothesized that these two forms of motion engage different parts of the visual system. Short linear bursts trigger so-called saccadic eye movements—extremely rapid but discontinuous darting of the eyes during which visual awareness is suppressed for intervals as brief as twenty milliseconds—whereas curved movements activate smooth-pursuit neurons, brain cells programmed to follow moving targets. This adaptation makes sense given that a straight line is a relatively predictable path, so your eyes can safely jump ahead, while a curved trajectory is less predictable and must therefore be tracked more closely.

If I know your name I'll say it out loud two or three times as well. Your own name is like a tractor beam for attention. It pulls you in. Have you ever been in a noisy room when suddenly you hear your name called out amid the din? The peculiar ability to hear meaningful sounds selectively through white noise is called the cocktail party effect. In a similar vein, one of Mack's experiments revealed that people are able to pick out their own names from a list of names even when under the spell of an inattentional state. If, however, the name is off by just one letter—Molly instead of Milly, or Bob instead of Rob—it tends to go unnoticed.

To add another layer of smoke, I'll usually throw out some questions. *Are you right- or left-handed? Can you feel the coin in your hand?* Responding to questions is a lot like trying to count the number of passes in the gorilla video or comparing the vertical and horizontal lines of a cross. Parsing a question, accessing the necessary information, and formulating an answer are fairly demanding cognitive tasks, enough to bring about an inattentional state.

Once the watch is loose, I slip it off your wrist and, while you ponder the apparent anticlimax (the coin didn't jump), I put the watch on my own wrist behind my back. Then I do a card trick to offset the awkward moment. I usually have to bite my lip at this point to keep from laughing, because your watch is on *my* wrist as I'm doing the trick, and you're looking right at it. No matter how many times I do this, I always think my victims are going to notice.

But do they?

OVER THE COURSE OF SEVERAL months, Mack and I repeated this very same procedure in her lab, on subjects of varying age, gender, and race. Out of fifteen subjects in all, only three no-

ticed, giving us a success rate of 80 percent. (As a comparison, the gorilla video fools between 50 and 60 percent of people on average.) We caught the whole experiment on tape, a cute little evidence film of crimes being committed in the name of science.

The most dramatic episode we filmed was the third trial, when the alarm on the watch I was stealing went off halfway through the scam, beeping loudly as I undid the buckle. At that point, I was sure the jig was up—but no, the woman didn't even blink. This really took us by surprise as it provided dramatic evidence of inattentional *deafness* in addition to tactical insensitivity. Furthermore, in two separate trials—including the one in which the alarm went off—the prong stubbornly slipped back into one of the holes on the strap as I tried to pull the watch loose. As a result, I had to stall for time, re-grab the wrist, and unbuckle the strap again. I was afraid such a bold move wouldn't fall beneath the critical threshold, and yet the two subjects in question were none the wiser.

In five out of the fifteen trials, we blindfolded the subjects and told them to focus on any strange sensations they felt. "I'm going to grab your wrists," I said before starting. "I want you to tell me if you feel anything out of the ordinary." I didn't talk or say their names or ask questions throughout the trials—and yet, of those five, only two noticed. We conducted postgame interviews and recorded the responses, which included statements such as:

> *I didn't feel a thing.*
> *I can't believe it.*
> *I didn't notice it until you told me.*
> *I felt you tugging at one point, but I had no idea you took my watch.*

I would never have thought it possible.
So you're not a smooth-talking murderer. (I recruited some
 people off the street.)

 Everyone expressed a similar strain of disbelief. It may
not have been the most rigorous experiment in history, doing
magic tricks and stealing watches, and one of our subjects, a
bassist from the music school, may have been stoned, but we
nonetheless gathered enough solid evidence from sober adults
to provide a clear demonstration of tactile insensitivity under
conditions of sustained inattention.

 When we started our experiment I'd been stealing watches
regularly for a while—yes, I always gave them back—and I was
constantly amazed at how easy it was. Scanning people's wrists
had become second nature—it was one of the first things I
would do when I met someone—and as soon as I walked into
any sort of social gathering I started casing the room so I knew
whom to target. I like to keep a running tally of the total value
of all the watches I've stolen. After Mack's experiment, I esti-
mated my yield at around $50,000, although I should qualify
this by saying that about half of this came out of one big score:
a $25,000 Patek Philippe I lifted off an attractive blonde at a
fancy dinner party.

 Truth is, I'm a serviceable pickpocket at best. My achieve-
ments are peanuts compared with those of professional theatri-
cal pickpockets like Apollo Robbins, a Vegas-based magician
turned stage thief who makes his living robbing audiences blind,
and who can boost just about anything—wallets, glasses, even
neckties—right off people's bodies without getting caught.
Robbins is famous for, among other things, stealing the presi-
dent's itinerary from under the nose of a U.S. Secret Service
agent who may or may not still have a job. I would never reach

Apollo's level. But I was beginning to feel like I understood the psychological principles that enabled him to get there.

My time in Mack's lab taught me a lot, and I hope I gave something back, too. It also made me wonder: If neuropsychology ought to be a standard part of every magician's core curriculum, as William Hirstein had suggested, what about the reverse? Should magic be routine training for neuroscientists?

It appears that, for some, it has become just that. Mack and I weren't the only ones who'd hit on the idea of using magic to study perception. In fact, the neuroscience of magic has become a cottage industry, a burgeoning field dubbed "neuromagic" by its founders. A number of A-list conjurors—including Apollo Robbins, Teller, and James Randi—spoke at the 2007 meeting of the Association for the Scientific Study of Consciousness, alongside the scientists and philosophers you'd expect to see giving talks at this sort of gathering. And the 2009 meeting of the Society for Neuroscience, the world's largest neuroscience conference, featured a panel discussion with Apollo Robbins and corporate magician Eric Mead, on "Magic, the Brain, and the Mind."

Recently, a team of neuroscientists at the Barrow Neurological Institute in Phoenix, the oldest stand-alone neurological institute in America, teamed up with several famous conjurors in the hope of modeling scientifically what these performers seemed to understand instinctively about human perception, citing "a rich and largely untapped source of insight into perception and awareness" and "a long legacy of informal experimentation" among magicians. Taking the mountain to Muhammad, as it were, these high-class neuroscientists were attending magic conventions and tournaments and staging magic shows in their labs as part of a grant-funded plan to use tricks as an experimental window into the human mind. Ac-

cording to my sources, the lead researcher of the Barrow group recently enrolled in the same three-day master class with Jeff McBride and Eugene Burger that I took when I went to the Vegas-based Magic and Mystery School. Sometimes reality is stranger than illusion.

ROUGHLY THIRTY MINUTES INTO THE film *Pretty Woman*, Vivian, the hooker with a heart of gold played by Julia Roberts, is enjoying a pancake. She takes a bite, and the camera briefly cuts away. In the next shot the camera is back on Vivian, and the pancake has magically transformed itself into a croissant. Another few moments pass, and it turns back into a pancake— a total of two transformations in the span of thirty seconds, an impressive feat even for a practiced magician.

Though it may be tempting to view this incredible morphing breakfast pastry as a metaphor for Vivian's own *Pygmalion*-like transformation from prostitute to princess, it's really only one of about two dozen editing mistakes in *Pretty Woman*, including a blooper in which a member of the crew is visible on-screen. Does this make *Pretty Woman* a bad movie? An amateur effort? Of course not. Flat acting and a syrupy, corn-pone story are what make *Pretty Woman* such a dreadful film. In terms of errors, it's below par. *The Godfather*, for instance, has fifty-six mistakes; *Star Wars* has an astronomical 271, not counting the scene where it sounds a lot like Luke calls Leia "Carrie."

Virtually every movie has dozens of so-called continuity errors, discrepant bits of unreality left behind in the final cut, the inevitable artifacts of an editing process whereby films are spliced together piecemeal from thousands of clips. Hardcore movie buffs have made a pastime out of scavenging for these

film flubs, but as far as the average moviegoer is concerned, they might as well not exist, because in a very real sense they don't. Even when the errors are quite glaring—like the one in *The Godfather* when the front windshield of Sonny's car is magically restored after being machine-gunned to shards at the tollbooth—we usually don't notice them, any more than we notice the shutter opening and closing twenty-four times per second on a projector or, for that matter, the very fact that a movie is nothing more than a series of still images flashing by in rapid succession.

The failure to notice changes in consecutive scenes, in film and in everyday life, is called change blindness, and like inattentional blindness, it is fundamental to magic. Try this trick on someone. Secretly remove the eight of clubs and the nine of spades from a pack of cards and place them on top of the deck. Now take out the nine of clubs and the eight of spades—a similar-looking pair—and show them to your audience, saying, "I'll take the eight and the nine and place them in the *center* of the deck." Insert both cards into the middle of the pack and square it up. Pause for a moment—misdirection time again—and announce to your audience that the cards will rise to the top. Make a magical gesture and flip over the top two cards. *Ta-da!* This trick may sound silly, but it stumps almost everyone—Wes fooled me with it at the pizzeria—because most people mistake the pair you pulled off the top for the two cards you placed in the middle.

A lot of people probably have an anecdotal familiarity with change blindness. Have you ever altered your appearance—a new hairstyle or color, braces taken off, a change in weight—only to find that nobody noticed? Cosmetic surgeons routinely report that their work goes undetected, even when quite substantial.

Misdirection further hampers our ability to detect changes from one scene to the next. Consider the so-called face test, in which a volunteer is shown two faces in quick succession on a computer screen. Under normal circumstances, virtually anyone can distinguish the two faces, provided that they're shown within the span of half a second. But if the subject is diverted by a task such as counting, or by a flicker on the screen, the faces begin to look the same.

To probe the limits of change blindness, Daniel Simons and his colleague Daniel Levin created their own movies filled with glaring continuity errors—far worse than anything Hollywood would ever allow. In one demonstration, the two researchers showed participants a short film of an actor typing behind a desk. Halfway through the film, the camera cuts away for a few seconds, and when it swings back, a different actor is now behind the desk. The vast majority of viewers fail to detect the switch, despite the fact that they have no trouble following the scene and describing various elements of it later on.

This con works live, too. In another set of experiments, Simons had an experimenter stop random pedestrians on the street and ask them for directions. While the unsuspecting stranger was giving the experimenter directions, a pair of stooges carrying a door walked between them, temporarily blocking the stranger's view. During this brief moment of interruption, the experimenter switched places with one of the stooges. Moments later, the stranger was giving directions to a completely different person—and yet, strange as it may seem, most of the strangers never missed a beat. They just kept on talking as though nothing out of the ordinary had happened.

What is going on in the brain during these bizarre lapses? Is

there a physiological explanation for how misdirection affects our neurons? To answer these questions, scientists figured out a way to induce inattentional states artificially, using a transcranial magnetic stimulator, the machine that briefly disrupts neural activity in localized brain regions by zapping them with a magnetic field. In one study, a TMS was used to disable the parietal cortex, a sliver of neurons behind the ear that aids in concentration. Subjects were then given the face test. Those in the control group passed with flying colors. But for those who took the test with the magnetic coils turned on, the faces blended into one another. This, in essence, is your brain on magic: misdirection paralyzes part of your cortex, putting it out of commission as effectively as a magnetic stun gun.

The experimental evidence suggests that the movie in your mind may lag behind reality by up to a quarter of a second—an eternity when you consider that it takes only about a tenth of a second for nerve impulses to shoot from the top of your head to the tip of your big toe—and if too much stimulus impedes on your faculties in a short amount of time, the film begins to degrade. "Even an image that strikes the retina one tenth of a second after a prior image can cancel out conscious perception of the first image," observes Caltech neuroscientist Christof Koch. But there is an even more striking implication to this research: consciousness—like the saccadic eye movements that make up much of our vision—might not be a smooth stream so much as a series of discrete images that appear continuous only after our brains fill in the gaps. The same mechanisms that magicians exploit to make a coin vanish and reappear, in other words, may also account for the continuity of our daily experience.

· · ·

OUR BRAINS EVOLVED DURING SIMPLER times. The human mind is optimized for environments that are slower and less saturated than the ones we currently inhabit. By and large, the Cro-Magnon world moved at a more leisurely pace. But speed is the hallmark of modernity, and we sapiens left our cognitive comfort zone behind on the open steppes of the mother country well before hunting and gathering finally gave way to drive-thrus and the information age. Shaped by millions of years of evolution, the human brain is remarkably proficient at what it was designed to do. But because the selective pressures that shaped our brains were radically different from those we encounter in the modern world, there are limits to how much of our high-tech environment we can consciously take in at once. As the window of optimal response times gets shaved down, and the gap between perception and awareness widens, lapses are inevitable. Pressed to the limit, our minds are bound to falter.

The good news is that we can train ourselves to be more mindful. In a new generation of experiments, Christof Koch and his team at Caltech are running tests with subjects who've been coached over the course of several days at executing so-called divided attention tasks: watching the cross and keeping an eye out for the car. The results show that, to a certain extent, we can sharpen our perception, much in the way that through proper drills anyone can learn to speed-read or sing better or sharpen their memory.

Magic, I found, taught me to divide my attention more effectively. After a while I got accustomed to ignoring the pyrotechnics and focusing instead on the magician's sleeve. I conditioned myself to watch both hands at once, and it was an amazing feeling when I realized I'd never done this before. The technique that I found worked best was to focus on the

least prominent elements of a scene—the hand that isn't waving the wand, for instance—because you're naturally inclined to notice the more salient ones. Analogously, when listening to Bach's lute suites—on the guitar, John Williams's recording, some of my favorite pieces of music—I mentally foreground the bass and keep the high end in the back of my mind. This helps me hear both voices more clearly, teasing out a level of complexity in the music that is hidden to the casual listener. It's like paying attention to all the players in a basketball game, rather than just the ones closest to the ball. Though difficult at first, after a while you acquire a knack for it, and the game takes on a whole new meaning. As I continued to hone my skills, I noticed that my powers of observation improved, and that the psychological tools I learned from doing magic pushed me toward a greater awareness of things I'd previously overlooked.

No matter how enlightened or Zen-like, however, a practiced way of seeing will never completely eradicate our mental glitches, because the organizational mechanisms by which cognitive illusions such as inattentional blindness arise are hardwired into the machinery of the mind. "Usually when we're fooled, the mind hasn't made a mistake," wrote magician and inventor Jerry Andrus. "It's come to the wrong conclusion for the right reason." The ability to concentrate for extended periods on complicated tasks is a signal virtue of the human brain. But the flip side of being able to stay focused and ignore peripheral distractions is that we don't always notice things outside the narrow spotlight of our attention. "What we're good at as adults is weeding out and inhibiting all these other parts of a scene," explains Alison Gopnik, a psychology professor at the University of California, Berkeley, and author of *The Philosophical Baby*.

Children, on the other hand, aren't nearly as good at ignoring peripheral distractions. As a result, they have a much wider attentional focus, which may help explain why magicians often have a hard time fooling them. I myself have slayed Nobel laureates with novice moves, but a group of nine-year-olds will often rip apart my best material. There may be a prosaic reason for this, which is that kids, being shorter on average than adults, are privy to certain bad angles and exposed lines of sight that adults typically don't see. In general, magic tricks are best viewed from above or head-on. That said, a lot of experts will also tell you that it has to do with the aikido-like way in which magic flips our expectations and our ability to focus against us. Because kids don't know what to anticipate, they tend to pay equal mind to everything, making it harder for magicians to execute secret moves without being caught. "One of the things that magicians are really good at is getting people to consciously attend to one part of a scene," says Gopnik. "We know that children are much less good at doing that. As a consequence, they're open to parts of a scene that aren't available to adults." It's as though gullibility is an acquired behavior, and children have not yet learned how to be deceived.

The adult brain may be limited, but we can learn a lot about it by studying its limitations. For one, blind spots such as those uncovered in Mack's laboratory nudge us toward a deeper understanding of how the brain constructs an internal representation of the world from multiple threads of incomplete information. It quickly becomes apparent that these mental representations, for all their stability and richness, are subjective constructions cobbled together from patchy, mismatched, and ambiguous fragments that are themselves subject to distortion, embellishment, and even outright fallacy. They are, to a certain extent, illusions.

Philosophers of the mind have invented a funny word, *quale*, to describe the subjective nature of first-person experience. Roughly speaking, qualia are ineffable sensations that can't be mapped onto external reality. Color is the classic example of a quale. What is color, it is asked—an intrinsic property of an object or something our brain fills in after the fact? Do we colorize the movie in our mind, so to speak?

This question gets to the heart of an ongoing academic food fight over how much in our minds is a construct and how much is objectively real, with heavy hitters in both camps. At one extreme is philosopher Daniel Dennett pushing what he calls "the illusion of consciousness," a theory that nearly everything we perceive is a Technicolor fantasy. Much of the research on change blindness and inattentional blindness seems to support this theory.

When we examine consciousness up close, it starts to look a bit like the quantum realm. Memories pop in and out of our minds like subatomic particles. Images and sounds tunnel through our senses. Perception, we find, is suffused throughout with uncertainties that would make Heisenberg blush. There's no denying that the brain is up to some pretty sly stuff. "Magicians know that a collection of cheap tricks will often suffice to produce 'magic,' and so does Mother Nature," Dennett notably observed. Consciousness may well be the greatest magic show of all.

THE MENTALISTS

In 1948 the American psychologist Bertram Forer conducted an experiment in which he administered a personality test, called the Diagnostic Interest Blank, to a group of thirty-nine college students. A week after conducting the survey, he handed each student a personality description that was supposedly based on the data he'd collected. The students were then asked to rate the accuracy of their profiles on a scale of zero to five, with five being a perfect match and zero being poor. The results were impressive. The average score was a 4.26, meaning that a majority of the students thought the personality descriptions were spot-on. Only 12.8 percent of the students ranked their profiles below a 4.0 ("very accurate"), and none scored theirs lower than 2.0 ("average"). Typical responses from the students included statements such as:

Surprisingly accurate and specific.
On the nose!
Very good. I wish you had said more.
Applies to me individually, as there are too many facets
which fit me too well to be a generalization.

The Diagnostic Interest Blank seemed to be a sharp tool indeed. Except for one thing: Forer never used it. In reality, he had scrapped the test and given every student identical "personality descriptions" that consisted of a list of generic statements lifted from a newsstand astrology book:

You have a great need for other people to like and admire
you.
You have a tendency to be critical of yourself.
You have a great deal of unused capacity, which you have
not turned to your advantage.

Forer had not unearthed some divine trove of universal truth at his local magazine store, but he had discovered a fascinating and surprisingly universal psychological principle, one that lies at the heart of every horoscope and palm reading and psychic divination, a multibillion dollar industry in the United States alone. Forer's original result has been replicated dozens of times—to this day, the average rating hovers around 4.2—and psychologists have since given a name to the astonishing eagerness with which people will embrace stock personality sketches as unique portraits. They call it the Barnum effect, after P. T. Barnum's famous dictum "We've got something for everyone."

One interesting corollary to Forer's original study is that the more personal information a subject willingly discloses, the

higher that participant tends to rate the accuracy of his reading. In a demonstration at the University of Kansas, volunteers were separated into three groups. A person claiming to be an astrologer asked one group for their exact birth dates—day, month, and year. The second group was asked to disclose only the month and year in which they were born; while the third group gave no information. The participants then received identical horoscopes allegedly based on the information about themselves they had given. Remarkably, the three groups rated the accuracy of their readings differently. Those who had revealed no information about themselves gave it an accuracy rating of 3.24, an above-average score but nothing extraordinary. Those who had given the month and year of their birth averaged a 3.76. And those who divulged their exact birth date, 4.38. In other words, the perceived accuracy of the astrological reading was a function not of what the astrologer told them, but of what they told the astrologer. Astonishingly, this means psychics can boost their powers just by letting their sitters talk more.

That's not to say that the content of a reading has no bearing on the result. For one, it must be generic enough not to be flat-out wrong. (Even so, this isn't as important as one might think, because people selectively remember accurate statements while forgetting inaccurate ones, a phenomenon known as selection bias.) Moderate praise also tends to be more compelling than outright flattery or severe criticism. Beyond that, there is remarkable latitude in the kinds of readings that will succeed. Crucially, Barnum descriptions work not because they are sufficiently ambiguous to ring true in most cases, but because, on some fundamental level, people want to believe them.

The use of the Barnum effect—along with demographic profiling, fishing for clues, and good old acting—to feign psychic powers is known as cold reading ("cold" in the sense that

you don't have any prior information about the subject). Cold reading is what psychics and mediums use to convince people they possess extrasensory insights. A good cold reader can appear to read minds, predict the future, and commune with the dead.

I first came across references to cold reading while combing through the literature on mentalism, a branch of magic that includes telepathy, mind reading, palm reading, fortune telling, ESP, clairvoyance, and metal bending—skills that, according to Jeff McBride, are the province of the all-seeing Oracle, stage three of the magician's life cycle. In these books, I learned how to extract private information from people, bend spoons with my thoughts, surreptitiously change the time on a wristwatch, convince strangers that I knew all about them, predict seemingly random events, duplicate drawings made in secret, and many other remarkable feats of the mind.

At first blush, I was skeptical. Does this mumbo-jumbo really fool anyone? The authors sure seemed to think so, enough at least to append their books with stern-sounding disclaimers cautioning readers that the methods therein were for entertainment purposes only. The gravity of these warnings made me laugh. Could this stuff really be that strong?

Being of a scientific disposition, I decided to test it out myself. Could I, a mere magician, become a mind reader? An occasion soon presented itself one night while I was doing magic in the basement of a Midtown bar. I was showing the bartender a few of my latest effects when an attractive thirty-five-year-old woman with saffron hair and misty green eyes rolled up next to me. She asked me to show her something, and almost as a reflex I performed one of my favorite card tricks.

"That's not magic," she scoffed, swiping a forelock out of her eyes. "Show me some real magic."

Fine, I thought to myself, here goes.

I handed her a piece of paper and asked her to write down a name—"someone who's close to you but not in this room"—and then fold it up without letting me see. Taking the paper, I tore it into ribbons and sprinkled the shreds in the palm of her hand. Then I grabbed her wrist, found her pulse, and with my best effort at gravitas steered her into a cold reading script. I asked her when she was born, studying her palms with unblinking intensity. I told her I sensed movement. Geographic, maybe emotional. Deep in her past. A trauma or broken bond. A closeness, followed by a great distance. Not a father? No. Like family, though, a brother perhaps. A love, far away now.

She knitted her brow and flashed a frail smile. *Yes.* A deep wound. The contours still visible on her soul. With conspicuous effort—summoning spirits is hard work—I sounded out the name:

G-e-o-r-g-e.

How did I know? Because I'd secretly peeked at the name in the act of tearing up the paper, an ingenious ruse known as a center tear. There is an entire body of literature that deals with just this one technique.

Color had risen in her cheeks, and her eyes were clouded over.

"George is still with you," I said, growing more confident. "And he misses you too."

The smile was gone, and her eyes were swamped with tears. "How did you . . . *know*?"

Experimenting further with these techniques, I was astounded at how often they worked, and even more so at the reactions I got. Grown men and women would break into tears. One man, a middle-aged guy in a Mets cap whom I met at a

restaurant near Columbia, accused me of spying on him. "You were watching me from across the bar," he said. "You must have been. You were listening in on my conversation. Otherwise how could you know all that stuff?" Others threatened me for invading their thoughts. One woman, a Russian exchange student, insisted we'd known each other in a past life. "We were in love," she said. "And you broke my heart."

There was something truly mesmerizing about this sort of magic. It was scary, because people actually believed it was real. You could start a religion with this stuff. I was beginning to see the rationale behind the disclaimers. I felt an extraordinary sense of power—"Tell me more!" people would plead, grabbing my wrist. "What else do you see?"—and an equally strong sense of guilt. I felt like a liar, which was ironic, because magicians lie all the time. But this was different somehow, and it made me uneasy. Mentalism, like the ability to cheat at poker, is an ethical minefield.

There are really two types of liars, I realized. On one hand you have professional magicians and showbiz mentalists who lie through their tricks, but don't, in general, lie about being magicians. They're what you might call honest liars. "All men are frauds," H. L. Mencken once said. "The only difference between them is that some admit it."

In the other camp are people like TV medium John Edward and telepathic performer Sylvia Browne and metal bender Uri Geller and palm readers and fortune-tellers and a good number of revival tent evangelists and faith healers and cult figures who employ conjuring tricks to promote false beliefs or to profit from people's grief or ignorance or fear, a scam so insidious it makes the Soapy Smiths of the world look like the neighborhood watch. They are what I would call dishonest liars.

The line that separates honest liars from dishonest liars can be a fine one and, not surprisingly, many magicians cross it in pursuit of money and power and fame. Before he became a famous escape artist, Houdini traveled the countryside as a spirit medium, telling fortunes and offering to put people in touch with their dead relatives. Often he'd case the local cemetery beforehand in search of inside information on the newly deceased. Years later, he looked back with shame on this period of his life and dedicated himself to unmasking fraudulent mediums with an almost religious fervor.

Used responsibly, however, mentalism can add emotional depth to a magic performance by giving the audience a reason to care, something that is not always true of garden-variety tricks. (You can make a coin vanish? Great, so what?) Whereas conventional magic tricks have a tendency to alienate the spectators—you know the secret, and they don't—mentalism engages them on a deeply personal level, creating an illusion of intimacy. The focus is on them and their problems, not on the magician. If magic is about being fooled, mentalism is about being understood.

As a mentalist, you appear to possess secret knowledge about other people, knowledge that they are often desperate to have. "Whereas magic creates questions," Jeff McBride says, "mentalism is about answering them." I figured that mastering the techniques of mentalism might help me broaden my repertoire and make my magic more relatable. This in turn would make me a better performer and perhaps even give me an edge at the IBM competition.

To learn more, I went to Las Vegas for MINDvention, the world's largest mentalism convention. MINDvention attracts top-flight mentalists from around the globe; at this year's, more than twenty countries were represented. It was held at

the Palace Station Hotel and Casino, where I'd now stayed half a dozen times. MINDvention was sharing the facilities with a role-playing-game convention known as NEONCON. NEONCON is for people who carry around twenty-sided dice and spend long hours painting miniature soldiers and tiny artillery units for tabletop battles of *Warhammer 40,000*. In other words: hardcore nerds. And yet there were more women at NEONCON than at the magic convention. Like, wow.

I saw several familiar faces as I walked into the main auditorium where the talks were being given, including Jeff Mc-Bride and Mystery School sage Eugene Burger. McBride, in particular, was a presence at almost every convention. He usually sat up front with a notebook and kung-fu-perfect posture, and his laugh was always the loudest in the house: a hearty buccaneer's howl.

With their suits and headset mikes, many of the guests at the convention looked like motivational speakers, and it's no coincidence. A lot of mentalists earn high-dollar fees giving mind-over-market pep talks to major corporations. There's a distinctly business-class vibe to the mentalism industry, and the discussions at MINDvention were frequently loaded with corporate buzzwords. There was talk of compliance technologies, cold calling, spectator control, positioning, and negative closing. "Hooters is a great place to practice cold reading," one speaker told us—which still doesn't seem like a good enough reason to go there. Mentalism, I realized, was one part magic, one part acting, and three parts sales.

Mentalism draws on a constellation of different skills. Some mental tricks rely on sleight of hand and require a great deal of manual dexterity—although it's easier to get away with sleight of hand in a mentalism context than it is during a magic show, because people typically aren't expecting it. The ideal cold

reader has a high emotional intelligence, keen powers of observation, a firm grasp of human psychology, a flair for the dramatic, and an ability to read a subject's reactions on the fly.

Mentalists speak a lot about the 15 percent. A magician should pull off every trick perfectly; a mentalist should not. Mentalism should only be about 85 percent accurate. Otherwise it's too good, and it looks like a trick. "Error is a necessary element in mentalism," observes Eugene Burger in his 1983 book *Audience Involvement*. "Without error, one is simply and very obviously doing magic tricks."

Mentalists are like jugglers in this regard—they appear more skillful by messing up once or twice. In traditional magic, you might pretend to fail at the outset—the so-called sucker trick—but in the end the magician always finds the card, escapes the death trap, nails the landing. Not so for mentalism. The idea is that the sixth sense, like the other five senses, should be fallible, prone to errors. As with juggling, introducing the occasional slipup makes the act seem more plausible. The power of mentalism, a lot of the experts will tell you, is in that 15 percent.

I was particularly interested to hear what people had to say about the ethics of mentalism and the use of disclaimers. The party line on ethics, according to the Psychic Entertainers Association, or PEA, is that pretty much anything goes, provided that no claim is made with the intent to cause a "detrimental reliance," be it financial or personal, on the authenticity of said claim among members of the general public, although what this entails in practice is the subject of considerable debate.

"As soon as you give a disclaimer, you devalue what you're doing," argued Jim Callahan, a lantern-jawed paranormalist who advertises that he can communicate with the dead using pendulums, during a panel discussion on the ethics of mental-

ism. Others, meanwhile, struck a note of caution. "The stuff
that we dabble in is incredibly powerful," said Andy Nyman, a
creative English mentalist and Buddy Holly look-alike. "A lot
of people are desperate to believe."

The very fact that this debate was taking place, and at a
session specifically devoted to ethical issues, was remarkable
in itself. Can you imagine the same sort of talk at a magic
convention? Magic isn't freighted with these kinds of moral
conundrums. No one of sound mind has ever faulted a con-
juror for failing to disclaim supernatural powers. No rational
person thinks David Copperfield is actually being cleaved in
two by a giant buzz saw in his popular Vegas show. And yet,
some years back, when Copperfield started mentally divining
people's phone numbers, many spectators were beside them-
selves. "I enjoyed your show," fans would say. "But the thing
you did with the telephone number, that wasn't a trick was it?
I know the difference between tricks and the real thing, and
that was real."

The producers of Monday Night Magic—a long-running
weekly magic show in downtown Manhattan—used to refuse
to book mentalists who made supernatural claims, and they
requested that all of their mentalism acts provide disclaim-
ers. (Jamy Ian Swiss, the sleight-of-hand master who for years
hosted the show, once said that magicians are the *only* honest
liars.) This policy rubbed many mentalists the wrong way, in-
cluding Bob Cassidy, who wrote the disclaimer used by the PEA
and was one of the panelists at MINDvention. The day I saw
Cassidy speak, he had on tinted glasses and a western-style shirt,
but by far his most distinctive feature was the great white cloud
of retro hair hovering above his head, which looked a bit like
the inside of an unspooled baseball. "Mentalism should not be
presented as a magic act," he insisted. "You lose a lot from it.

I never say I'm psychic. I say I'm a mind reader. Let them fig-
ure out what that means." A tall corporate mentalist in a red
button-down with thinning hair and a black goatee took an
even more radical view. "My concern is not whether I'm lying,"
he said, "but whether I'm lying in a way I can get away with."

No one voiced any immediate objections to this rather cyn-
ical point of view, although later in the evening I met a San
Diego magician with thick glasses and a gray Old Testament
beard who told me he thought magicians had a responsibility
to police the mentalism world and protect lay audiences from
its more unseemly elements. "It's incumbent on people like us
that know the tricks to try and keep the population from being
ripped off," he said. "Especially when you've got troops com-
ing home dead and bereaved families, and psychics are taking
advantage of them." (Shortly after 9/11, television psychic John
Edward began taping segments for his show in which he of-
fered to contact victims of the World Trade Center attacks on
behalf of their loved ones.) "I think we should be out in front
blowing these people out of the water. We should be doing
stings and going into séances and finding out who the bereaved
are and talking to them afterward. Because there's almost no
one else that can do this kind of work."

In fact, magicians have been rooting out superstition and
exposing fake psychics for centuries—although their motives
aren't always pure, and they've often wavered in their convic-
tions. Houdini embodied this contradiction more fully than
any other magician in modern history. "Magicians always
come after mentalists," Bob Cassidy complained, claiming
that Houdini's primary motivation for crusading against spirit
mediums was to "keep his name in the papers." Whatever his
reasons, Houdini spent much of his life debunking spiritual-
ism. And yet, while he may not have been a spiritualist, he

always held out hope for an afterlife. In the decade following his death in 1926, on Halloween, his widow, Bess, hosted a yearly séance with the aim of contacting her husband in the next world. The Houdini séance has since become a ritual re-enacted by magicians all across the country on the anniversary of his death. Following in Houdini's footsteps, the Society of American Magicians now mans an Occult Investigation Committee designed to probe supernatural claims. The committee's general directive has a picture of Houdini on it and reads like something out of *Ghostbusters*. I became a member in 2009, but have yet to be sent out on a case.

PASSING OFF MAGIC TRICKS AS miracles is as old as religion. Ancient priests used steam turbines to power open the temple doors, as if by spirits, when fires were lit upon the altar. Hydraulic statues bawled to worshippers, and wine flowed from pressurized vessels—ancient rites designed to cudgel fear into the masses.

In tracing the history of magic back to the early Christian era, one finds convincing evidence that Jesus himself may have been a magician, and that the gospel miracles—water into wine, multiplying loaves, levitation—were stage tricks drawn from the conjuror's repertoire.

This was indeed the picture of Jesus that endured for centuries after his death, when Christianity was still seen as a pagan religion and Christian apologists exerted considerable effort refuting the charge that Jesus was a charlatan. Further evidence comes from the parallels found between the gospel rites (including the Last Supper and the forty days in the desert) and a collection of spells and rituals from Egypt known as the Magical Papyri, which were compiled between the second

century BC and the fifth century AD. These similarities suggest that Jesus may have studied the practices of Egyptian wizards and miracle men during the eighteen years of his life unaccounted for in the Gospels (age twelve to thirty).

While the facts surrounding Jesus's life are murky at best, it is clear from the Gospels and contemporaneous sources that during his own lifetime, Jesus was seen principally as a miracle worker. It was because of his miracles, some of which were framed as fulfillments of Hebrew prophecy, that he attracted followers and was eventually executed. Miracles were his claim to fame. Archaeological evidence supports this conclusion. In 2008, scientists from the Oxford Centre for Maritime Archaeology uncovered a two-thousand-year-old earthenware bowl in Alexandria's great harbor engraved with what many experts believe to be the first known mention of Jesus. The engraving on the bowl reads simply, "Christ, the magician."

Ironically, church authorities would later anathematize all forms of magic, along with juggling and acrobatics, as the work of evil spirits. For centuries, magicians were persecuted for being in league with Satan, and sleight of hand was condemned as the devil's pastime. Magicians feared death, and many fell victim to the witch-hunting crazes that regularly swept across Europe during the early modern period. The first English manual on sleight of hand, Reginald Scot's *Discoverie of Witchcraft*, published in the late sixteenth century, was meant to save sorcerers' lives by demystifying their tricks. Back when magicians ran the risk of being burned at the stake, this sort of exposure, which today might raise hackles among the anointed, was a strategy for dodging the pyre. In the *Discoverie*, Elizabethan masked magician Reginald Scot defends his fellow conjurers against charges of sorcery by explaining the secular methods behind the dark arts. *(See, it's not real magic; it's just a trick. Put down*

the torch.) The book so infuriated witch-slaying Bible peddler King James I that he ordered all copies of it burned. But the book survived, and for the next two hundred years it reigned as the standard magic textbook in the English-speaking world.

Many modern religious figures have also used conjuring tricks to attract followers. Hindu fakirs and African medicine men have been caught trying to pass off tricks lifted from the *Tarbell Course in Magic,* an eight-volume encyclopedia, as divine works, and Joseph Smith, founder of the Mormon Church, began his career as a treasure hunter who swore he could locate silver mines and lost Spanish gold with a divining rod. (He'd palm a lump of ore and plant it in the trawl.) Smith accumulated a healthy rap sheet before realizing that he could make more money—and have more wives—in the religion business. Still no word on those gold plates, though.

Uri Geller claims to have made his fortune in a similar manner, as a dowser for oil and mining companies. "My money I didn't make from bending spoons," he told an audience of two thousand magicians at the International Magic Convention in London, where he received the Berglas Foundation Award for his services to magic. "I made my wealth from finding oil and gold."

While mentalism techniques go back at least two thousand years, the first recorded account of mentalism being marketed as a form of entertainment is of a 1572 exhibition by an Italian knight named Girolamo Scotto, who became the Holy Roman Emperor's favorite court conjurer. In a command performance for Archduke Ferdinand II, Scotto picked out from an array of coins the very same one the archduchess had selected in her mind. He then proceeded to locate a thought-of word in a book—a *book test,* in mentalism lingo—and duplicate the archduke's handwriting from another room. Scotto's act killed.

Modern mentalism emerged in the nineteenth century, its growth coinciding with the rise of spiritualism. The word *telepathy* was coined in 1882, just as scientists were learning how to send signals wirelessly through the air. It was the dawn of vaudeville and radio, theosophy and spirit cabinets, turban acts and the telephone. Inspired by the discovery of electromagnetic waves and the advent of telecommunications, theories of thought transference and "mental telegraphy" became fashionable among many prominent thinkers. If one form of intangible communication was possible, they reasoned, why not others? For a while, executives at telegraph companies worried that telepathy might signal the death of their business.

In an attempt to capitalize on this trend, many performers began adding mentalism to their acts. In Paris during the mid-1800s, French conjuror Jean-Eugène Robert-Houdin invented one of the earliest-known second-sight acts, a two-person mentalism routine in which a secret code is used to simulate telepathy. With his son Emile blindfolded onstage, Robert-Houdin would thread his way through the audience glancing at objects spectators had brought with them to the show. "Here's an interesting object," he would say. "Yes, please hand it over. I'll ask you to concentrate on it." His son would then identify the object from onstage. The code, which took years to perfect, worked by embedding information in the phrasing of the request. "Here, what is this?" for instance, might indicate that the object in question was a watch. Further specificity could be added by inserting extra words into the phrase. "Here, please, what is this?" might signify a gold watch, for instance, while "Here, look, what is this?" might mean the watch was silver. A similar set of cues could communicate letters and numbers, names and dates, and just about any common object. Forty years later, Yorkshire conjuror Charles Morritt and his partner,

Lilian, improved on Robert-Houdin's act by using a technique called silent thought transmission, in which the cues were embedded not in the words themselves but in the pattern of gaps between them. The length of a pause between two syllables, for instance, might denote the color of an object or the denomination of a coin. These classic code acts have inspired mentalists ever since.

We even see evidence of the mentalist's toolkit leaking over into politics during the days of Boss Tweed, when crooked pollsters rigged ballots with covert writing implements known as swami gimmicks, which can be used to simulate precognition. In the 1920s, mentalists began appearing among the performers listed on cruise ship manifests, and radio mentalism became a staple of popular entertainment. Coming off the success of *The Jungle*, Upton Sinclair wrote *Mental Radio* in 1930, a book about his second wife's psychic powers, to which Albert Einstein contributed a glowing preface.

One of the most popular and well-paid performers of the vaudeville era was a crystal gazer named Claude Alexander Conlin, who began his career as a black hat in Soapy Smith's con man militia and later billed himself as Alexander, the Man Who Knows. The bit that minted him a fortune was his question-and-answer act. Draped in an Oriental robe, Alexander would answer audience questions scrawled on sealed slips of paper by holding them up to an invisible third eye on his forehead and using Barnum-esque language in his replies. He also made millions doing private readings for rich society types.

The man widely considered to have set the standard for contemporary mentalism was Joseph Dunninger, a New Yorker who popularized himself as a radio performer in the 1940s and read the minds of six presidents and one pope. "Never have I witnessed anything as mystifying or seemingly impossible,"

Thomas Edison said of Dunninger's thought-reading act. Not only was Edison fooled, but so were many scientists—along with millions of laypeople who listened to his weekly radio show and later watched him on television. "For those who believe," he would say, "no explanation is necessary; for those who do not believe, no explanation will suffice."

Dunninger's heyday in the 1940s and '50s marked the end of what might properly be called the second wave of mentalism. The third wave hit in the 1970s, when Uri Geller started bending spoons and restarting broken watches on television. Geller's arrival in New York in the mid-1970s was, according to Bob Cassidy, "a big revolution." Mentalism was officially added as an event at the Magic Olympics in 1979, and spoon-bending parties, a staple of the swinging '70s, persist even to this day. University of Arizona parapsychologist Gary Schwartz threw a psychokinetic jamboree as recently as 2001.

The secret to mentally bending a spoon is not, as was suggested in *The Matrix*, to realize that there is no spoon, but to realize instead that you've got to bend the spoon with your bare hands when no one is paying attention. Unless you're using a fancy magnetic metal-bending apparatus, called a PK system, the standard method is to introduce a small bend in the head of the spoon before the trick even begins, hiding this action behind a smokescreen of misdirection. Once the spoon is bent, you hold it vertically by the tip of the handle with the bend facing the spectator—it's best if no one is at your sides—and gradually rotate it downward toward the audience, while twisting it along the vertical axis. Done correctly, the spoon looks like it visibly liquefies in your hands. The illusion is so strong you'll fool yourself with it.

The best metal bender in the world is a ferociously talented mentalist named Banachek, aka The Man Who Fooled

the Scientists. In 1979, while still a teenager, Banachek (born Steven Shaw) and magician Michael Edwards conned a team of scientists at St. Louis's Washington University into thinking the two could bend spoons, keys, and other metal objects with their minds. After 120 hours of tests conducted inside a $500,000 state-of-the-art research facility funded by the McDonnell Douglas Corporation and overseen by a physicist, the researchers were convinced beyond all doubt that Shaw and Edwards had telekinetic powers. The infamous hoax, nicknamed Project Alpha, was made public in early 1983, when Shaw and Edwards confessed that the whole thing had been a put-up job engineered by skeptic James Randi.

Today, interest in mentalism is once again on the uptick, in part due to the sluggish economy. When the market goes south, demand for mentalism rises as people seek solace and an easy escape from their woes. Like guns and booze, gambling and the lotto, mentalism is a countercyclical industry, peaking in times of crisis. These days, more magicians are turning to mentalism as a hedge against a gloomy future. Meanwhile, a new crop of paranormalist shows has hit the airways. "Financially the rewards are much higher right now doing mentalism than doing magic," Docc Hilford, a Miami-based mind reader, told a group of magicians at the Ronjo magic store on Long Island in March 2009. "Just the glimmer, the slight flicker of a possible hope in something, anything, is enough that people will pay for it right now." Hilford is known for being a wicked cold reader. Some years back, he and magician Simon Lovell were stranded at a magic convention without any money. Hilford told Lovell not to worry, and he shuffled off to a local hair salon to do some readings. "Two hours later," Simon recalls, "he came back with $600 in cash." ("He's a carny at heart," Wes said of Hilford.)

A magic store clerk from LA, with whom I had a lengthy conversation about the lure of mentalism, summed up the temptation succinctly: "Why bother doing magic shows when I can make three times that much doing readings for old retired ladies?" he asked. The only answer I could come up with was that I'm the wrong kind of liar.

ON THE LAST DAY OF MINDvention, I got my hair cut at a barbershop down the road from the Palace Station. Next to the barbershop was a karate dojo and a palm reader. Call it fate. I'd never been to a psychic before, and given what I now knew about mentalism, I was especially curious. So I walked in and paid forty bucks for a reading.

The psychic's name was Stephanie and she was middle-aged and slightly overweight, with dark hair and dark eyes and a face pitted with acne scars. She led me into a back room filled with Bible knickknacks: cherubs on harps, dancing angels, and a plastic Jesus with the words "Divine Miracle" printed on it. The walls were plastered with tarot drawings, and I noticed that the calendar hadn't been turned in months. I sat down at a wide glass table, and she asked me for my name and my birthday.

"Good boy," she said, in a hoarse voice. "Now make two good wishes."

I did.

"Good boy. Let's see your right palm."

I held it out.

"Good boy."

She took my hand and told me she sensed movement. In the past two years things had kind of gone upside down for me. It seemed like everything I tried to do was three steps forward

and four steps back. I didn't sleep well. I tossed and turned at night. I worried about all kinds of stuff that was going on in my life. I also had a bit of a hot temper, although it never lasted long. I was kindhearted and I liked to help people. But sometimes when I needed help, there was no one around I could depend on, and I had to fend for myself.

I had to admit: for the most part, she was spot-on.

There was also someone in my family who was sick (check), although there were no immediate deaths on the horizon. I, for one, had a very long life ahead of me. I'd had my heart broken in the past and was tired of playing games (check). I wasn't getting any younger, after all. (Who is?) It was time to settle down and start a family. (Sure, why not?) There would be traveling in my future (yep), profitable investments (no joke?), and a visit from an old friend or relative on the horizon (you mean Nick?).

"Do you often see things people should be worried about?" I asked.

"Yeah," she sighed.

I raised my eyebrows at her.

"Would you like to know about it?"

I nodded. *Pray continue.*

"I pick up that there's some people that are gossiping about you," she said. "I don't know why. You never tried to do anything bad to them. But they just like gossiping about you." Who were these gossipers, I thought to myself with a shudder, and what were they saying? Seconds later, the rational side of my brain lurched into action and, like a stern boxing coach, chided me for letting my guard down.

Marshalling my thoughts, I decided to shift the focus of the conversation away from my issues and instead train the spotlight on Stephanie. If nothing else, I wanted to know how she'd gotten into the mentalism business in the first place.

I asked her how she had discovered her gift, and she shrugged. "It's something you're born with," she said. "I was about eight years old, and I seen this old lady. She was walking. I told my mom that I feel something dangerous was gonna happen to her. And then my mom approached the lady and told her, you know, and she didn't believe her. And me and my mom and the old lady was walking across the street and a truck came and almost hit the old lady and my mom pulled her back. It's a gift that you're born with. It's called the third veil. You're born with a layer of skin on your face, like a little mesh. My mom had it, my grandma had it."

After we finished, she led me out past a room with a massage table and a Tibetan singing bowl for chakra cleansing, and I thanked her and shook her hand.

"Good boy," she said. "You're ready to go."

Later that day, I caught myself brooding over what Stephanie said—that is, until I remembered the source and pushed those thoughts aside. And yet, no matter how hard I tried to dislodge them, they had a stubborn way of creeping back into my consciousness. My memory was playing tricks on me, it seemed. Had I told her where I was from, or had she guessed it? (She'd asked me about my life in New York.) And how did she know my mother was ill? Selection bias set in, reinforcing the hits—what she'd gotten right—while disguising the misses. She said I'd be traveling soon, I recalled, as I boarded a plane back to New York that afternoon. Lying awake that night, I remembered how she'd said I had insomnia.

One of the scariest things about mentalism is that even after you understand how it works, it still feels believable. Subsequent Forer experiments have even shown that the perceived accuracy of sham personality descriptions shoots up when the readings are ascribed to mystical sources such as astrology and palmistry. People want to believe.

In 1988, a young performance artist named José Alvarez catapulted to stardom in Australia by posing as a spirit medium. He called forth phantoms on national television and spoke in tongues at the Sydney Opera House. In the process, he attracted a massive cult following. Later that year, Alvarez announced publicly that he'd made it all up—in fact, it had been yet another prank hatched by serial hoaxer James Randi, of Project Alpha fame. And yet many of Alvarez's fans continued to insist that he was for real.

I had a similar experience some months ago, while doing magic at a friend's dinner party. A few card tricks and a watch steal later, the topic of mind reading came up, and I mentioned that I'd dabbled in the psychic arts. Immediately, one of the guests, a writer in her late twenties whom I'd only just met, asked me to show her something.

At first I was hesitant. After my initial bout of experimentation, I'd cut back on the mind-reading thing. It was a little too creepy. But she wouldn't let it go, and finally I agreed. What's one more reading? I thought. She wrote a name down on a scrap of paper and folded it up while I averted my gaze. Then I tore the paper to shreds. The name was Julia.

"It's not a family member, is it?" I asked, picking up some subtle negative cues. "No, not a family member," I continued. "But like family in a way." Here I was using a technique called the vanishing negative. By phrasing the negation as a question—"It's not a family member, is it?"—with ambiguous inflection, I sound right regardless of what the answer turns out to be. If I sense a yes coming, I go with it—"Yes, that's what I thought." And if the answer is no, I simply restate the question as a declarative statement: "No, it's not a family member," and add, "but *like* family." And again, you only *want* to be right 85 percent of the time.

"I think that's what I'm picking up on," I said. "I'm sensing an almost maternal bond between the two of you."

She was blushing a little. I was getting warmer.

"A close family friend, yes?"

She smiled and uncrossed her arms.

"Her name starts with a J—like Judy or Julie."

"Julia!" she cried, ecstatic. "She's my aunt. I mean, she's not my aunt, but she's like my aunt. She's my mom's best friend from high school. I've known her forever."

"I can see her now. She's roughly your height, darkish hair."

She nodded enthusiastically.

"She's good natured, loyal, has a warm sense of humor. You two are a lot alike, I can tell." (We tend to believe that our friends and, to a lesser extent, our loved ones, are either exactly like us or exactly the opposite.)

She was eating it up.

"I'm also sensing some distance—emotional or geographic. Does Julia live nearby?"

She shook her head. "She lives in England."

"That's what I thought. You didn't hear from Julia recently, did you?" Not surprisingly, the person is often someone who's been on their minds lately.

"Yes, I did! I just got an e-mail from her the other day."

I started feeling cocky. Maybe I really was psychic.

"Julia had some news for you, didn't she?"

"Oh my God. She did!"

"It was some important news."

"It was."

"Very important."

"Yes."

"She wanted to tell you"—and that's when I overreached—"she's pregnant."

Her jaw sagged and she eyed me warily. "Um, no," she said, her voice flattening. "She has cancer."

The word *cancer* seemed to reverberate across the room like a gunshot, and a stunned hush fell over the table. Nobody said a word. Later on my friends would confess to me that they were thinking the same thing I was, only they were hoping that I wouldn't say it. But my mouth was on autopilot, and it just came flying out.

"Well," I said, scratching my forehead. "That's like being pregnant with a tumor."

Gulp!

Fortunately, the woman was a good sport, and she didn't take offense. Feeling guilty nonetheless, I apologized profusely and explained the trick to her in detail.

"Okay," she said, brushing me off. "I get the thing with the paper. But don't you think there's something else to it?"

"What do you mean?" I asked, genuinely confused.

"I don't know," she said. "Don't you think there's something there? Some part of it that's real? I mean, you don't believe *any* of it?"

Unable to come up with a satisfactory answer, I recalled what magician Ricky Jay once said, after being asked if he'd ever seen a real mind reader.

"No," he replied. "But I've seen a *great* one."

CLOWNING AROUND

For all the awe that magicians manage to conjure up with their tricks, the world of magic could use a makeover. Let's face it, whenever there are more mullets than women, you know you've got an image problem. The 1980s outfits, the sartorial excess, the endless catalog of fashion don'ts. I mean, are all those rhinestones really necessary? Then there are the stock lines, the verbal rim shots, the lame brick-wall wheezes, the shopworn stand-up comedy clichés. And the stale knee-slappers aren't even the worst offenders. I once saw a balloon magician crack a Holocaust joke in front of two hundred people, many of them children. "I see very little address given to presentation by most of the people that you see in magic," Wes told me. And he was right.

I'd come a long way in my study of magic. I'd learned hundreds of techniques and dozens of new tricks. I talked the

talk and walked the walk. When I showed up at the pizzeria now, people asked *me* for advice. I was no longer a tenderfoot, the new kid at the table. I could hang with the best of them. Wes and I had gotten to know each other well enough to complete each other's sentences. Whereas he'd once been gruff and antagonistic toward me, he now greeted me as an old friend—a gruff and antagonistic old friend, but an old friend nonetheless.

Technical prowess and grade-A foolers, however, will only get you so far. You can nail every note of a piano concerto, but that doesn't make you a great musician, while even a three-chord progression can be breathtaking if played with real feeling. The same is true for magic. All the moves and sleights in the world are useless unless you can make an emotional connection with your audience. At the end of the day, magicians are performers. And yet magicians often invest tremendous effort into trying to fool people while forgetting that magic is supposed to be entertaining and beautiful. I was certainly guilty of this. I'd spent a lot of time learning how to trick people and very little time trying to connect with them. I needed to change that. It also occurred to me that it might be a good idea to pay a little more attention to life outside of magic, something I hadn't done in quite a while. Come to think of it, maybe that's why I felt disconnected from my audiences.

The routines that triumphed at tournaments and in front of lay audiences, I had noticed, were more than just a series of tricks strung together like Christmas lights. They were tightly scripted, character-driven performances with clear storylines and sharply defined themes. They were often very funny. They engaged the audience on multiple levels. Of course, they packed plenty of Bible-size miracles, too. But the best acts were more than just fool-a-thons. They had emotional depth, some-

thing missing from a lot of magic, including mine. I'd built up my chops considerably, but I still had a long way to go toward becoming a better showman. "If there is a reason that explains the success of all the greats," said the Spanish master Arturo De Ascanio, channeling Polonius, "it is that they have learned to know themselves and have thus been able to exploit and take advantage of their own personality." His student Juan Tamariz reaffirmed this philosophy at the FLASOMA convention in Peru. "The most important thing in magic is not the secret, the method, or even the emotions produced," he said. "It's the person."

I consulted Wes and the pizza parlor crew, and they urged me to forget about magic and focus on theater. "Magic is a subset of theater, and as such it has all the same responsibilities," Wes growled, while I scarfed down a heaping plate of pasta primavera. (The food at Rustico II had grown on me; I was now in love with their linguine.) "Magicians' egos get in the way," he continued. "We like to think of magic as an art unto itself, not just as a subset of theater. But that's what it is. If magic is gonna work, the audience has to care about it, same way they have to care about a story in a play or sit-com or whatever. Otherwise it's just a fucking card trick, and who gives a shit."

A self-proclaimed dramaturge, Wes advised me to work on stage direction and blocking, choreography and persona. "In some way it's easier for us because we have something that has the potential to be interesting, because it breaks the rules of the universe. Of course just the fact that it breaks the rules of the universe doesn't make it interesting in and of itself to most people because it has no relevance. If you can give it relevance, now it's interesting." Bob Friedhoffer, who was also at the table, put an even finer point on this line of reasoning:

"You're a fucking move monkey," he grunted, after I flaunted the spin change I'd seen at the Magic Olympics, and which I could now do in both hands simultaneously. "No one gives a fuck about your moves."

ELEANOR ROOSEVELT SAID WE SHOULD do one thing each day that scares us. Today I was doing two. I was facing my stage fright—ever since the Magic Olympics, I'd been terrified of performing in front of large crowds—and my fear of clowns. Let's just say I read too many Stephen King books growing up. Coulrophobia is no joke, if we are to believe the British media's take on a 2008 study of young hospital patients in the United Kingdom. According to the press, patients hated clowns and found them terrifying.* Even so, I'd persuaded myself that a class on clowning might help make me funnier and more relaxed onstage.

Wes had convinced me that magicians should study other forms of performance art. "We're all in the same game," he said. So I started exploring the interface between magic and the allied arts, things that surround magic and give it its shape. I took dance lessons and learned the rudiments of juggling. I took yoga to improve my posture. "Anything that makes you aware of how you're moving and gives you control over it is use-

*I dug a little deeper, and it turned out that this study was not what the media had made it out to be. The study had nothing to do with clowns and mentioned them only in passing. In fact, there are mountains of evidence showing that clowns (as well as comedians and magicians) have helped hundreds of thousands of hospital patients. And that's only the beginning. There are clown ministries and clowning troupes that engage in social protest on behalf of the disenfranchised. Clowns and jugglers and magicians have ventured into war zones and refugee camps to provide at-risk children with much-needed psychological relief. In short: Clowns good, British tabloids bad.

ful," Wes told me. (Wes, I was surprised to learn, was a practicing Hindu and a trained yogi who gave up meat and took up meditation at the age of sixteen.)

I took a comedy-writing workshop. I took improv classes. I took screenwriting. I took voice lessons. Following the advice of Eugene Burger, whose voice is as deep as the Mariana Trench, I read poetry on tape to improve my tone and my diction. "This teaches you how to pause," said Burger. "It takes courage to pause. Most magicians are terrified of silence." I attended a balloon-twisting seminar at Fantasma Magic, taught by a guy who called himself Twistin' Todd. (The workshop was strictly BYOB—Bring Your Own Balloons.)

And now I was going to clown school.

The class was held on the fourth floor of a gutted Hell's Kitchen warehouse, two blocks east of the Hudson River. I had a brief existential crisis when I saw the shakily scrawled sign that read CLOWN WORKSHOP, with an arrow pointing to the left. Where had my life gone wrong? The other members of my peer group were busy getting promotions, buying land, and having children. They were professors and doctors and corporate lawyers. Not me. I was in an old warehouse taking clown classes. Honk! Honk!

Our teacher was a handsome man in his early forties named Christopher Bayes. He had high cheekbones and wavy hair to his chin. He looked more like Eddie Vedder than Bozo, and I was relieved to find that he wasn't togged up in floppy shoes and face paint. Just jeans and a T-shirt.

"The clown is the physical manifestation of the unsocialized self," he opened. "It's the essence of the playful spirit before you were defeated by society, by the world. You see the peak of clown at two or three years old." He paused, searching. "But the clown is shy to come out, because it's been betrayed. We

betray it, in high school generally. We betray our enthusiasm and, by so doing, betray the clown."

Wow, I thought to myself, this was one wise clown.

Bayes broke us off into pairs and told us to improvise a scene using only three words: *ta-da*, *aha*, and *ha-ha*. This exercise was supposed to help us coax out our inner clown. My partner was a willowy blonde and recent NYU grad named Rebecca. "I have a background in dance," she had told the class during a round of introductions. "And I need something to do with my life." This seemed to be a fairly common theme among the workshop participants, which I found somewhat surprising. It had never occurred to me before that clowning could fulfill this particular need.

We started on opposite ends of the studio. As soon as Bayes yelled go, I sprinted across the room and ran into the wall at full speed. Crashing into the concrete harder than I expected, I crumpled to the floor like an empty coat.

The entire class groaned.

"Why'd you do that?" our teacher asked.

I scratched my head.

"It makes it kind of hard for her if you die in the first five seconds," he said.

"I didn't die," I said. "I was just injured."

"Play with her! Play together! No death and killing."

Bayes gave us a fanfare, and we started over. This time I was supposed to engage my scene partner rather than commit seppuku, so I pantomimed pulling a flower from behind her ear. (Hey, it's what I knew.)

"Ta-da!"

She laughed approvingly. "Ahaha."

Bayes gestured toward Rebecca. "You do one now!"

"I don't know any magic tricks," she said, breaking scene.

Her voice was a slide whistle, the "Bankrupt" sound on *Wheel of Fortune.*

"Invent one!" Bayes shrieked.

She made an object vanish and then reappear.

"Ha-ha-ha!" I bawled, clutching my stomach.

Next, I pretended to cut her in half with a chainsaw while making screeching noises, and Bayes told Rebecca to scream. She let out a high-pitched, maiden-on-the-tracks squeal.

Then I yelled, "Ta-da!" And she was restored.

It was her turn again. I climbed inside an invisible box and she put her right hand on her hip. "Does it have to be a magic trick?" she asked, breaking scene a second time.

"Yes!" Bayes snapped.

She waved an invisible wand over the box, and I was transformed into a giant tiger. Chasing what seemed like the obvious joke, I lurched at her—*ROOOOOAAAR!*—and bit ferociously into her neck and arm. She toppled to the floor, all ninety pounds of her wilting like a hothouse flower. Evidently I'd gone a little too method. The audience gasped, as if legitimately concerned for her safety. And, to be fair, she looked genuinely scared. With a flash of remorse, I loped back to my chair with my tail between my legs. *And . . . scene.*

THE CLOWN IS A UNIVERSAL figure. From court jester to commedia dell'arte harlequin to Charlie Chaplin and the Marx Brothers, Homer Simpson, and Jacques Tati, every culture has clowns. In many ancient civilizations the clown and the magician were one and the same. In some Native American tribes— like the Hopi—the clown was an antenna to the spirit world. Today, when a circus clown is resurrected onstage—after being hit over the head with a sledgehammer or fired out of a

cannon—we're witnessing the cultural vestiges of an ancient necromantic ritual. This archetypal connection to the spirit world may explain why clowns are habitually recast as demonic figures—as in *Poltergeist*, say, or Stephen King's *It*.

In the Western tradition, clowns mediated the link between the pious and the profane in rituals going back to the Roman Saturnalia and extending on through Christian customs like the Feast of Fools, an annual send-up of the local clergy, observed on the first of January for more than a thousand years throughout Christendom, in which the peasant classes danced through the streets in bishop's miters while harlequins lampooned the pulpit from the shelter of the court. (The Church officially banned the ritual in 1431.) For centuries, comedy and clowning were a standard part of the Easter service. The story of Christ's martyrdom was told through mock sermons, off-color jokes about the apostles, digs at the saints—a practice known as *Fabula Paschalis*, or "Easter Tales." Today we feel the syncretic aftershocks of this custom at Mardi Gras and Carnival. Easter, after all, began as a pagan ritual, an equinoctial celebration of rebirth and renewal tacked on to a dozen different resurrection myths well before post-apostolic Christian proselytizers repurposed it to commemorate Jesus's last big illusion.

An analogous strain of burlesque gave rise to the magical incantation "hocus-pocus," a phrase concocted in the seventeenth century to mock the liturgy of the Eucharist, which in Latin contains the words *Hoc est corpus meum* ("This is my body"). With the word *hocus-pocus*, the magician parodies the miracle of transubstantiation, the Church's showstopper. The magician, one might say, is a clown let loose in a church; magic, a satirical reappropriation of religious custom. That *hocus* sounds like *jocus* (Latin for "prank" or "jest") is also telling, as are the linguistic links found in many languages between the words for

magic trick and the word for game or amusement. In English, we may call them tricks. But for many magicians that word has a negative connotation. I prefer the Spanish term *juegos de mano* (games of the hand) or the Italian *giochi di prestigio*.

These parallels remind us that the experience of magic is essentially a comic one. If you tape a magic show and study the crowd's reactions you'll discover that laughter is the most common response, more so even than the oohs and ahhs of wonder. When the card rises to the top of the deck, when the coin vanishes and reappears, we laugh. Why is this? What makes magic so funny?

"The main trigger for laughter is surprise," Bayes told us, speaking of how the clown gets his laughs. "There's lots of ways to find that trigger. Some of them are tricks. Some of them are math. And some of them come from building something with integrity and then smashing it. So you smash the expectation of what you think is going to happen."

The same goes for the magician. Magic transports us to an absurd universe, parodying the laws of physics in a whimsical toying of cause and effect. "Magic creates tension," says Juan Tamariz, "a logical conflict that it does not resolve. That's why people often laugh after a trick, even when we haven't done anything funny."

Tamariz is also fond of saying that magic holds a mirror up to our impossible desires. We all would like to fly, see the future, know another's thoughts, mend what has been broken. Great magic is anchored to a symbolic logic that transcends its status as an illusion. "Magic is an art that has two defining characteristics," according to Tamariz. "It must be impossible and it must be fascinating. It must be impossible, because otherwise it's not magic. And it must be fascinating, otherwise it's not art."

The physical absurdity of a card rising to the top of the deck after being placed in the middle, for instance, is only part of what makes a trick like the Ambitious Card so memorable. It also tells a story. At its core, the Ambitious Card is metaphor for liberation, a tale of triumph told in miniature. Imprisoned in the deck, the card breaks free, defying our every attempt to pin it down. It's the close-up equivalent of a Houdini escape. How fitting, then, that this was the one puzzle the great self-liberator couldn't solve.

Like clowning, magic is also an art primarily geared toward children, actual and inner. "For kids, the game never stops," Bayes mused at the end of our workshop. "The game is just transformed. That's why it's so hard for kids to sleep. Because they refuse to admit there's no more possibility for fun."

I WAS DRAGGING MY HEELS up the stairs to the second day of clown class when I poked my head down a long hallway on the third floor. I wasn't looking for anything in particular, except maybe a way to kill time. At first I thought the hallway was empty, just another bombed-out wing of the warehouse, and I turned to leave.

It was then that I spotted an attractive woman in tight gray jeans and cowboy boots sitting cross-legged in a chair against the wall. She was tall and slender, in her mid-twenties, with pale cheeks and straight brown hair and wide-set eyes, beautiful but not in that overly manicured, Manolo'd way you often find in New York. She looked up from a clipboard resting in her lap. "Are you here for the audition?" she asked. Apparently there were non-clown-related activities going on in the building.

"Oh . . . um . . . no," I stammered.

She looked puzzled. I wanted to talk to her, but my mind was pinwheeling. C'mon Alex, say something smooth! Something that'll make her like you!

"I go to clown school," I said, pointing at the ceiling. "One floor up."

Yikes.

It was a rough beginning, to say the least, but I managed to strike up a conversation. Her name was Kate. She was an actress. Lived in the city. I rambled on in my usual obnoxious way, panting in double time. Later she would confess that she had found me annoying at first, but that gradually I grew on her. At the time, though, I felt certain she was going to red-light me at any moment. Sweat beaded on my brow as I angled for a laugh. I asked if she wanted to see a card trick. Sadly, this was my A-game.

She slanted a dubious look my way. "Okay," she said icily. "Sure."

I showed her Paul Harris's Bizarre Twist, a minimalist miracle in which an ace flips over despite being trapped between two other cards, then changes color in front of the spectator's eyes. Everything is examinable, and only three cards are used—a real gem of a trick. (Paul Harris is a true visionary.)

Surprise flickered across her face. "Wait. What?" she said, brightening. "Show me another."

I followed up with John Guastaferro's Tailspin. Four face-up aces turn facedown one at a time, then instantly transform into *another* four of a kind named by the spectator. It doesn't get much prettier than this. I fumbled through the Elmsley counts, which were still giving me trouble—Wes had been coaching me on this move—but managed an able rendition in spite of my nervousness.

Kate let out a warm laugh. "Wait," she said. "Are you kid-

ding me? Show me how you did that." Here was my chance, I thought. It was a long shot, but I had to go for it. "I'll tell you what," I said, trying to sound nonchalant. "Meet me for a drink later, and I'll show you." The few seconds of silence that followed were like an hour-long wait for test results at the doctor's office after spring break. Her lips puckered, and she raised an eyebrow. Then she smiled and said yes.

After the drink came pizza in the Village. Cherry blossoms in Brooklyn. Indie films and Italian dinners. We got matching temporary tattoos. Not only did she love card tricks, but she thought physics was cool—sexy, even. I felt like I had the first time I walked into my therapist's office and saw a copy of *Ulysses* on the bookshelf: she was a keeper.

Kate turned out to be more helpful than any drama workshop or chapter on Stanislavsky. She showed me how to block out an act, find my light, and project onstage. She became my acting coach, my Fosse. She was a talented actress and she had good taste. Whenever I'd start flourishing my fingers or revert to stock gags and magical clichés, she'd put her foot down and say, "Just be yourself." Or if I made an off-color joke, she'd frown and let me know that "magic is creepy enough as it is. It really doesn't need your help."

When we first met, I was about to shell out a thousand dollars to study the sleeving methods that won Rocco Silano, an Armani-sheathed spellbinder from New Jersey, the Most Original Act award at the Magic Olympics in Stockholm. With Dean Martin playing, Rocco converted gas into water, water into ice, a corncob into popcorn, a kiss into lipstick, and distilled fruit, juice, cigarettes, pipes, ice cream, and Campari-filled highballs out of thin air. (I remember thinking that it'd be cool to have Rocco at a party, in spite of the mess he'd make on the floor.) After chatting with him over dinner at a

Monday Night Magic after-party, I was ready to enlist in his boot camp. But Kate knew better. "That's not you," she said. She also found it kind of gross the way he played with his food. When I briefly considered a course in the art of needle swallowing—after spending a bunch of money on the instructional DVDs and beginner kits—Kate nixed those plans as well. "You're a goofy physics geek," she said. "Your magic should reflect that."

Magicians like to pretend that they're cool and mysterious, cultivating the image of the smooth operator, the suave seducer. Their stage names are always things like the Great Tomsoni or the Amazing Randi or the International Man of Mystery—never Alex the Magical Superdoofus or the Incredible Nerdini. But does all this posturing really make them look cooler? Or just more ridiculous for trying to hide their true stripes? Why couldn't more magicians own up to their own nerdiness? Magic was geeky. And that was okay.

A lot of it just came down to acknowledging who I was not. There were a great many magicians I admired but would be hard pressed to emulate. I could never play the guido-fabulous lothario who pulls flowers and Campari from thin air. I would never manipulate cards the way Jeff McBride did. I wasn't a con man or a cardsharp or a psychic seer.

There comes a point in your life when you realize it's easier to accept who you are than it is to change it. For the longest time, I'd tried to shoehorn myself into different identities by imitating other magicians. I would buy magic tricks indiscriminately. At every lecture, I'd scoop up the package deal. I'd order books and DVDs and props as if ordering takeout. I thought I had to learn everything.

Now I began to realize that the vast majority of tricks just weren't for me. That's not to say that they didn't look amaz-

ing in the hands of other performers, just that they didn't suit my personality. I was reminded yet again of renowned English magician David Devant, who once boasted that he only knew six tricks. Because that was all he needed.

"Try to proceed with a kind of playful integrity," Chris Bayes told us. "Because in that integrity we actually find more possibility of surprise than we do in an idea of how to trick us into laughing. You bring it from yourself. And we see this little gift that you brought for us, which is the gift of your truth. Not an idea of your truth, but the gift of your real truth. And you can play forever with that, because it's *infinite*."

These words set my mind in motion. Rather than hopscotching across the globe searching for secrets in distant corners of the world, what if I returned to the subjects that were nearest and dearest to me? What if I went back to what interested me as a math and physics buff? On reflection, I realized that I'd been doing tricks that relied in some way on the connections between magic and physics at least as far back as my disastrous appearance at the Magic Olympics. I now began to see those tentative first steps toward developing an act that combined magic and science as exactly the path I needed to follow. This time, however, instead of being a shtick, math and physics would be the heart and soul of my routine.

I realized right away that this approach might not win me a tournament or land me on television, but it would at least be truthful. "The problem with magic," Eugene Burger told us at the Mystery School, "is that it's often not sincere enough." Magic will always be about deception, but within that framework perhaps one can still find a kernel of authenticity. And while I wasn't exactly sure how math or physics was going to help me craft my routine, with the contest fast approaching, I decided it was worth a shot.

I knew, at least, that the connection between mathematics and conjuring went way back, to some of the oldest magic texts. I also knew that the relationship had always been somewhat strained. In his book *Mathematics, Magic, and Mystery,* Martin Gardner observed that math-based tricks were generally regarded with double disdain: magicians found them nerdy and tedious, while mathematicians dismissed them as trivial. This branch of magic was a bit like a child of divorce being shuttled back and forth between two parents, with neither parent wanting custody.

This disdain was not wholly unwarranted. Mathematical magic tends to be dry and procedural, a consequence of the fact that the underlying principles must be concealed somehow. This is usually accomplished by burying the secret beneath a slag heap of arbitrary moves—cutting, dealing, counting, and whatnot. As a result, the methods are frequently more interesting than the effects. But there are exceptions.

One name that kept popping up was Persi Diaconis, an eccentric silver-haired math genius and one of the world's top statisticians. Magic, however, was his first love, and he'd always remained true to it, even as he climbed through the upper stratospheres of academia—Harvard, MIT, Stanford. In fact, it was in service to this love that he made the climb. At age fourteen, Diaconis dropped out of high school and left his home on Long Island to study with Dai Vernon. For the next decade, he shadowed Vernon, training alongside hustlers and cardsharps in gambling dens across the country. A naturally gifted magician, Diaconis soon became an underground legend.

He also showed an early gift for math—his lightning-fast ability to calculate gambling odds was crucial to his success at the table. So, ten years after he left home Diaconis returned to New York at Vernon's behest and enrolled in night school. A

few years later, he earned a full scholarship to study math at Harvard. Today, he's a professor at Stanford and a two-time MacArthur Fellow, not to mention close friends with some of the world's top magicians. He's also rumored to have one of the most extensive private magic libraries on the planet.

It's rare for a person to become a legend in two fields, let alone two so seemingly distant as math and magic. But from what little he's written on magic, it's clear that Diaconis views tricks through the eyes of a math professor. "Erdnase's methods are not only novel for the time," he wrote in the introduction to Vernon's 1984 classic *Revelations*. "They are the right solutions to important problems." Years later, speaking to a fellow math scholar, he likened the process of designing magic tricks to that of solving math problems. "The way I do magic is very similar to mathematics," he said. "Inventing a magic trick and inventing a theorem are very, very similar activities in the following sense. In both subjects you have a problem you're trying to solve with constraints."

Diaconis has solved a number of famous math problems, many of which were inspired by his love of magic. In 2007, for instance, he proved that a typical coin toss isn't perfectly fair; rather, it's slightly biased in favor of whichever side the coin starts on, because of how coins are weighted. If it starts out heads, in other words, then heads is a marginally better bet. But Diaconis is perhaps best known for a 1992 paper he published on card shuffling—"Trailing the Dovetail Shuffle to Its Lair"—which unraveled two long-standing mysteries in both mathematics and magic and turned out to have implications that went far beyond either discipline.

With the date of the IBM competition closing in on me, I decided I had to meet this man, if only to find out whether any of his mathematical insights might illuminate my own path.

But when I asked people in the know about the possibility of arranging a meeting with Diaconis, I was quickly discouraged.

"He's way underground," said one well-connected source. "He's super secretive. Hangs out with Ricky Jay. Guys you can't even talk to."

Really?

"Not about secrets at least."

Apparently my meeting with Diaconis was not to be. But even on a road littered with obstacles, you're bound to catch the occasional lucky break. As it happened, Diaconis's coauthor on the card-shuffling paper was a professor in the math department at Columbia, a stone's throw from the physics building. I e-mailed him to request a meeting and received a response the following day. Turns out he was giving a lecture that night on card shuffling. Gripped by a sudden sense of urgency, I canceled my plans, armed my fire wallet, stuffed my backpack with cards, and—with a reluctant Kate in tow—raced toward campus.

Chapter Eleven

THE PERFECT SHUFFLE

I first saw David Bayer—or part of him, anyway—in a movie back in 2001. A lot of people saw him that year, although most of them, like me, didn't know it at the time. That's because they only got to see a small part of his anatomy: his hands. His body and his face and his voice—every other part of him—belonged to Russell Crowe. But the hands belonged to Bayer.

Bayer was Russell Crowe's hand double in *A Beautiful Mind*, the film about mathematician John Nash. It was Bayer's beautiful hands that scribbled enigmatic formulas on the chalkboards and windowpanes of an imaginary 1940s Princeton. The film's producers wanted a movie with real math in it, unlike the fairy-tale *Good Will Hunting*. (Remember the problem on the chalkboard in the MIT hallway that supposedly took the faculty two years to solve? Turns out it was an elementary exercise in graph

theory that moviegoing mathletes cracked during the few seconds it was on-screen.) So the producers of *A Beautiful Mind* brought Bayer on as a consultant and later as an actor, and to this day he still gets residuals for his handiwork. Come to think of it, I'd met (and shaken) a lot of famous hands in my time: Simon Lovell, who did Ed Norton's base deals in *Rounders*; Xtreme Card Manipulator Dave Buck, whose talented fingers flourished for Jeremy Piven in *Smokin' Aces*; magician and actor Christopher Hart, whose right hand played Thing in the *Addams Family* movies. And now Bayer.

His class met just after six o'clock on a crisp October evening in a small seminar room on the second floor of Milbank Hall, the oldest building on Barnard's campus, across the street from Columbia. Bayer walked into the seminar room sporting jeans and a T-shirt. After a brief introduction, he removed a deck of cards from his leather bag. He handed them out for inspection and asked us to shuffle three times. Being the resident card expert, I did the shuffling. Bayer then asked me to pick a card at random and bury it in the middle of the pack, after which he took the deck and scanned through the faces of the cards. Moments later, he removed a lone card and held it up for all to see. "Was this it?" he asked, smiling. "The ace of hearts?" Of course it was.

It may not have been as dramatic as a levitation, but this to me was an astonishing trick. It was the shuffling that made no sense. How could he have let me shuffle, not once but three times? Wouldn't all that shuffling lose the card forever? He couldn't have used a key card or a crimp or daub or a marked deck. And clearly he wasn't employing sophisticated gambling techniques à la Richard Turner. He was a math professor, not a magician. There was no gimmickry or sleight of hand involved. Even if he'd known the order of the cards beforehand, shuf-

fling would have ruined it. There had to be a catch—and the catch, Bayer explained, had to do with the peculiar mathematical properties of shuffling.

The trick we'd just witnessed was a modified version of an effect originally conceived by an American magician and chicken farmer named Charles Jordan, who lived in rural California during the early twentieth century. Jordan never performed publicly—instead choosing to earn his keep by selling tricks, raising chickens, and winning mail-in puzzle contests—but he did invent a number of groundbreaking card sleights, including two false counts still widely in use.

His most enduring legacy, however, was something called Long-Distance Mind Reading, a magic trick performed by mail. In Jordan's original version, the magician mails a deck of cards to the "spectator," who cuts the cards in half and shuffles the two halves together. The deck is cut once more, and a lone card is removed from one of the two piles. After noting its identity, the spectator places the card in the middle of the *other* half and sends it back to the magician, who identifies the selection a few days later by return post.

Jordan published a small ad for the trick in the back of the *Sphinx*, the premier magic magazine of his day, in the spring of 1916. At the time, it went unnoticed, perhaps because the mail was so slow. For almost a century it was all but forgotten, lost in the mire of history, like a buried treasure waiting to be unearthed.

Until Persi Diaconis came along.

The Jordan trick caught his eye because it suggested something counterintuitive about shuffling, namely that shuffling doesn't work as well as most people think it does. Being a magician and a gambling expert at heart—his second deals, I've heard, are second to none—Diaconis wanted to understand

shuffling from a mathematical point of view. If shuffling truly randomizes the cards, he reasoned, then Jordan's trick would be impossible, because there would be no systematic way of locating the selection once the cards had been mixed. The fact that it *was* possible meant that the conventional wisdom on shuffling had to be wrong.

While at Harvard, Diaconis teamed up with Bayer, who was a postdoc at the time, and together they set out to test this hypothesis. Their task was to determine how many shuffles it takes to adequately mix a deck of cards such that no trace of the original order remains. Only after solving this problem would they be able to decipher Jordan's mind-reading mystery.

Their best lead was a technical memorandum written by a mathematician named Edgar Gilbert at Bell Labs, the research arm of AT&T, which had circulated in the fall of 1955. The memorandum sketched out the first useful mathematical model of card shuffling, one that laid the foundation for all subsequent work on the subject.

Why would the world's largest phone company have been interested in card shuffling? It all came down to probability. The phone company uses complex probabilistic theories to model switchboard capacity. The phone network connects people all over the country, so it has to be extremely spread out, but it also must be capable of handling variations in call volume, otherwise a spike in the number of calls can overload the grid—much in the way that when Michael Jackson died the massive surge of Internet queries temporarily brought down Google News. "They want to model all these random processes, so they care about probability," Bayer explained. "Card shuffling was very much in the spirit of what they were doing."

The phone company was also interested in how information can be transmitted over staticky channels. In 1948, in a land-

mark paper, Bell Labs mathematician Claude Shannon founded the field of information theory, a branch of mathematics concerned with measuring and quantifying information. What began as a theoretical investigation into signal processing turned out to have profound consequences. Biologists now use information theory to study genetic codes. Physicists use it to understand the digestive system of black holes. To the extent that it laid out a formal set of rules for how data can be stored and transmitted, information theory—along with its offshoot, coding theory—provided the mathematical framework for the digital age.

Gilbert's 1955 memo on shuffling analyzed the problem through the dual lenses of probability and information theory. A deck of cards can be viewed as containing a quantifiable amount of information. Think of each card as a number or a letter. Depending on how you arrange the deck, you can spell out different messages. Shuffling, meanwhile, erases the messages. It's the static on the wire.

Roughly speaking, shuffling represents entropy—nature's stubborn tendency toward disorder. Entropy is why you can turn an egg into an omelet but not an omelet into an egg. It's why heat flows from hot objects to cold objects and not the other way around. It's why ice melts. According to the second law of thermodynamics—which really isn't a law so much as a statistical imperative—the entropy of the universe is always increasing, and this is ultimately why shuffling tends to mix up a deck of cards.

There are many ways to shuffle, of course, but the most common method—the one typically used in casinos—is the riffle shuffle. To do a riffle shuffle, you begin by splitting the deck into two roughly equal stacks. You then flick the cards with your thumbs off the bottoms of the piles in an alternating fashion, interlacing the two stacks. In theory, there are about as

many combinations of fifty-two cards as there are particles in the Milky Way, but in practice, not all these combinations are likely, or even possible, after a few riffle shuffles.

For simplicity's sake, let's say we have just eight cards, the ace through eight of spades. We cut the deck into two equal piles—A♠ 2♠ 3♠ 4♠ and 5♠ 6♠ 7♠ 8♠—and riffle them together. After the shuffle, the deck might look something like this: 5♠ A♠ 6♠ 7♠ 2♠ 3♠ 8♠ 4♠. The numbers are no longer in order, but you can still pick out the two original sequences. The riffle shuffle weaves the two sequences together, but it doesn't jumble up the cards within each sequence. The ace always precedes the two, the two always precedes the three, the three always precedes the four, and so on. A single riffle shuffle might produce the string 5♠, 6♠ A♠ 7♠ 2♠ 3♠ 8♠ 4♠ but never 3♠ 7♠ 8♠ 4♠ A♠ 5♠ 2♠ 6♠.

A single shuffle doubles the number of so-called rising sequences. A rising sequence is a sequence that's always increasing, such as 5♠, 6♠, 7♠, 8♠. Shuffling once produces a combination with at most two rising sequences, and each additional shuffle no more than doubles that number. If you shuffle twice, for instance, the resulting combination contains at most four rising sequences. After three shuffles you get a maximum of eight, and so forth. It doesn't always double every time, because you randomly lose some along the way, but you never wind up with more than twice as many rising sequences as in the preceding shuffle, and this is true no matter how many cards you use, be it eight or eight million. As a result, the number of rising sequences is like a barometer that tells you how thoroughly a deck has been mixed.

So how many times on average do you need to shuffle a deck before the cards become truly random? This was the question that no one could answer before Diaconis and Bayer came

along—and the one on which Jordan's mystery hinged. Using cutting-edge probability and statistics, Diaconis and Bayer turned the seminal Bell Labs concept into a sophisticated new model, which Bayer then tested using computer simulations that shuffled virtual decks billions of times and analyzed the results.

What they found after a subsequent theoretical analysis came as a surprise. It took an average of *seven* shuffles to mix a deck— far more than anyone had anticipated. "The numbers were extremely compelling," said Bayer. "It's rare for empirical data."*

When Bayer did his trick for us in class, he'd used a pack of playing cards in new deck order, so he knew the starting

*It's also rare to get such a magical number, symbolically speaking. Seven is the granddaddy of sacred numbers, as ancient as history. In the Bible there are seven days of creation, seven virtues, seven deadly sins, seven pillars of wisdom, seven sorrows (and joys) of the Virgin, seven divisions of the Lord's Prayer, seven sacraments, seven cardinal sins, and seven graces. The Book of Revelations, the last chapter of the New Testament, is built around the number seven. It speaks of seven trumpets (heralding the end of days), seven golden lamp stands (representing the seven churches of the apocalypse), seven golden stars (representing the seven angels of the apocalypse), seven spirits before the throne of God, seven plagues, seven bowls of wrath, seven vials, seven judgments, seven kings, a seven-headed beast, a dragon with seven heads wearing seven diadems, a lamb with seven eyes, and an earthquake that kills seven thousand people.

The three most important Jewish feasts each lasts seven days, as do Levitical purifications, and the sabbatical occurs every seven years. Ancient astrologers recognized seven planets. In Islam, there are seven heavens, the seventh being by far the most paradisiacal, and seven holy sleepers (as is also true in Roman martyrdom). Buddhists revere the seven treasures. In many religions, the seventh son of a seventh son is endowed with magical powers. Japanese folklore has seven gods of good fortune. Inanna, the most powerful goddess in Sumerian folklore, passes through seven gates on her journey through the underworld.

There are seven days in a week, seven seas, seven continents, seven dwarves, seven wonders of the ancient world, seven *Police Academy* movies, seven whole notes in a Western scale, and seven words, as per George Carlin, that you can't say on TV. Shakespeare famously wrote of the seven ages of man. The average number of objects a human being can retain in short-term memory is seven. (This is why phone numbers have seven digits). Seven is the most likely roll in craps, and the opposite sides of a dice always add to seven. *Se7en* was Brad Pitt's best film, and Seven of Nine, portrayed by actress Jeri Ryan, was incontrovertibly the hottest girl ever to appear on *Star Trek*.

sequence of the cards. Because shuffling three times splices the deck into at most eight rising sequences, he was able to tell simply by looking through the deck which card was out of place.

To understand exactly how this works, consider a simplified version using our eight-card deck. The cards begin in sequential order: A♠ 2♠ 3♠ 4♠ 5♠ 6♠ 7♠ 8♠. The spectator shuffles once, picks a card at random, and replaces it at a different position. The magician then examines the cards and finds them in, say, the following configuration: 5♠ 6♠ A♠ 7♠ 3♠ 8♠ 4♠ 2♠. Can you tell which card was picked? Clearly the two is out of place, because the two should always come before the three, not after. Ergo, it's the two of spades.

Charles Jordan, the magician who posted the ad in the *Sphinx*, had stumbled upon this principle nearly a hundred years ago, and exploited it in his miracle by mail. The Jordan trick is slightly different, because the magician only looks at half the deck, but this is the main thrust of it. Either one card is found to be out of sequence or one card in the sequence is missing, depending on which half of the deck is mailed back to the magician.

Before Bayer and Diaconis published their results, shuffling three or four times before a game was the industry standard at the world's top casinos, even for high rollers. Nobody ever doubted that this was adequate. With their work, the two mathematicians had uncovered a massive breach in casino security.

In the early days of card counting, when single-deck blackjack games were common in Nevada, and shuffling was far from thorough, it was relatively easy to gain an advantage over the house and claim big payouts. Indeed, the first few generations of card counters made millions. "It was basically like fishing in Newfoundland at that point," said Bayer. "You could just clean up on single-deck hands in Las Vegas."

Shortly after the shuffling paper appeared in print, Bayer was approached by an attorney representing a group of professional gamblers facing indictment for cheating at blackjack in Atlantic City. As an expert witness, Bayer was hired to build a defense pinned on the fact that the crew's dubious winnings could be credited to shoddy shuffles and so-called card sequencing—that is, remembering unmixed strings of cards—rather than outright cheating. Bayer proved that you could legally beat the house by exploiting a persistent lack of randomness in the cards—the result of too few shuffles. In theory, this bit of exculpatory evidence should have been enough to exonerate the crew, but the case was settled out of court and never went to trial.

More striking even than the number of shuffles required to randomize a deck of cards is the way in which the cards become mixed. Rather than being an incremental process, with the amount of randomness gradually increasing, shuffling turns out to be highly nonlinear. Think of water freezing. As the ambient temperature drops, the water gets colder, but it remains a liquid—at ten degrees, at one degree, even at one-millionth of a degree Celsius—until the mercury hits zero, and then, presto! Water becomes ice.

In the same fashion, there's little appreciable difference between one shuffle and five shuffles, or between seven shuffles and a hundred. Two shuffles aren't twice as random as one, and four aren't twice as good as two, as one might expect. Even after six shuffles, you can still pick out distinctly non-random patches. But right around the seventh shuffle—presto! The cards rapidly become mixed. The randomness suddenly congeals, and the deck undergoes what is known as a phase transition.

If you graph the amount of order, or information, in the deck against the number of shuffles, it looks like a steep cliff with a valley beneath it. Up until about the sixth shuffle it's basically

flat (the top of the cliff). Then, between six and seven shuffles, it drops off sharply (the cliff). After that it flatlines again (the valley). Seven shuffles is the tipping point, when the randomness snowballs and the deck decays exponentially into chaos.

As it turns out, this sort of nonlinear mixing occurs all over the place. When you knead bread dough, for instance, it smoothes out rather abruptly after a certain number of folds. Or, if you mix chocolate sauce into cake batter, you'll see swirls of chocolate as you stir, and as you keep stirring, the swirls will suddenly disappear when the batter becomes uniformly mixed. After that, stirring doesn't do much, except maybe ruin your batter, much as shuffling too many times wears out a deck.

Drug companies worry about this sort of thing all the time. Every batch of cold medicine, for example, needs to be suitably mixed, because you don't want one person getting all the antihistamine while someone else is left with the analgesic. Overmixing, on the other hand, can denature the chemicals and ruin the batch, so it falls upon the company's in-house Goldilocks, who might have a degree in statistics or chemical engineering, to determine the optimal mixing strategy.

"One can view all of reality as shaped by probability theory," Bayer said to us at the end of his lecture. Indeed, what started out as a somewhat esoteric investigation into the statistical properties of an old magic trick led to a model for a widespread class of systems. "People knew this kind of cutoff phenomenon happened as a random process in lots of situations," he said. "But there was never a single model that showed that it happened before this one."

THE CONJURING ARTS RESEARCH CENTER, one of the world's largest magic libraries, is found inside a colorless build-

ing on West Thirtieth Street, a few blocks from another magic landmark: Tannen's. On my first visit, I wasn't sure what to expect—a Masonic lintel, the Eye of Horus on an architrave, the Gryffindor lion—but it wasn't like that at all. The directory listed a rug company and a few residences, nothing to suggest that behind these doors lay the ultimate repository of arcane magical knowledge.

I took the elevator to the fifth floor and found myself in a long, dark hall at the far end of which was a lone door. A few magic-themed posters on the walls reassured me I was in the right place. Moments later, the door swung open and I saw a young woman walking briskly toward me. "You must be Alex," she said in a formal tone. "Right this way."

Her name was Alexis and she was the head librarian. The Conjuring Arts Research Center is not a walk-in library. Appointments are required at least one week in advance, so they'd been expecting me. It's also not a browsing library, so visitors must be supervised at all times.

I followed Alexis into a windowless salon decorated with heavy oak furniture, skulls, swoops of red velvet, display cases loaded with puzzles and magic props and handmade decks of cards and printing plates and original Houdini handcuffs and lock picks and diagrams of escapes, all surrounded by ceiling-high shelves loaded with books, some of which looked very old. This was it, I thought, magic's Library of Alexandria.

After Bayer's class, I'd decided I wanted to see the original issue of the *Sphinx* in which Charles Jordan's mind-reading mystery had first appeared. The only place I knew of with archives going back that far was the Conjuring Arts Research Center. While I was here, I figured I might also spend some time contemplating the history and philosophy of magic—a pursuit Jeff McBride associates with the realm of the Sage. And

maybe, just maybe, I'd chance upon some ancient secrets that would help me in the construction of my routine.

This is actually a fairly common tactic. Magicians are constantly digging up old material and passing it off as new. A number of David Blaine's earliest effects, for instance, were tomb-raided from ancient texts. One of them was inspired by an Egyptian papyrus, housed at a museum in Berlin, that depicts the conjuror Djedi of Djed-Snefru ripping the head off a goose while pyramid-builder King Cheops looks on in awe. Djedi re-attaches the head, and the bird waddles off. Forty-five hundred years later, David Blaine performed this same trick on his debut television special (except he used a chicken instead of a goose).

My motivation had been further reinforced by something gambling expert Jason England told me on one of my many trips to Vegas. "If you want to fool magicians," he said, "you're not going to fool them with a new move. You're going to fool them with some hundred-year-old mathematical principle. Forget about the latest move. Go the other direction. Go dig up some ancient book." He paused for a moment, and then added, "Go to the library."

Rustico II regular Bob Friedhoffer shared this view, although he had a different way of putting it. "Learn the history," he said to me one day. "I'm serious. Learn it or you're dead to me."

The Conjuring Arts Research Center houses roughly fifteen thousand books and magazines, along with rare unpublished manuscripts and letters and ephemera and scribal works dating back to the fifteenth century. There are more than a thousand volumes printed before 1900, and several hundred that predate the founding of our great nation. As my eyes fixed on a long shelf packed with books on math and magic, I wondered if perhaps my dream effect wasn't hidden somewhere in those pages.

I wove in and out of the stacks, shadowed every step of the

way by the ever-vigilant Alexis. Sweeping my gaze over the towering wall-to-wall shelves, I saw books on lying and psychology, conjuring theory, crowd manipulation, and puzzles. There was a shelf devoted to the history of playing cards, and an entire row of forcing books, which are props used to force words and phrases onto your spectators; manuals on coin tricks, escapes, ventriloquism, juggling, thaumaturgy, psychokinesis, and levitation. Strolling past the gambling section, I reached for a book on cheating at poker, and Alexis grabbed my wrist.

"Don't touch it," she said tartly. The books were fragile, she explained, and had to be handled carefully. "What do you need?"

I pointed sheepishly at the book, and she shimmied it off the shelf without touching the binding.

Alexis then led me into another, smaller room toward the rear of the library that contained, among other things, a number of declassified CIA documents. Back in the 1950s, during its kooky MK-ULTRA days, the CIA hired magician John Mulholland to train spies in the art of deception, an initiative predicated on the assumption that, as CIA deputy director and amateur magician John E. McLaughlin put it, "magic and espionage are really kindred arts."

The man behind this remarkable collection was a deep-pocketed sleight-of-hand master and potato baron named William Kalush, who worked with David Blaine on a number of effects, including one in which Kalush fired a rifle bullet into Blaine's mouth. Many of the items in the library were on semipermanent loan from Kalush's private stash. Wealthy and well connected, Kalush was buddies with Blaine (who sat on the board) and card star Ricky Jay. Jay-Z, an acquaintance of Kalush and a magic fan, had donated the bookcases.

The library's greatest treasures were kept in the rare book room, hidden in the back and protected by locks. I was not al-

lowed to enter, but I'd heard this room housed an English book on microscopy with descriptions of water spouters, tricksters who regurgitate swallowed liquids; a Swedish cookbook from the 1700s with a section on postprandial magic tricks; a three-hundred-year-old Belgian legal text that explains various methods for cheating at dice; and an original edition of Reginald Scot's 1584 *Discoverie of Witchcraft*. Inside this treasure room were secrets in Dutch, French, German, Italian, Japanese, Portuguese, Russian, Spanish, and Swedish. (The library employs a full-time translator, whose previous jobs included a stint as the official translator to Pope John Paul I.) A first edition of S. W. Erdnase's 1902 *The Expert at the Card Table* was one of the newest items on the shelves. I felt faint.

HUNCHED OVER A SMALL TABLE in the library's main salon, I contemplated the document Alexis had brought out for me. It seemed to glow in the soft yellow warmth of the reading lamp. The cover was printed in red Egyptian lettering with a drawing of the Sphinx at the top. It was dated May 1916. The *Sphinx* was quite possibly the most influential magic magazine of all time. Original copies are as valuable as they are rare. This was the first one I'd ever seen up close.

I peeled back the cover. The pages were foxed and faded and smelled faintly of must and mothballs and—I could have sworn—hair tonic. Inside were minutes of recent meetings, a roster of newly elected members, and other oddments. I scanned the first page.

```
The 156th regular monthly meeting was held
at the Magical Palace, 493 Sixth Avenue, New
York City, on Saturday . . . The Committee on
```

```
Admissions reported as worthy the candidate
whose application was received last month, and
after being balloted for, was declared duly
elected . . . The Mysteries were conferred
in short form on E. D. Robinson of Rutland,
Vermont, and he was well pleased with the
ceremony . . . President Dick showed his
improved 4-Ace trick and several other card
creations keeping time with his left eyebrow,
all of which pleased greatly.
```

Leafing through the magazine, I imagined a time when gentleman conjurors assembled in their very own meeting house, insulated from the rigors of city life, rather than being reduced to meeting at pizzerias and taco shops, hospitals, and veterans lodges. How the mighty had fallen.

I finally found what I was looking for on the third-to-last page. Buried among diagrams for apparatuses and props, directions for how to build a Die Box, and promotions for new effects was the most modest of ads:

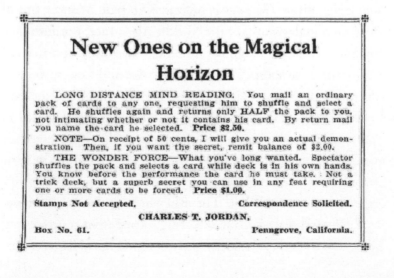

Staring at Jordan's ad, I fell to thinking about the unlikely paths that can lead to great discoveries. It struck me as rather poetic that this old trick had inspired a modern mathematical breakthrough, for some of the earliest recorded magic tricks appear in a fifteenth-century book written by a Tuscan mathematician who happened to be a close friend of Leonardo da Vinci's and helped him paint *The Last Supper*. *De viribus quantitatis* (*On the Power of Numbers*) contains instructions on how to eat fire, wash your hands in molten lead, write on a rose petal, make a coin or an egg bounce up and down by forces unseen, and read minds using mentalism techniques still in use today. (Most of these tricks actually work, as Bill Kalush will tell you.) The book also has the first written accounts of card tricks. *De viribus quantitatis* was never published; it lay hidden in the University of Bologna archives for five hundred years before being brought to light by a British mathematician who stumbled across references to it in other works. Now the world's only English translation was locked inside the CARC's rare book room, a few feet from where I was sitting.

The library's second-oldest volume is the medieval Latin pseudepigraphon *The Book of Secrets of Albertus Magnus*, one of the most popular works of the Middle Ages. In it, the author— probably one of St. Magnus's students—describes hundreds of extraordinary properties of animals, herbs, and stones, some of which can be used to make magic. Among them is a method for resurrecting a drowned fly by burying it in ashes, which to a naïve audience looks like a miracle even today. The secret lies in the fact that insects breathe through tiny openings in their exoskeletons. Submerging a fly in water cuts off its oxygen supply, causing it to pass out. The ashes in turn dry it off, allowing the fly to breathe again, effecting an apparent resurrection. Thus, this trick doubles as an early entomological experiment.

The Book of Secrets belongs to a class of vernacular literature that was popular in Europe during the fifteenth century and endured well into the Elizabethan age. As Europe emerged from the Dark Ages and printing presses spread across the Continent, so-called books of secrets—bizarre medleys of magic, bestiary,* metallurgy, recipes, tinctures and elixirs, and some actual scientific facts—became commonplace. From our modern vantage point, it's easy to dismiss most of this stuff as hokum. But empirical science was born out of these ungainly mash-ups.

Today we tend to view magic and science as polar opposites, with superstition at one end and rationality at the other. But this is a relatively recent distinction. For centuries, magic and science were widely seen as parallel paths to wisdom. Newton wrote more about the occult than any other subject, while toiling in secret over alchemical tracts that, had they been exposed, would have landed him in prison, because alchemy was deemed satanic by the Church. After his death, the Royal Society stashed away the embarrassing evidence, and for centuries these papers remained hidden, known only to a select few. Rediscovered in the mid-1900s, they reveal the striking extent to which Newton's laws—the bedrock of physics—were shaped by theories of attraction and repulsion laid out in the alchemical cookbooks of his day. Gottfried Leibniz, coinventor of calculus, got his start as an alchemist in Nuremberg. Robert Boyle, founder of modern chemistry, spent half his life searching for the philosopher's stone, the legendary substance that turns lead into gold. Jan Baptista van Helmont, the occult philosopher who laid out the first useful theory of gases in the early 1700s, did so through the prism of a profoundly mystical worldview. Practically every great thinker of the scientific revolution was interested in magic.

*No, not bestiality, but *bestiary*, as in a collection of facts about beasts.

Technical curiosity and a penchant for tinkering continued to link science and magic during the nineteenth century, albeit in a more down-to-earth way. By and large the icons of nineteenth-century magic were Edisonian types who toyed with elaborate contraptions in private laboratories and studios. The father of modern magic, Jean-Eugène Robert-Houdin, was himself an accomplished scientist who conducted early experiments in electromagnetism and invented a number of devices for regulating electrical currents. (Beginning in the mid-eighteenth century, exhibitions of electromagnetic phenomena—which were variously billed as scientific experiments and spiritual manifestations—became a common feature of entertainment magic.) Robert-Houdin also built mechanical figures and automata, including a small android that he sold to P. T. Barnum. He designed the world's first electric burglar alarm. His famous mechanical orange tree, which blossomed real fruit, is a classic of magical engineering. Using his knowledge of magic and physics, he once quashed a tribal rebellion in French Algeria by dazzling the local chieftains with his godlike powers—a mission for which he received a royal commendation.

An amateur magician and friend of Robert-Houdin invented trick photography and created the first special-effects films. (Magic played a foundational role in the development and dissemination of movie technology.) Another nineteenth-century engineer, Henry Dircks, invented Pepper's Ghost, an early theatrical illusion that inspired two of the most famous tales in *Alice's Adventures in Wonderland*—the "Cheshire Cat" and "Pig and Pepper." (An avid fan of magic, Lewis Carroll witnessed the illusion while attending a magic show with none other than Alice Liddell, the real-life inspiration for the Alice stories.) Other magicians invented the parachute, the first ribbonless typewriters, coin-op locks, and vending machines.

The tradition of the magician-scientist persisted even through-out much of recent history. Up until the late 1930s, magic shows were still being billed as scientific amusements or wonders of natural philosophy. And until just a few years ago, the Academy of Magical Arts, one of America's three magic fraternities, was known as the Academy of Magical Arts and Sciences.

To the heroes of the scientific revolution, science and magic were kindred sources of wonder. More than five centuries after the first conjuring texts came into being, the art and science of magic are as vibrant and mysterious as ever. Meanwhile scientists of all stripes—be they psychologists, neurobiologists, or mathematicians—continue to look toward magic as a source of inspiration.

As THE DAY OF THE IBM competition drew near, I began searching with ever-greater urgency for the perfect trick. My subway reading now consisted of obscure math articles, old Martin Gardner columns, books on probability and information theory I'd plucked from the math library. I managed to track down Gilbert's original 1955 Bell Labs memo, which turned out to be as rare as issues of the *Sphinx*. It had never been published, and none of the dozen or so mathematicians I contacted—guys who, at one point or another, had all worked on the problem of shuffling—had ever seen a copy, including Bayer. After some serious gumshoeing, I finally located Gilbert himself. He was retired and lived in New Jersey. I reached out and touched him the old-fashioned way—by phone—and he kindly mailed me a copy.

I became a regular at Bayer's office hours. I did card tricks for him and his grad students, which Bayer seemed to enjoy, although he did ask me on more than one occasion if I'd ever

considered psychiatric treatment. Rumors began to spread of a crazy magician lurking in the halls of the math department. Walking into a symposium one afternoon, I saw Bayer nudge a professor sitting next to him and whisper, "That's the magician." Word traveled fast.

If Persi Diaconis is the coolest mathematician in the world, Bayer comes in a close second. A wisecracking, effervescent man of fifty-five who always wears jeans and frequently goes barefoot, with shaggy wisps of gray hair and curious green eyes, Bayer runs marathons, plays the ukulele, and climbs mountains in his spare time. In a field full of wallflowers—an extroverted mathematician, goes an old joke, is one who looks at *your* feet while he's talking—Bayer is remarkably outgoing.

Listening to him talk is an exercise in mental agility, the intellectual equivalent of riding a mechanical bull. His thoughts buck and swerve and double back so quickly, often in mid-sentence, that it's a struggle to stay on board. When he gave me a crash course on information theory, it began with a story about Grateful Dead bassist Phil Lesh. (It made perfect sense at the time, but I'd be hard-pressed to repeat it. Also, using a slide rule is apparently a lot like playing a fretless bass.) A system for cheating at blackjack turned into an indictment of Wall Street. Why can nobody match the NSA at code breaking? Why are there so few nuclear powers? Why did the Giants fall into a losing streak after seemingly sound trades? It was all connected by the formulas he scribbled on the board. Whenever he was deep in thought—like after I showed him my Ambitious Card routine—he swirled his tongue around in his mouth and puckered his lips as if sucking on a piece of candy.

In return for entertaining him, Bayer taught me about his research, dished about Russell Crowe, and regaled me with tales of Diaconis's exploits. One of those stories was about a

trick Bayer saw Diaconis perform at, of all places, a computer science conference. Strolling into a large lecture hall, where he was scheduled to give a talk, Diaconis whipped out a deck of cards and explained to the bemused audience that he was about to show them some magic. He wrapped a rubber band around the deck and threw it across the lecture hall. "He actually made a good shot," Bayer remembers. "It landed on the middle of this table on the other side of the room." (Bayer also recalls that the deck seemed oddly light.) The person nearest the deck gave it a cut, and five people took cards off the top. "If you have a red card, stand up," Diaconis instructed them. Moments later, he named all five cards in order from across the room.

After baffling a roomful of computer scientists with this trick, he proceeded to baffle them further with an abstract lecture on something called the theory of finite fields. "This was deep modern algebra," Bayer said. "I mean you can take an entire year of algebra, and minor in it, and not understand the talk. I didn't, and I teach that course."

The trick Bayer witnessed was a version of something known as the Tossed-out Deck, a classic of card mentalism wherein a deck is thrown into the audience, cards are selected, and the magician names the cards under seemingly impossible circumstances. It's a nice effect because it engages multiple spectators, and the act of tossing the deck out into the crowd seems very fair, because of the distance it puts between the magician and the magic. As with the Ambitious Card and the cups and balls, many great magicians have tackled the Tossed-out Deck, and there are dozens of methods.

But pretty much every method has at least two flaws. First, the deck won't stand up to close examination, unless you switch decks after the fact. Second, the magician usually needs to fish for clues in order to zero in on the cards. ("I sense a high card.

Is it a seven or above? Is it an odd card?") In capable hands, these are minor issues, but they are flaws nonetheless.

Diaconis's version was pristine. Aside from being a little light, the deck was ungaffed, meaning there were no repeating banks of cards or marks on the backs. Furthermore, there was no fishing. Diaconis didn't ask a single question before naming all five cards. He merely instructed the people with red cards to stand up. How could he have learned the identity of all five cards from this information alone? It was too good to be true. If I could learn this trick, I'd be a god among men. Or at least a man among little kids.

The secret, it turned out, was rooted in an obscure mathematical principle known as a De Bruijn sequence, after Dutch mathematician Nicolaas Govert de Bruijn. A De Bruijn sequence is a sequence of characters—letters or numbers or what have you—in which every possible subsequence of a given length appears once and only once. Consider, for example, the following string of eight letters: RRRBRBBB. This is a binary De Bruijn sequence of order 3. *Binary* means that the "alphabet" from which the sequence is composed contains only two elements (R and B), and it's of *order* 3 because every possible three-letter subsequence—RRR, RRB, RBR, BRB, RBB, BBB, BBR, BRR—appears once and only once. For instance, the three-letter subsequence RBR, which starts on the third letter of the string and ends on the fifth, doesn't appear anywhere else in the sequence.

This particular sequence is also said to be *cyclic*, because when you get to the far right end, you loop back around to the far left, as if you were hitting the carriage return on a typewriter. In other words, the subsequence BRR starts with the last letter on the right (B), continues at the far left (R), and ends on the second letter from the left (R). It helps to picture a circle:

The oldest-known De Bruijn sequence appears in Sanskrit, in a 3,000-year-old fragment of Vedic poetry. These days, engineers use De Bruijn sequences to build smarter robots, neuroscientists use them to study how the brain encodes a stream of sensory input, programmers apply them to game design, and cybercriminals use them to hack open electronic locks protected by numerical key codes like those found on many luxury cars.

The De Bruijn sequence can also be weaponized to create mind-blowing magic. To see how, imagine that R stands for a red card and B for a black card and that I have a packet of eight cards in the following order: Q♥, 3♦, A♥, 4♣, 2♥, 3♠, 2♠, 7♣. This corresponds to the color sequence shown in the circle, with the queen of hearts at twelve o'clock. Now, let's say I remove three consecutive cards from somewhere in this eight-card packet. All I need to tell you is the color sequence, and you'll know what cards I've taken. If, for example, I tell you that the colors are red, black, red, you know immediately that the three cards I've selected are A♥, 4♣, and 2♥, because that's the only sequence of red, black, red in the string. And because the sequence is cyclic, the deck can be cut as many

times as you like. All cutting does is change the starting point on the circle.

With only eight cards it's not a very strong trick, but imagine doing it with lots of cards. Persi Diaconis used a thirty-two-card packet, hence the "light deck" Bayer had observed. It was still amazing, but I decided I wanted to take it to the next level and do it with a full regulation deck, one that could be freely examined. Evidently, nobody had ever done this before. Which meant that if I cracked the code to this one effect, I'd be the only person in the world able to perform it.

I teamed up with a grad student I met through Bayer, a woman named Nava, who was also interested in magic, and we wrote a computer program to find a suitable fifty-two-card sequence. Then I arranged a deck of cards in order according to this color pattern. Next I had to memorize the order of the cards. If this sounds like a lot of memorization, that's because it is. The trick is mentally demanding, but that's the price you pay for such a perfect trick. (As magicians like to say, every miracle has a price.) It also has the virtue of its defect, because this complexity helps disguise the method. Even if someone were to figure out the underlying principle—and that's a stretch—most people would probably have a hard time imagining that anyone could commit so much information to memory. Maybe this is why magicians have been using stacked decks and mnemonic systems since the sixteenth century. As Jamy Ian Swiss aptly put it, "One of the best-kept secrets we have as magicians is that laymen would never imagine we would work so hard to fool them."

Even had I not smoked a lot of pot in college, memorizing this much information without some kind of cognitive aid would have been daunting, so I consulted former U.S.A. Memory Champion Joshua Foer, an expert on mnemon-

ics and author of the book *Moonwalking with Einstein*. He taught me an amazing technique, called the method of loci, which can endow even the wimpiest brain with superhuman powers of recall. The technique works by tapping into the near-limitless depths of spatial memory. Contrary to popular belief, photographic memory is not solely the province of savants. Everyone has a photographic memory. Most people just don't know how to access it. The method of loci takes you there.

The basic idea is to store memories as images inside an imaginary space known as a memory palace. To memorize a deck of cards, for example, you first associate each card with an image—usually a person, object, or action. I chose to use people. The four of clubs, for instance, was Penn Jillette. (I made all the fours magicians.) The five of diamonds was Richard Feynman. (Fives were scientists.) The eight of clubs was Shaquille O'Neal. (Eights were athletes.)

After assigning an image to each card, you install the images at different points (or loci) along a predetermined path through your memory palace. Any kind of place will work, although it's best to use one that's familiar to you, such as your home or office. I chose the house I grew up in. You also want to pick a route that's easy to retrace. I decided to follow the left wall, from the entryway to the dining room, through the kitchen, and into my parents' bedroom, then into the living room, my dad's study, my bedroom, and finally the garage.

By placing the images in your memory palace, you're effectively encoding the order of the cards as a set of spatial relationships inside your mind. Later on, when you want to remember them, you simply retrace your steps through this virtual world. Strange as it may seem, the images appear in your mind almost effortlessly. The system is also remarkably robust. Once the

images are fixed in your memory palace, they tend to stay there until you consciously evict them.

It may sound like a lot of work—why memorize more than you need to?—but the counterintuitive thing about memory is that more is often easier to remember than less. Memory is largely an associative process, and the more associations you make—particularly visual ones—the easier it is for memories to gain traction in your brain.

Once you've done the necessary spadework, committing a deck to memory is a breeze. It took me, a total novice, the lesser part of an evening. The world's top mnemonists can memorize shuffled decks in under a minute. The current world record is 21.9 seconds—less time than it takes most people to deal out 52 cards. And it doesn't work just for cards, either. The same strategy can be applied to words, letters, numbers—anything. In 2006 the World Memory Champion used it to memorize a string of 1,040 random digits in half an hour. Another well-adjusted individual has filled his memory palace with the first 65,536 digits of *pi*.

In addition to memorizing the order of the cards, I also had to know which color sequence each group of cards corresponded to. In the eight-card example just given, for instance, you need to know that red, black, red corresponds to A♥, 4♣, 2♥. The best way to remember this is to convert the subsequence red, black, red into a *number* (using a binary code), and then install that number inside your memory palace next to the first card in the group (in this case the A♥). The number effectively tells you where in your memory palace to look.

To memorize the numbers, I used another memory trick called the Major System, which turns numbers into words. The number 36, for instance, became the word *mash*, because in the Major System, 3 = m and 6 = sh. (You fill in the vowels your-

self.) After I turned all the numbers into words, I partnered them with the cards to form new images. For example, the four of clubs, together with the number 36, became an image of Penn Jillette (4♣) watching the show *M.A.S.H.* (36).

Blame it on human nature, but it's a well-known fact that our brains privilege lurid memories above more mundane ones. With this in mind, and following in the footsteps of champion mnemonists like Foer, I turned my memory palace into the set of a Pasolini film. In the entryway, David Duchovny (2♥) is consuming his own excrement (9 = poo). Physicist Richard Feynman (5♥) is puffing a doobie (19) at the kitchen table. Tom Cruise (10♦) is bleeding to death from a knife (28) wound inside the garage. Unspeakable acts are afoot in the linen closet. By the end of my virtual journey, I'd desecrated my childhood home. It was like that time during my senior year when my parents went on vacation and left me in charge for the weekend.

Once I had the trick down, it looked like this. A mixed deck of fifty-two cards is tossed into the audience. The person nearest the deck cuts as many times as they like, and six* people take cards off the top. "Should I do the red cards first or the black cards first?" I ask, casually. Of course, it doesn't matter. "All right, if you have a black card, please stand up." As soon I see the color configuration, I know all.

I want to put as much psychic distance as I possible between the moment when I actually learn the identity of the cards—that is, when the people with black cards stand up—and the climax, when I call out all six cards. If I name the cards right away, it suggests a link between the color sequence and

*In an eight-card De Bruijn deck, the smallest unique subsequence is three cards long, but with fifty-two cards, the smallest unique subsequence is *six* cards long, for reasons I won't go into. This is why six cards are selected.

the cards. So I add some misdirection by tossing out a few silly, irrelevant questions. "What's your sign?" I ask, pointing to one of my volunteers. This gets a laugh about half the time. I turn to another volunteer. "Did you have a pet growing up?" I single out a male spectator: "Boxers or briefs?"

In every great magic trick, form follows function. This silly bit spotlights the fact that I'm clearly not fishing for clues, while at the same time diverting attention away from the secret—all of which prevents people from connecting the dots. Once I've asked a few dumb questions, I tell everyone who has a card to stand up. Then I name all the cards in order, pointing at each person as I go down the line like a crack shot taking target practice.

All bull's-eyes.

THIS EFFECT WAS A DUPER'S dream. The method was elegant. The impact was strong. It scored with muggles and magicians alike. It became my go-to trick for when I needed to fry a fellow member of the guild. I fooled some of the smartest magicians in New York City with it—the old guys at the pizzeria, the local president of the IBM, the regulars at Tannen's and Fantasma. It was conjuror's kryptonite. No one had a clue. Of course, this sent a tsunami of duping delight gushing through my veins. Jason England had been right. "If you want to fool magicians," he'd said, "you're going to fool them with some hundred-year-old mathematical principle." His words echoed in my mind like a prophecy.

My weapon of math destruction was so well received (and so puzzled over) that Joshua Jay, an editor at *Magic* magazine and a virtuoso magician, offered to publish it in his monthly column. My invention would be forever enshrined in the

world's most widely read magic journal, alongside the works of Vernon and Houdini and Marlo and Tamariz and Wes James. I had yet to publish a single paper in a scientific journal, but I'd somehow managed to pull off an analogous feat in magic. Life, I suppose, has a way of playing tricks on you.

To a man with a hammer, the whole world looks like a nail. Unable to think about anything but shuffling, math, and magic, I became convinced that the secrets of the universe were found inside a pack of playing cards.

For starters, there's a curious symbolism encoded in a deck of cards. There are two colors (red and black) symbolizing day and night; four suits—spades, hearts, clubs, and diamonds—one for each season (or seasons of the magician life cycle, if you like). The twelve court cards correspond to the months of the Gregorian calendar. Each suit contains thirteen cards, for the thirteen lunar cycles. There are fifty-two cards in a deck, those being the fifty-two weeks in a year. And if you add up the values of all 52 cards, including the joker, you get exactly 365. Add to this the seven shuffles and the surprising reach of the Bayer-Diaconis model—how shuffling mimics the behavior of everything from kneading dough to mixing chemicals—and cards really do start to look like cosmic instruments.

It goes even deeper when one considers the properties of a perfect, or faro, shuffle. Bayer and Diaconis got their result using a mechanical model for the messy, imprecise way people normally shuffle. The cards aren't cut exactly in half, they're riffled together haphazardly, and so forth. As it turns out, a certain measure of sloppiness is the essence of a good shuffle. Only through imprecision does randomness sluice through and accumulate, eventually drowning out the order completely.

A faro shuffle on the other hand—whereby the cards are divided exactly in half and perfectly interwoven—isn't random at all. In fact, it's completely predictable. Eight perfect shuffles will return a fifty-two-card deck to its original order, with every card having cycled back to its starting position. And it doesn't just work for 52 cards. A deck of any size will eventually return to its starting order after a finite sequence of faro shuffles, although eight isn't always the magic number.

One can derive a general formula for the relationship between the number of cards in the deck and the number of faro shuffles needed to complete one full cycle. The correlation, it turns out, is far from intuitive. If you have 25 cards, for instance, it takes 20 faros to reset the deck whereas for 32 cards it only takes 5. You have to faro a 104-card deck 51 times to return it to its original order, but only 36 faros are needed if you have 1,000 cards. With a million cards, the number of faro shuffles in one cycle jumps to 180, and for a billion it spikes to 667,332.

An intimidating sleight, the faro shuffle is often called the holy grail of card magic. (Of course there are lots of holy grails, depending on whom you ask.) For over a century it existed primarily as a concept, a theoretical construct, poorly understood. No one could execute the move, and a plurality of magicians deemed it impossible. It was the four-minute mile of magic. The looping nature of the faro was known, theoretically speaking, going back to the early 1900s, and there are references in Erdnase to "faro belts," but these early treatments are peppered with errors.

The watershed really came in the 1950s, with the work of Chicago card expert Edward Marlo and British computer scientist Alex Elmsley. Elmsley was the first to write down the general formula for the faro. By experimenting with the move, he also uncovered a number of interesting applications, includ-

ing a procedure for moving a card to any position in the deck, using a sequence of perfect shuffles. (The procedure brought to light a deep connection between the faro shuffle and the binary number system, the universal language of modern computing.)

The remarkable looping property of the faro shuffle is a facet of group theory. Loosely speaking, group theory is the mathematical language of symmetry. This is important because, from the top down, nature loves symmetry almost as much as she abhors a vacuum. Group theory has applications to biology, chemistry, and most notably, physics, where it provides the mathematical framework for the Standard Model— the overarching theory of elementary particles and forces that explains virtually every known natural phenomenon.

So, in a sense, a deck of cards really does contain the secrets of the universe.

The method most commonly used for the faro is to do it in your hands, rather than on a table. First you divide the deck exactly in half. (This takes practice.) Then you butt the short edges together under pressure, while keeping the two halves square, and gently work the cards into an alternating weave.

Technique has progressed a great deal in the last fifty years, and though it's still considered an advanced move, the faro is now fairly common among sleight-of-hand junkies. A small number of people—maybe a hundred or so—can do it one-handed. Smaller still are the ranks of those who have mastered the table faro, by any measure the hardest move in all of magic. A heroic sleight, the table faro is done not in the hands but on a flat surface. This posture affords far less control over the cards, making it a veritable leap of faith. Only a handful of people in the world can do it—blind cardsharp Richard Turner being one of them. (He does it in just over a second.) Turner can also do what is informally known as a volitional faro. This is when,

instead of being butted together, the two halves are actually rif-fled together, with the thumbs alternately releasing the cards—one from the left, one from the right, and so on—until all 52 are interlaced. Turner can shuffle an entire deck this way in 8.1 seconds. "If you think this is easy," notes veteran sleight-of-hand expert Jon Racherbaumer, "try making love while stand-ing up in a hammock while juggling seven ice-cream cones."

The regular in-the-hands faro is a subtle, knacky move, but far from impossible, provided you're willing to sacrifice a large chunk of your social life. After being intimate with cards for so long that they began to feel like an extra appendage, I eventu-ally saw the day arrive when, to my astonishment, I could faro a deck with remarkable consistency.

To get to the point where I could bang out eight perfect faros in a row under fire took a lot of practice. In the time I spent acquiring this skill, I could've learned French. But French is spoken only in a few pockets of the world. Magic is a univer-sal language. Not only that, but French wouldn't have brought me any nearer to mastering one of the greatest card effects of all time—the trick that would become my closer.

PICTURE THIS. A SURPRISINGLY HANDSOME magician asks a volunteer to write down the name of someone they know and fold up the paper without revealing the name to anyone. The magician tears up the paper and attempts to draw the face of the person with a black magic marker on a large sketchpad. Af-ter two unsuccessful but hilarious tries—first he draws a happy face, then a sad face—he produces a deck of cards and removes them from the box. On the edges of the deck are a number of randomly scattered blue markings. Hc fans the cards to show that they are mixed.

"The dots are like an inkblot test," he explains. "They can become whatever it is your imagination projects onto them." He then asks the volunteer to select a card and return it to the pack.

The deck is shuffled and, as if by the action of some mysterious force, the dots begin to form a pattern, visibly organizing themselves into the name of the card the volunteer selected.

But wait. It gets better.

"I now want you to focus all your mental energy on the name you wrote down," he says, fixing his volunteer with a serious look. "This is someone who means a lot to you, isn't it? Someone who has played an important role in your life?"

The spectator nods.

"And you haven't told anyone who it is."

Looking over the anxious faces of the audience, the magician shuffles one last time—for a total of eight shuffles in all, but who's counting—and, like a picture emerging from static, the dots rearrange themselves into the name that the volunteer secretly wrote down at the beginning of the trick.

There are very few genuine miracles in this world: childbirth, the Big Bang, John Bonham's kick drum on "Good Times, Bad Times," Joe DiMaggio's fifty-six-game hitting streak.

And this . . .

It came to me like a hallucination, in one feverish evening. I saw it fully formed, like chemist August Kekulé's famous vision of the benzene ring. Together with my Tossed-out Deck, I now had two amazing effects, worth a solid ten minutes of jaw-dropping magic. Both exploited elegant mathematical principles. Both had a mentalism angle. Both drew heavily on the skills I'd acquired along the way—the center tear, cold reading, false shuffles, the faro—a tour de force of deception. My routine was complete.

I had found my tricks.

FLIGHT TIME

Y ou can practice all you like in front of a mirror—and even in front of your thespian girlfriend—but there's no substitute for a live audience. In the heat of battle, Murphy's Law takes over and the unexpected becomes the norm. As I began to roll out my new routine, I became painfully aware of all the ways in which it could go wrong. Mostly it came down to the human element. People shuffled when I told them to cut. They forgot their card. Their handwriting was too messy for me to read the secret name.

"I can't see," a spectator told me after she took a card during a gig at a shoebox theater in the Village.

"Oh, are those house lights too bright?" I asked.

"No, I can't *see*."

Finally I realized what she meant. I'd chosen a blind spectator.

When I performed my Tossed-out Deck routine at the geriatrics-only International Battle of Magicians in Canton, Ohio, two of my spectators were so old they couldn't stand.

Over time, I became acquainted with the subtle art of audience management. I figured out how to avoid, or at least roll with, the inevitable slew of curveballs live performances throw your way. Like a good jazz musician, I learned how to improvise and turn mistakes into opportunities and find my outs when things went sideways. Being able to think on your feet is a critical skill—in magic as in life. "One of the things you learn as a professional," Wes told me, "is no matter what happens, keep going."

Penn and Teller liken the process of becoming stage ready to getting a pilot's license. Before pilots can get their wings, they need to log a certain amount of supervised flight time. There's no way around this. You simply have to log the hours.

I logged hours every chance I got. I invited people over for a party and made them watch my act. I hijacked other people's parties and turned their guests into guinea pigs. I did open mike nights. I performed for Arien Mack, my accomplice in the watch-stealing experiment, along with her students, at one of their weekly lab meetings. "That's truly remarkable," she said with a dry smile. "All that work, you could have done something useful." Donning the mantle of the Sage, I turned my newly minted routine into a teaching tool—a sermon on magic, math, and entropy—which I performed for David Bayer's modern algebra class. Yes, I was breaking the magician's code yet again by teaching them the secrets behind the tricks. But by now I'd decided that there was just as much beauty and mystery to be found behind the curtain as there was in front of it.

Once you start assembling a routine, it's amazing how the structure develops, assuming you've thought it through to the

end. All the pieces fit snugly together like a puzzle, balancing one another out. You discover the internal logic of every action, the pretext for every gesture, the red herrings that allow you to conceal your true purpose.

Kate helped me write out a script for my act. ("Don't call it patter," Jeff McBride told us at the Mystery School. "Call it scripts. It automatically elevates it. Patter is for magic tricks. Scripts are for theater.") She advised me on how to structure my tricks into a coherent narrative. She gave me wardrobe tips and coached me on my delivery and timing.

One of my biggest problems was pacing. I spoke entirely too fast. So I practiced with a metronome to get a feel for the natural rhythms of my act, an idea I got from maestro Juan Tamariz. (Dai Vernon famously said that magic, like speech, needs punctuation.) On pizzeria fixture Jack Diamond's counsel, I also filmed my routine from different angles, so I could study the sight lines.

When I took piano as a teenager, I'd do run-throughs first thing in the morning. If you can nail an étude with sleep in your eyes, you're good to go. With this in mind, I practiced my magic routine in my pajamas, minutes after waking up, struggling to pound out eight perfect faro shuffles before my first cup of coffee. Eventually I felt comfortable enough that I could (almost) do it in my sleep.

Then came my big break. Through a well-connected friend, I received an offer to perform at the Gershwin Hotel in the Flatiron district, where I'd be sharing the bill with several famous acts. This was it, I thought, my moment of truth.

On the Saturday before the show, I conferred with Wes. I hadn't been to Rustico II in a while, because I'd been busy working on my act and spending time with Kate, and I could tell he'd already begun to write me off.

When I arrived at the pizzeria, I found Wes standing outside sucking on a cigarette, even though it was freezing. Shivering in my hoodie, I showed him the special gimmicked sketch pad I'd constructed, which made my second trick possible. I thought it was pretty ingenious, but Wes only shook his head.

"It'll never work," he said, ever the Dutch uncle. "The spectator will notice the tension." He took a long pull off his menthol. "When's the gig?"

I told him the show was in three days.

"Oh, you're fucked," he said, and threw down his smoke.

But for once Wes was wrong. Three days, one pep talk from Kate, and half a Xanax later, I found myself onstage. The house was standing room only, despite the weather—a Nor'easter had dumped a foot of snow on the city that morning—and the show went off without a hitch. When the secret name materialized on the deck after the eighth faro, the volunteer, a tall young woman named Lennon, covered her face. "Oh my God!" she screamed, and the audience went wild. Not only did they seem to like my tricks, they also seemed to like me, maybe because I wasn't trying to be somebody else. I felt surprisingly relaxed onstage. Okay, the Xanax helped, but it was more than that: I was having fun.

"I think magic is an art very closely related to poetry," Tamariz says. "The poet manipulates words, and the magician manipulates objects. We are transcending reality in order to produce something poetic, something beautiful, something interior." For the first time, I felt like I'd found the poetry in my magic.

But I wasn't prepared to rest on my laurels just yet. My mission wasn't over. Another challenge awaited me, one I'd been preparing for and dreaming about ever since I'd been redlighted at the Magic Olympics.

There was one more audience I still needed to face.

• • •

Doing magic for laypeople is one thing. But performing in front of fellow magicians is something else entirely. As IBM convention chairman Terry Richison put it, "Performing for a roomful of magicians—*whew*—that takes a lot of guts."

For me it was the final test, my last labor.

A shot at redemption.

I'd come a long way since the Magic Olympics in Stockholm, both as a performer and as a person. Looking back, I was amazed at how much I'd learned. Not only had I mastered hundreds of moves and dozens of mind-blowing tricks, but I now had an original act I could take with me anywhere. It was a far cry from my Olympic routine, which I'd basically stitched together with shoestring and chewing gum.

At this point, trophies were beside the point. I wasn't looking to win a prize. I simply wanted to face my fears and prove to myself—and to the judges—that I could hang with the big boys. (And by big boys, I mean high school kids, in several cases.) I also wanted advice on how I might further tighten my act.

So with Kate by my side providing moral support and last-minute performance tips, I flew to San Diego for the IBM Gold Cups, the most prestigious annual close-up competition in the world.

And guess what? I didn't win.

One magician who did was a high school kid from Acton, Massachusetts, named Shin Lim, a half pint in a white suit with a cunning card to mouth—wherein a signed selection appears folded up inside the magician's mouth. Fortunately, as a physics student, I was accustomed to being bested by Asian kids several years my junior.

But I more than held my own. The IBM always attracts top-notch talent, and 2010 was an especially strong field. There was LA card star Nathan Gibson, a sleight-of-hand prodigy who had lifted seventeen close-up trophies by the age of eighteen. Swedish magician Johan Stahl—whose radical new sleeving system, called "sleeveless sleeving," allowed him to vanish objects with his cuffs rolled up—had won the SAM nationals earlier that year and was an odds-on favorite. But he'd have to beat twenty-three-year-old Ben Jackson, a tall Texan who'd taken first place at the 2010 World Magic Seminar in Las Vegas four months earlier. There was even a young man who had juggled swords on *America's Got Talent*. "I got to the semifinals," he told me, exposing a mouth full of metal. "America didn't vote enough for me."

Each of the twenty-eight competitors in close-up had to perform his or her—there was one her—act three times, each time in a different room. My first two heats went off without incident, but in the third room something terrifying and unexpected happened.

Just as I was about to begin, a tall white-haired man sauntered in and took a seat in the front row. He looked like a basset hound in a navy blazer. I recognized him immediately. It was frost-faced former IBM president Obie O'Brien, the head judge who'd presided over my elimination at the World Championships in Sweden. He was such a big deal that he even had a prize named after him. Each year, the winner of the people's choice award receives an OBIE, a wooden plaque worth a free registration to the following year's convention and a coveted invitation to the FFFF.

Seeing him walk into the room, I felt as if a trapdoor had opened up under my feet. Time seemed to slow down. Red lights began flashing in my head. For a moment, I felt completely paralyzed.

Then I remembered Wes's sage advice—no matter what happens, *keep going*—and an odd calm came over me. I started my act. Before long, eight minutes were up and the audience was cheering. Several of the judges had smiles on their faces. It was my best performance yet.

At that moment, I knew it didn't matter if I won or lost. I no longer cared. I'd done what I'd set out to do. As I struck my set and gathered up my props, I looked over at O'Brien and smiled.

And he even smiled back.

SIPPING A V8 ON THE long northeast slope of the flight back home, thirty thousand feet above the Grand Canyon, I thought of Arthur C. Clarke's famous observation that any sufficiently advanced technology is indistinguishable from magic, and how this saying also holds true, perhaps especially so, in cases where the technology in question is the human brain.

Every truly great idea, be it in art or science, is a kind of magic trick. A colleague of physicist Richard Feynman once referred to him as a magician of the highest caliber. "Even after we understand what they have done," he said of geniuses like Feynman, "the process by which they have done it is completely dark."

But what many of these great thinkers seem to have in common is a love of games and a belief that we do our best work when we're fooling around. As Isaac Asimov once put it, "The most exciting phrase to hear in science, the one that heralds new discoveries, is not 'Eureka!' [I've found it!], but 'That's funny.'"

Frank Lloyd Wright conceived Fallingwater while playing with toy blocks. Leonardo da Vinci was obsessed with puzzles and games and tricks. When Feynman found himself in a rut

after the Second World War, he realized it was because he'd stopped having fun. "I used to enjoy doing physics," he recalled in his memoirs. "I used to play with it." Less than a week later, he was eating at the university cafeteria and he saw someone toss a dinner plate in the air. The peculiar wobble of the plate intrigued him. Shrugging off the skepticism of his peers, he began tooling around with the physics of dishware. Years later, he described this as a major turning point. "There was no importance to what I was doing, but ultimately there was," he wrote. "The diagrams and the whole business that I got the Nobel Prize for came from that piddling around with the wobbling plate." Not surprisingly, a similar spirit animated David Bayer and Persi Diaconis when they first began their work on the mathematics of card shuffling. "We started out just playing," Bayer told me. "We were just amusing ourselves."

As young children, we learn almost exclusively through play. Why should adulthood be all that different? Once thought of as a static organ, the adult brain turns out to be remarkably plastic. Fresh brain cells sprout from injured tissue. New connections form as our neurons rewire themselves. A recognition of the importance of play, not just during childhood, but well into adulthood, lies at the foundation of the new science of neurobics, or brain fitness, a rapidly growing field that aims to keep a graying population mentally sharp with a daily dose of puzzles and brain teasers. The secret to keeping your mind young, we now know, is to continuously revisit the conditions you experienced as a child, when everything was new and mysterious and you hadn't yet figured out the rules of the game.

Magic is about re-creating these conditions. It lets us suspend adulthood and retrieve, however fleetingly, that childlike sense of astonishment that was once our resting state but fades as we age.

As fun as it is to fool people, it's just as fun—more so, even—to be fooled. There's nothing I enjoy more than seeing a trick and having no clue how it's done, because it means there's some new principle at work that I have yet to learn, and behind that, a creative mind at play. This is the feeling of communing with genius—not unlike learning a new concept in physics or listening to a beautiful piece of music.

Being fooled is fun, too, because it's a controlled way of experiencing a loss of control. Much like a roller coaster or a scary movie, it lets you loosen your grip on reality without actually losing your mind. This is strangely cathartic, and when it's over, you feel more in control, less afraid. For magicians, watching magic is about chasing this feeling—call it duped delight, the maddening ecstasy of being a layperson again, a novice, if only for a moment.

Just before Vernon died, comedian and amateur magician Dick Cavett asked him if there was anything he wished for. Vernon's answer, like his magic, was simple.

"I wish somebody could fool me one more time."

MAGIC TERMINOLOGY

AMBITIOUS CARD A classic routine wherein a signed card rises to the top of the deck after being placed in the middle. It was an Ambitious Card effect that fooled Houdini.

ASCANIO SPREAD A method for showing five cards as four.

BACK FINGER CLIP The concealment of an object, usually a card or coin, at the back of the hand, clipped between the index and second fingers.

BACK PALM The concealment of an object at the back of the hand, gripped between the index finger and pinkie.

BLIND SHUFFLE A false shuffle that leaves the order of the cards unchanged.

BOOK TEST A classic of mentalism in which the magician divines a word or phrase randomly selected from a book.

BOTTOM (OR BASE) DEAL A trick deal in which the bottom card is dealt instead of the top card.

BREAK A gap secretly held in the deck to mark the location of one or more cards.

CARD CONTROL Any of a number of sleights for moving a card to a desired position in the deck.

CHARLIER CUT A one-handed cut.

CLASSIC PALM The fundamental concealment in coin magic; the coin is held between the muscles at the base of the thumb and little finger.

CLASSIC PASS The rapid transposition of two halves of a deck. It's done by pivoting the top half under the bottom with the middle and ring fingers.

CLOSE-UP MAGIC Magic performed at short range, in an intimate setting, with small props.

COLOR CHANGE The visual transformation of one card into another.

COOLER/COLD DECK A presequenced deck of cards secretly switched into play during a game or routine.

CULL A move used to isolate and control individual cards during a shuffle or spread.

CUPS AND BALLS An ancient effect in which three balls transpose, multiply, vanish, and reappear beneath the mouths of three cups. A typical cups-and-balls routine uses three wide-mouthed, stackable cups. The balls vanish and reappear under the mouths of the cups, penetrate the solid bottoms, and at the climax, large objects called jumbo loads are usually produced: lemons, giant balls, live animals. There are hundreds of variations, and most magicians know at least one.

DOUBLE LIFT A sleight for turning over two cards as if they were a single card.

EGG BAG A gimmicked bag used to vanish objects, including but not limited to eggs.

ELMSLEY COUNT A false count used to conceal one or more cards in a packet.

FARO SHUFFLE A shuffle in which the deck is cut exactly in half and the cards are perfectly interwoven.

FLASH An accidental revelation.

FLASH PAPER Sheets of paper, made from nitrocellulose, that flash brightly when ignited and leave no ash.

FLOURISH An embellishment, e.g., a coin roll or card fan.

FORCE A choice controlled by the magician.

GAFF 1. (n.) A gimmick.
 2. (adj.) Gimmicked.

HAND MUCKING A method of cheating at cards in which the cards one has been dealt are switched for cards secretly removed from play earlier in the game.

LAP To drop an object into the lap while seated.

L'HOMME MASQUE LOAD A move in which a coin is secretly transfered from one hand to the other by means of a waving motion.

LOAD 1. (n.) An object to be produced. A *jumbo* load is an especially large object, usually produced as a finale.
 2. (v.) To place a load in a desired location by secret means.

MANIPULATION (MANIP) A mix of flourishes, vanishes, and changes usually performed with cards, coins, or balls.

MATRIX/COIN ASSEMBLY An effect wherein four coins placed at the four corners of a mat or cloth magically assemble at a single corner.

MENTALISM A branch of magic that simulates telepathy, telekinesis, and other psychic acts.

MIDDLE DEAL A trick deal in which a card from the middle of the deck is dealt instead of the top card.

OUT An alternative ending to a trick gone awry.

PALM Any of a number of sleights for concealing objects in the hand.

PK (PSYCHOKINESIS) A branch of mentalism that involves psychically bending and moving objects, especially cutlery, keys, watch dials, and coins.

RETENTION PASS A false transfer that exploits an intrinsic lag in the brain's visual frame rate known as persistence of vision. To perform a retention pass, pinch a coin at its extreme edge between the thumb and first finger of your right hand and place it openly in your left palm without letting go. Begin to close the fingers of the left hand. The instant the coin is out of sight, extend the last three digits of your right hand and secretly retract the coin. The left hand makes a fist while the right casually palms the coin and drops to the side. When done convincingly, the viewer actually sees the coin in the left palm for a split second after the hands separate. Magicians call this getting a good burn.

RIFFLE SHUFFLE A common shuffle wherein the cards are cut into two stacks of roughly equal size that are then riffled together.

SECOND DEAL A trick deal in which the second card from the top is dealt instead of the top card.

SPIRIT HAND A fake hand used as cover for behind-the-scenes work.

SPREAD PASS A move for transposing the two halves of a deck in the act of spreading the cards.

STACK A prearranged deck of cards.

STAGE MAGIC Magic that typically involves large illusions and props performed in a theater.

STOOGE An audience member who is in league with the magician.

STREET MAGIC A style of close-up magic popularized by David Blaine in which the magician wows random spectators in public.

SUBTLETY/ACQUITMENT A false display, e.g., showing the hands as empty while palming a coin or card.

SWAMI GIMMICK A secret writing implement used to simulate precognition.

TALKING Unwanted noisemaking by props, especially coins.

TENKAI PALM A palm in which a coin or card is held parallel to the floor against the palm by the curled tip of the thumb.

THUMB PALM A palm in which a coin is clipped edgewise in the fork of the thumb.

THUMB TIP A fake thumb used to conceal small objects.

TOPIT A hidden pouch sewn into the lining of a coat.

TOSSED-OUT DECK A classic of mental magic wherein the magician divines the names of several cards selected from a deck that has been tossed out in the audience.

XCM (EXTREME CARD MANIPULATION) A form of modern card artistry characterized by exotic and technically demanding flourishes. XCM is often likened to juggling with a deck of cards.

ZARROW SHUFFLE A blind on-the-table riffle shuffle.

ACKNOWLEDGMENTS

This book would not have been possible had a number of outstanding magicians not been willing to share their insights and expertise with me—and for that I will be forever grateful. Wesley James taught me more about magic, and life, than I ever thought I could learn in a pizzeria. Jeff McBride and Eugene Burger helped open my eyes to the rigors of the craft. Richard Turner was a true gentleman and more than generous with his time. Armando Lucero and Paul Vigil motivated me to seek out elegance and beauty in the art. Joshua Jay shared his extensive knowledge with me on numerous occasions. Juan Tamariz was a constant source of inspiration who fooled me every time. Teller, Simon Lovell, Ken Schwabe, David Roth, Bob Friedhoffer, John Born, Asi Wind, Benzi Train, Cheng Lin, Jack Diamond, Eric Decamps, Doug Edwards, Ricky Smith, Max Maven, Magick Balay, Derrick Chung, Jonathan

Hidalgo, Tony Chang, Michael Feldman, and George Silverman all lent a hand at various stages in the researching and writing of this book.

I am indebted to the many scientists with whom I communicated and/or collaborated. I am especially grateful to my coresearchers at the New School for Social Research—Arien Mack, Clarissa Slesar, Jason Clarke, and Muge Erol—who let me use their facilities and helped me design the watch-stealing experiment; and to Dave Bayer at Columbia for all the time he spent teaching me about card shuffling. The Columbia University Physics department, meanwhile, deserves a medal for putting up with my antics. Thanks also to Joshua Foer, for teaching me his amazing memory techniques, and to Nava Chitrik for her mathematical insights and programming expertise.

I am deeply grateful to my editor, Tim Duggan, for his expert guidance, patience, and encouragement; to Emily Cunningham, for her many helpful suggestions; to Jenna Dolan, who skillfully copyedited the manuscript; to Katherine Beitner and Leah Wasielewski, for their marketing and publicity skills; and to everyone else at HarperCollins for their hard work on behalf of this book.

I owe an immeasurable debt of gratitude to my agent, Elyse Cheney, who truly does work magic, and to all the folks at Cheney Literary—Alexander Jacobs, Sarah Rainone, Hannah Elnan, Kristen O'Toole, and Nicole Steen—for their outstanding work. I am indebted to Beth Rashbaum for her feedback, help, and astute commentary. Thanks also to Christopher Glazek for checking my facts.

A number of friends and relatives contributed to this book and, in many cases, suffered through early drafts. Kristen Richardson's impeccable taste and unerring guidance inform every chapter. Kate Villanova's unwavering support, sage ad-

vice, and sound judgment made this book—not to mention my life—better in countless ways, both large and small. Tim Farrington offered detailed criticism and helped me sharpen my writing—for which I still owe him several dinners. Konstantin Kakaes was an exceptionally obliging and careful reader. Nick Stang was an unflinching supporter from day one. Rachel Jones provided many thoughtful suggestions during the formative stages of the manuscript. Burkhard Bilger was an unflagging booster who encouraged me to get this project off the ground. Corey Powell at *Discover* was a terrific boss and mentor. Ellen Rosenbush, Roger Hodge, Ben Metcalf, and Miriam Markowitz at *Harper's* were a joy to work with. Thanks also to Sinclair Smith, Anaheed Alani, Steven Levitt, Ira Glass, John Hodgman, Buzz Bissinger, Angie Smithmier Eilers, Bonnie Talbert, Allison Schrager, Theresa Hong, Sarah Gelman, Camille Roman, Alex Hamowy, Sarah Grossbard, Marisa Biaggi, Kimberly Katz, Emir Kamenica, Jen Chu, Nathaniel Mendelsohn, David Weintraub, Jeff Enos, Miriam Enos, Maria Richard, Kristin Wall, Kate Enoch, Jessamyn Conrad, Amanda Simson, Tracy Rossi, Daniel Chapmen, Joy Didier, Gary Cheng, Pontus Ahlqvist, Becky Grossman, Amber Miller, Gabriel Perez-Giz, Joseph Thurakal, and John Kehayias.

Finally, thanks to my family for their love and support.

Hundreds of sources went into the reporting, writing, and fact-checking of this book. To save space (and trees), detailed information about source material has been made available online at: www.FoolingHoudini.com.